D1412457

A Handbook of the Collection

Herbert F. Johnson Museum of Art

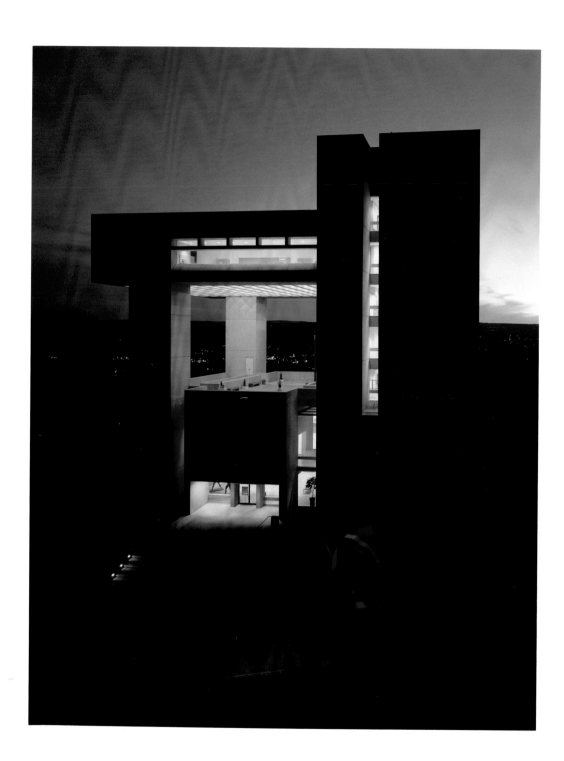

Herbert F. Johnson Museum

A Handbook of the Collection

Herbert F. Johnson Museum of Art

CORNELL UNIVERSITY · ITHACA, NEW YORK · 1998

This catalogue has been made possible by grants from the George and Mary Rockwell Fund, the Georges Lurcy Charitable and Educational Trust, and the National Endowment for the Arts.

Published by the Herbert F. Johnson Museum of Art
© 1998 by Cornell University

Library of Congress Catalog Card Number: 97-77170
ISBN: 0-9646042-7-2 (cloth)
0-9646042-6-4 (paper)

Edited by Sarah D. Benson, Franklin W. Robinson, Anthony H. Sarmiento, and Faith Short.

FRONTISPIECE:
East facade of the Johnson Museum

FRONT COVER:
Robert Rauschenberg, *Migration* (detail)
© Robert Rauschenberg/Licensed by VAGA, New York, NY
(see page 200)

759
H

BACK COVER:
West and south facades of the Johnson Museum

Collections photographed by: Frank DiMeo.
Architectural photographs by: Robert Barker.
Archival photographs courtesy of the Division of Rare and Manuscript Collections, Cornell University Library.

Reproduction rights granted for works appearing on the following pages: © 1998 Estate of Pablo Picasso/Artists Rights Society (ARS), New York, 145; © 1998 Georges Braque/Artists Rights Society (ARS), New York/ADGAP, Paris, 147; © 1998 Jean Metzinger/Artists Rights Society (ARS), New York/ADGAP, Paris, 148; © Giorgio de Chirico/Licensed by VAGA, New York, NY, 150; © 1998 Otto Dix/Artists Rights Society (ARS), New York/VG Bild-Kunst, Bonn, 152; © 1998 Succession H. Matisse/Artists Rights Society (ARS), New York, 154, 155; © 1998 Jean Dubuffet/Artists Rights Society (ARS), New York/ADGAP, Paris, 156; © 1998 Alberto Giacometti/ Artists Rights Society (ARS), New York/ADGAP, Paris, 157; © Frank Lloyd Wright Archives, Taliesin West, Scottsdale, AZ, 173; © Estate of Stuart Davis/Licensed by VAGA, New York, NY, 182; © 1998 Estate of Arshile Gorky/Artists Rights Society (ARS), New York, 185; © Georgia O'Keeffe Foundation, 189; © Philip Evergood/Courtesy Terry Dintenfass, Inc., New York, 190; © T. H. Benton and R. P. Benton Testamentary Trusts/Licensed by VAGA, New York, NY, 192; © 1998 Willem De Kooning Revocable Trust/Artists Rights Society (ARS), New York, 193; © Estate of Yasuo Kuniyoshi/Licensed by VAGA, New York, NY, 194; © 1998 Milton Avery Trust/Artists Rights Society (ARS), New York, 197; © Robert Rauschenberg/Licensed by VAGA, New York, NY, 200, 201; © Richard Estes/Licensed by VAGA, New York, NY/Courtesy Marlborough Gallery, NY, 204; © Vito Acconci/Courtesy Barbara Gladstone Gallery, New York, 205; © George Segal/Licensed by VAGA, New York, NY, 206; © 1998 Frank Stella/Artists Rights Society (ARS), New York, 210

Contents

Authors

Steven Ames

Warren Bunn

Robert G. Calkins

Nancy E. Green

Jill-Elyse Grossvogel

Salah Hassan

Cathy Rosa Klimaszewski

Asa Mittman

Judith Moore

Stanley J. O'Connor

Hunter R. Rawlings iii

Franklin W. Robinson

John L. Sullivan iii

Nora Taylor

Sean M. Ulmer

Masako Watanabe

Elka Weinstein

Andrew C. Weislogel

Todd D. Weyman

Martie W. Young

A Treasure House for Cornell

T HE ARTS AT CORNELL have had a long and distinguished history. Major artists are counted among our alumni, from the pioneer abstract painter Arthur G. Dove and the great photographer Margaret Bourke-White to Susan Rothenberg, Richard Artschwager, and many other artists of our own time. The faculty of the Colleges of Architecture, Art, and Planning, Arts and Sciences, and across the campus work closely with the Center for the Performing Arts and many other units to provide a rich diet of art in every medium for our students and the general public.

The Herbert F. Johnson Museum of Art is an integral part of this process, providing an exciting and wide-ranging education in art from many centuries and cultures from around the world. Housed in a landmark building by I. M. Pei, it is truly a learning museum for everyone, a place for creativity, contemplation, and spiritual renewal.

This handbook is a testament to the energy and dedication, the connoisseurship and generosity, of generations of Cornell alumni and friends. We are deeply grateful to them all for their support. Every student who writes a paper on a Rembrandt etching, every schoolchild who participates in an African mask-making workshop, every visitor who enjoys both the superb Chinese ceramics and the spectacular view of Lake Cayuga from our fifth floor, owes a debt of gratitude to those who have made this collection, and this handbook, possible.

HUNTER R. RAWLINGS III, *President*
Cornell University

A Global Collection,
A Global Education

THE HERBERT F. JOHNSON MUSEUM provides one of the great learning experiences of a Cornell education. It is here that students can see a Chinese Buddha from the sixth century, a Dan mask from West Africa, an ancient Greek vase from the time of the Parthenon, modern sculpture from New York and Paris, and video from Tokyo and Berlin. It is here that they can begin to educate themselves, outside the classroom and for the rest of their lives. It is here that they can begin to think creatively and critically and to feel the joy that great art can bring.

I hope that all of us who love Cornell will join me in helping this wonderful museum fulfill its mission.

STEVEN AMES, *Chair*
Herbert F. Johnson Museum Advisory Council

Acknowledgments

THIS VOLUME IS A TRIBUTE to the foresight, generosity and commitment of many people. Above all, we must thank Herbert F. Johnson, whose vision conceived this building and asked that it be designed by "the Frank Lloyd Wright of our time." I. M. Pei lived up to this request triumphantly. At the same time, the Museum was lucky – even before the present building – to attract truly gifted directors, especially Alan Solomon, our first, Inez Garson, and Thomas Leavitt, who guided and shaped this institution for 23 years and helped give it national stature. We must also mention Martie Young, the model of a scholar-curator-professor, who literally created the collection of Asian art here.

A museum is its collection, and the reader of this book will note the names of so many of our most generous donors. They are too numerous to list here, but I cannot refrain from naming a few who are no longer with us: William Chapman, who gave us the core of our print collection; George and Mary Rockwell, the donors of so many of our Asian holdings; and Mr. and Mrs. Louis Keeler, Dr. and Mrs. Milton Kramer, and David Goodstein, all of whom greatly enriched our collection of old master paintings.

The Johnson Museum has been fortunate in being supported and advised by a profoundly committed and collegial Advisory Council. All of us on the staff are grateful to the members of this group, and, in particular, to the three chairs it has had: David Solinger, Richard Schwartz and Steven Ames. We are especially grateful, too, to the George and Mary Rockwell Fund, the Georges Lurcy Charitable Trust, and the National Endowment for the Arts for their generous grants to this project.

Finally, I must thank the curators, guest authors and editors of this handbook – listed on another page – for the hard work and expertise that has resulted in such a highly informative guide to a collection which gives instruction and delight to the students of Cornell University and the residents of New York State, and beyond.

FRANKLIN W. ROBINSON
The Richard J. Schwartz Director

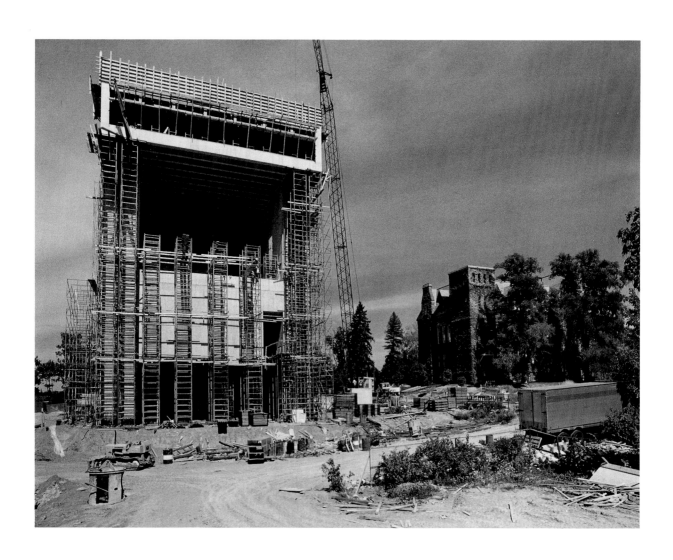

A History of the Museum

"My castles in the air were now reared more loftily and broadly; for they began to include laboratories, museums and even galleries of art."

—ANDREW DICKSON WHITE

LAYING THE FOUNDATION

In 1865, Ezra Cornell and Andrew Dickson White became cofounders of Cornell University. Andrew Dickson White became Cornell's first president and laid the intellectual foundation for an institution that would embrace education in the broadest sense. White, a graduate of Yale (Class of 1853), maintained a strong interest in the arts throughout his lifetime and was an impassioned collector. His vision of a university had begun to crystallize during his postgraduate studies in Europe; it included a "union of liberal and practical education" and "the full cultural development of the individual." He was inspired by the libraries and museums of Europe, which became important elements in his plan for Cornell.

From the beginning, White sought to create an educational environment at Cornell that would inspire as well as instruct. He brought to the University a collection of plaster casts of Greek and Roman sculpture to familiarize students with the importance of classical art, and he enriched the campus grounds with sculpture, paintings, and memorial plaques. He felt "art should serve a moral purpose" and hoped to "inspire students to high purpose and to develop in them an appreciation of beauty to 'leaven the lump.'"

It seemed that White's art gallery might be realized in 1881 when Jennie McGraw Fiske, the only child of Cornell benefactor John McGraw, passed away, leaving a large portion of her assets to the University. White had hoped that his gallery of fine and classical arts would find a home in the newly constructed mansion that Mrs. Fiske had built on University Avenue. But shortly after her death, a long and well-publicized battle over her will ensued

between the University and her husband of thirteen months, Professor Willard Fiske. Infuriated by what he believed to be duplicitous dealings on the part of the University, Fiske went to court to break the will. The Great Will Case lasted until 1890, when the Supreme Court ruled against Cornell. In the aftermath, the mansion was bought by a relative, Thomas McGraw, for $30,000, and the art collection and furnishings were auctioned off.

Even after he retired as president of Cornell in 1885, White continued to use his influence and resources to help build a collection of art for the University. Through his friendship with General Rush C. Hawkins, a collector of art and books who lived in Providence, Rhode Island, White arranged for a gift of an extraordinary painting by Gari Melchers, *The Communion*. A prominent American expatriate painter, Melchers exhibited the work in the Paris International Exposition in 1889, where it won the Grand Prix for the American section. It was there that White first saw the painting, which left a lasting impression. This major work was given to Cornell by Hawkins in 1911 and was proudly displayed in the south vestibule of Goldwin Smith Hall. Its placement was supervised by Melchers himself and Professor Olaf Brauner, whose daughter was to marry Herbert F. Johnson. The painting is now on view in the Johnson Museum.

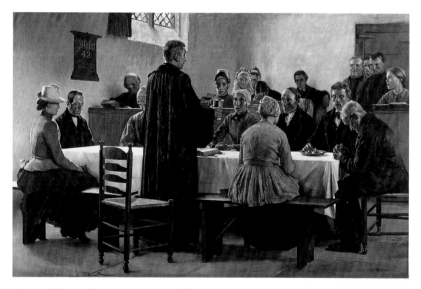

Gari Melchers, *The Communion*, oil on canvas. Collection of the College of Arts and Sciences, Cornell University. Gift of the artist and General Rush C. Hawkins.

White wrote to Hawkins in April of that year, "I cannot express to you my gratitude for this superb gift. All I can say is that in my opinion it will prove the beginning of a new epoch in the University feeling toward the claims upon us of art in the highest places." White never gave up his dream of an art gallery for Cornell, hoping that "some day we shall find a Trustee or a public spirited citizen in the University or out of it, who will add to the nucleus which this noble picture furnishes… there remains in me a faith that a gallery will begin to be developed some day not very distant."

Although an art museum would not be forthcoming in White's lifetime, a museum of casts was organized in 1891 by Alfred Emerson, newly appointed professor of art and archaeology. This

endeavor was funded by Henry W. Sage, and the collection opened in McGraw Hall on January 31, 1894, Sage's eightieth birthday. Regarded at the time as one of the finest collections in any American institution, the casts were used to teach the classical tradition and remained in McGraw Hall until they were moved to Goldwin Smith in 1906.

AN ART MUSEUM IS BORN

There is little mention of an art museum in Cornell's history for the next half century, except for a brief period in the mid-1920s when a series of traveling exhibitions was brought to campus and shown in the gallery located in the sculpture studio of old Morse Hall; an art gallery in Willard Straight Hall was maintained by the College of Architecture for exhibitions of work by eminent contemporary artists in the 1930s.

Finally in 1953, White's dream of an art museum for Cornell was realized under the presidency of Deane Malott, with funds donated by Ernest I. White, a nephew of Andrew Dickson White.

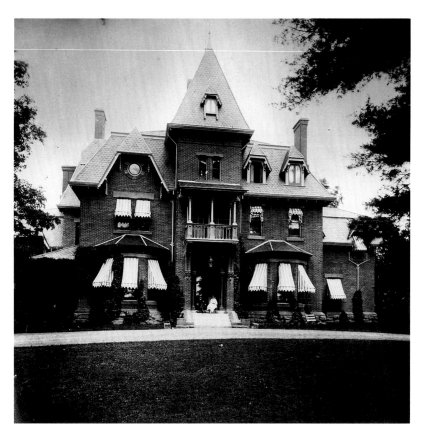

President Andrew Dickson White built this house as a private residence with the intention of giving it to the University for the use of future presidents after he retired. In June of 1874 the house was completed, and White, his wife Mary, and their four children moved into their new home. In future years, the house would serve as the residence for University presidents Livingston Farrand and Edmund Ezra Day. In 1953 it became Cornell's first museum of art.

On November 22, the Andrew Dickson White Museum of Art celebrated its formal opening. Appropriately, the new museum was housed in the very building that had served as the residence for A. D. White and his family during his tenure as the University's first president. This stately structure on the hill above East Avenue was designed by William Henry Miller, one of Cornell's first architecture graduates and an architect who changed the face of Ithaca around the turn of the century.

According to correspondence, Malott's decision to found an art museum for Cornell was inspired by the first extensive gift of art to the University, bequeathed by William Chapman in 1947 – a distinguished collection of 3,000 prints, including works by the masters of the medium from the sixteenth to the twentieth centuries. Shortly after the A. D. White Museum opened, President Malott wrote to Chapman's niece, "The very existence of your uncle's collection here was perhaps the single factor prompting me to work for and finally establish this important facility."

Converting the Victorian parlors of White's mansion into exhibition galleries on a limited budget was no small task; it was

undertaken with skill and ingenuity by the Museum's first director, Alan R. Solomon. Malott selected Solomon from the faculty of the Department of Fine Arts; he worked part-time as museum director and part-time teaching art history. Under Solomon's direction, the Museum got off to an impressive beginning. He was a graduate of Harvard, and his area of expertise was modern art. He had ties to the art scene in New York and a close relationship with Leo Castelli and other dealers. With their help, Solomon began to show contemporary art at the Museum, including works by Jasper Johns, Robert Rauschenberg, and Richard Diebenkorn.

When the Museum opened, the art collection was small – the most significant holdings were the distinguished collection of prints donated by William Chapman. Consequently, the Museum functioned more as a gallery in the early years. During the first seven months of operation, the Museum offered forty-one exhibitions (several were shown twice), an incredible number for a new museum with a small staff. They included Hudson River School paintings, Dürer prints, Whistler prints, Miró paintings, and several traveling shows from major museums – Atget, Brady, and Adams photographs, *Europe: The New Generation*, and *Redon Prints* from the Museum of Modern Art; *Norwegian Decorative Arts from the Smithsonian;* and twentieth-century European art from the Guggenheim. In his annual report for 1953–54, Solomon noted, "Because of the greater accessibility of contemporary material, the exhibitions of twentieth-century art have tended to reach a higher level of quality than those of the art from other periods. In spite of this qualification it will be noted that the Museum maintained a schedule in which about nineteen of the exhibitions were based on modern paintings or sculpture, while twenty-three consisted of other kinds of material." Solomon also mentioned that the vigorous exhibition schedule was deliberate, because he believed that "a great deal of activity in our early period of operation was necessary to attract and hold public interest."

The desire to link the Museum closely with other departments on campus and to involve students in Museum activities is evident from the beginning. During the first year, more than 10,000 people visited the Museum, and joint projects were planned with the Colleges of Architecture, Home Economics, and Engineering, the Department of Fine Arts in the College of Arts and Sciences, and the Willard Straight Art Committee. The Museum became the center for the annual Festival of Contemporary Arts, which started on campus in 1945. Solomon hoped "by

The first extensive gift of art to the University came from William P. Chapman, Jr., in the 1940s. Chapman acquired an impressive collection of prints over a period of nearly forty years, including works by Dürer, Rembrandt, Van Dyck, Meryon, and Whistler. His first gift to the University in 1942 consisted of 52 etchings and 15 lithographs that survey Whistler's development from 1858 to 1889; another gift of 772 prints followed in 1943, and a final bequest following his death of 2,339 prints was received in 1947.

William Chapman graduated from Cornell in 1895. He was a lawyer by profession and lived in New York City; as a young man he spent Saturday afternoons studying in the print room of the New York Public Library. Chapman began collecting prints in 1909. "I never bought any print unless I liked it," he said, "never for the sole reason that it was rare and that the artist was distinguished. That seemed to relate to the history of art rather than to the philosophy and enjoyment of the beautiful."

the diversity of [museum] programs to involve the general student in a dynamic way in the process of fitting art into life." Looking back on the first year of the Museum, he noted that it had become "an active force in campus life. Besides forty art exhibitions, the museum has offered chamber music concerts, art films, panel discussions, gallery talks, an art lending service, and other programs relating to the arts."

Solomon left Cornell in 1961 to become director of the Jewish Museum in New York. Under his direction, the A. D. White Museum offered exhibitions that seem quite remarkable even today for a fledgling art museum with a limited budget, often attracting national interest. He organized the first retrospective of Arthur Dove, an alumnus, and the first major exhibition of Robert Rauschenberg, while also acquiring important works by Rauschenberg, Lee Bontecou, and Adolph Gottlieb, among others. He firmly established the idea that an art museum would invigorate the intellectual life of the campus and enrich the education of Cornell students.

Following Solomon's departure, President Malott appointed Richard Madigan as the first full-time director of the Museum. Madigan was a young man of 23 who had worked at the Corning Museum of Glass, where Malott served on the Board of Trustees. (Madigan had received a bachelor's degree in political science from Drew University.) Soon after Madigan's appointment, Malott appointed six faculty curators to serve as an advisory committee for the Museum. While the number of exhibitions was cut back dramatically to 24 in Madigan's first year, renovations to the building continued, new gallery and office spaces were added, and several notable works were acquired for the collection. Among these were paintings by Eugène Boudin, Otto Marseus van Schrieck, and Léon L'Hermitte, as well as prints by Picasso, Bonnard, Manet, and Chagall.

THE SECOND DECADE —
A TRANSITIONAL PERIOD

Following Madigan's departure in 1963 for the Corcoran Gallery of Art, a series of interim directors was appointed before a final selection for director was made in 1968. Inez Garson, who had served the Museum as assistant to the director under Solomon and Madigan, became the Museum's acting director from 1963 to 1966; this "interim administration" also included part-time curators –

Martie Young and Mrs. Rockwell –
a Dynamic Duo

Professor Albert S. Roe, and Professor Martie W. Young, curator of Asian art. Roe assumed responsibility for museum operations with the title of senior curator in 1966–67 when Garson left for a position at the Museum of Modern Art. He was followed by Young, who served as acting director in 1967–68.

By the early 1960s the Museum was experiencing serious problems with the facility, which were noted in Garson's annual reports – inadequate storage space for the growing collection, security issues, the constant maintenance concerns of an older building, inadequate shipping and receiving facilities, and lack of proper lighting in the galleries, and difficulties with temperature and humidity controls. Because of these concerns, the Museum was having difficulty borrowing shows and major works of art from other institutions. Interest was mounting for a new art museum, and in May of 1963, shortly before his retirement, President Malott set up a committee to help in the basic planning of requirements for a new museum, with Provost Atwood as Chair. After his arrival on campus, the new president of the University, James Perkins, appointed members to the group. In August of 1964, the committee, headed by Vice President of Academic Affairs, William R. Keast, sent the president a proposal. They recommended that a building of 70,000 square feet be erected on "the beautiful Morse Hall site" and advocated "an architectural design of the very highest standard." The committee noted that the new building "offers an unparalleled opportunity to bring to the campus a new sense of quality."

Mrs. Rockwell's husband George was a University trustee, and a loyal Cornellian (Class of 1913). He brought Mary to his alma mater where she met Professor Young in 1962. She was a collector of ceramics and had spent several years in China as a young child. On one of her trips to Cornell, Mrs. Rockwell brought some ceramics for Young to look at. From that point on, a friendship developed that lasted until her death in 1988. She slowly began to help Cornell's curator build a collection, and once the plans for a new museum were under way, the collecting began in earnest.

Over the years, the Asian collection grew steadily, and after her death her entire collection was given to the Museum. As a tribute to their generosity, the fifth floor has been named the George and Mary Rockwell Galleries of Asian Art. Thanks to them and many other donors, the Asian collection now numbers more than 7,000 works in many media from China, Japan, Korea, India, Persia, and Southeast Asia.

As plans for a new building moved forward, the Museum staff grappled with the constraints of the aging facility and continued to develop the collections while maintaining an active exhibition and program schedule. Due largely to gifts from collectors and donors (the Museum had minimal funds for the purchase of art), the collection was growing in size and stature. In the annual report for 1963–64, several notable additions were listed: a large collection of Tiffany Favrile glass; a painting by Roberto Matta; and Chinese, Indian, and Roman objects. Asian art was becoming a gem among the collections under the direction of Martie Young. He had been trained at Harvard where he received his Ph.D. in art history with a concentration in Chinese painting and ceramics. He came to Cornell in 1959 to serve on the faculty of the Fine Arts Department. In his dual role as professor and curator, he began building a collection of Asian art from a mere handful of objects. In the beginning, Young recalls a dozen or so Asian works: several Chinese paintings, a Tibetan musket, what was purported to be the Dalai Lama's robe, some ceramics, and Japanese prints, which were then housed in the print room. With the help of collectors Mary Rockwell and her husband George, the collection grew dramatically and remains a principal strength of the Museum's holdings to this day.

A major event for the A. D. White Museum during the 1960s was *ART: USA* in the winter of 1967. Organized by S. C. Johnson and Sons, Inc., the exhibition consisted of 102 American paintings by Robert Rauschenberg, Ellsworth Kelly, Stuart Davis, Andrew Wyeth, and many others. The response was overwhelming. In just five weeks, five times as many people saw this exhibition as had seen any previous show at the Museum; in fact, only a slightly larger number of people had visited the Museum the entire previous year. Special tours of the show were given to schoolchildren and adult groups by the curator of the exhibition, John E. Brown. Eighty-five groups from 20 schools in the region visited the show. It was a smashing success and underscored the impact the Museum could have on the campus and the community.

Herbert Fisk Johnson, president of Johnson Wax, had a longstanding interest in art and saw the project as "an act of faith in American art and an experiment by a business firm in international relations on a people to people level." The show traveled throughout the United States and abroad and was seen by 750,000 people in 14 countries.

A NEW ERA BEGINS

Three major events in the Museum's history occurred in the mid-1960s that moved the Museum forward dramatically – Herbert F. Johnson, Class of 1922, agreed to fund the construction of the new museum building, Thomas W. Leavitt was appointed director of the Museum, and I. M. Pei was selected as the architect for the new structure.

President Perkins approached Johnson, a Cornell trustee, and he agreed to give $4,000,000 for the project in 1967. His only condition was that an architect of stature be hired, "the Frank Lloyd Wright of our time." Johnson was a collector of art and appreciated fine architecture. He had commissioned Frank Lloyd Wright to design the headquarters of Johnson Wax and his private residence. Johnson wanted an adventurous architect for the new museum who would create a building of distinction, one that the world would pay attention to.

With plans for the Museum under way, the search for a new director accelerated, and the University chose Dr. Thomas W. Leavitt. Leavitt received his Ph.D. in art history at Harvard with a concentration in American painting and sculpture. He had extensive museum experience as director of the Pasadena Art Museum and the Santa Barbara Museum of Art. Leavitt began his tenure as director of the Johnson Museum of Art on July 1, 1968.

Shortly after Leavitt's appointment, Ieoh Ming Pei was chosen to design the new building. Pei was selected from a list of leading architects after an intensive search by a committee chaired by Thomas W. Mackesey, Cornell's chief administrative officer for

After graduating from Cornell in 1922, Herbert F. Johnson joined the family business, Johnson Wax (S. C. Johnson and Son, Inc.), which was founded by his grandfather. Six years later he became president and chairman and served in these positions until 1958, and as honorary chairman until 1966. During his tenure, Johnson established the Johnson Foundation, which grew out of his involvement with educational, cultural, and philanthropic projects. His interest in art led to the creation of two major traveling exhibitions that toured museums in this country and Europe, *ART: USA*, and *OBJECTS: USA*, a collection of work by 250 American craftsmen.

When the company needed a new office building in the 1930s, Johnson hired Frank Lloyd Wright to design the structure, which was hailed as "the greatest innovation in business housing since the skyscraper." Pleased with the results, he commissioned Wright for two more projects – the world-famous Johnson Research Tower, and "Wingspread," the family residence which was later converted into a headquarters and conference center for the Johnson Foundation.

Johnson was a member of Cornell University's Board of Trustees and later served as Trustee Emeritus and Presidential Councillor. Johnson's life-long interest in art and education and his dedication to the growth and development of the University led to the gift of a new art museum for his alma mater.

Thomas W. Leavitt was born in Boston in 1930, the son of a painter and the grandson of a sculptor. He received a bachelor's degree in American literature from Middlebury College in 1951, his M.A. in art history from Boston University in 1952, and his Ph.D. from Harvard in 1958.

Throughout his career he was a leader on the national art scene, serving as the first head of the Museum Program at the National Endowment for the Arts and the first university museum director to be elected president of the American Association of Museums. He was director of the Johnson Museum from 1968 to 1991. The exhibitions he organized received national recognition, and the collections grew dramatically, to more than 20,000 works of art. Leavitt felt that "the most important talent a museum director can have is the ability to recognize an important work of art or art movement and to decide whether people need to see it at a given moment."

planning and former dean of the College of Architecture. Among the other architects the committee considered were Kevin Roche, Marcel Breuer, Louis Kahn, and Edward L. Barnes. Interest in Pei grew as the committee became more familiar with his work. Young was strongly interested in Pei, and Leavitt had looked at several of his buildings and visited his firm. Pei had several important projects in the works, including the Everson Museum and the Air and Space Museum in Boulder. The turning point in the decision-making process occurred on a winter day in 1967 when Young arranged a field trip to Syracuse for the committee to see the Newhouse building at Syracuse University, recently completed by Pei, and the Everson Museum, which was under construction.

The Newhouse building was striking but had operational problems; it was the visit to the Everson that helped clinch the decision. Young remembers the visit vividly: "We went into this building all shrouded by canvas, and walked into the interior lobby … it was just pure poured concrete and wood forms. We walked in and it was glorious, it was the most exciting space I had ever seen, an ingenious use of volume and form."

While plans for the new building continued, programs and collection development at the A. D. White Museum continued uninterrupted. Upon his arrival on campus in July of 1968, Leavitt recalls finding "a very viable museum program." The first show he saw was the Tony Smith sculpture exhibition with "giant pieces all over the Arts Quad and in front of the A. D. White Museum." The Smith show was followed by *Treasures of Medieval Art*, organized by Professor Robert Calkins. Print shows from the Museum collections were organized by Ruth Schlesinger, assistant curator of prints. Leavitt's first exhibition was *Earth Art* in February 1969, a groundbreaking event for the Museum. Nine young artists were brought together for their first group show in a museum, among them Hans Haacke, Richard Long, Robert Smithson, and Neil Jenney. Eight of the artists came to the Cornell campus for three weeks to create works of art with dirt, coal, asbestos, rock, salt, ice, and other natural materials in and around the Museum; Robert Morris, who could not make it to campus because of a blizzard, sent instructions by telephone. In conjunction with the show, a symposium was organized featuring the eight artists, drawing national attention and interest. The exhibition helped to establish environmental art as a legitimate art form, and it furthered the Museum's reputation for avant-garde exhibitions. A tradition of wide-ranging shows was attracting visitors from the University, the community, and central New York State. During the academic

year of 1968–69, attendance at the A. D. White Museum reached 31,233, more than double the number of visitors three years before.

The permanent collection was gaining in size and stature as well. The annual report of 1968–69 noted that the Museum Associates gave more than $30,000 for acquisitions, and it highlighted several impressive additions to the collection, including an early painting by Hans Hofmann, a major drawing by Claude-Emile Schuffenecker, and a linoleum cut by Picasso. With funds provided by Mr. and Mrs. George Rockwell, several acquisitions were made for the distinguished Asian collection. Contemporary paintings also grew with the purchase of several works made possible with a matching grant from the National Endowment for the Arts.

DESIGNING A TEACHING MUSEUM

It is part of campus legend that the location selected for the new museum, a "prominent knoll" on the north end of Library Slope, is the very spot where Ezra Cornell stood and said he wanted to found a university. On the edge of campus near Fall Creek Gorge and overlooking Cayuga Lake, it offers commanding views of the countryside and campus.

Initially, there was much discussion about where the new museum would be located. It seemed logical to some to place it at the north end of the Arts Quadrangle close to the art, architecture, and art history departments. However, in the end, the trustees decided the Library Slope site was the ideal location for the new building, which was to be a major architectural statement, taking full advantage of the spectacular views.

The location of the new museum would be a major factor in the evolution of the building's design, coupled with the particular needs of a teaching museum. The program for the building was worked on over an extended period of time by Young, Garson, and Leavitt. It was decided that the Museum would contain study galleries for course-related shows, a lecture room, and galleries of varying sizes to accommodate both traveling exhibitions and the permanent collections. Ada Louise Huxtable discussed the prerequisites in an article in *The New York Times:* "The building is intended to act as a kind of viewing platform for splendid vistas on all sides … and is also meant to serve as an attraction for alumni and parents as well as students and art lovers, and to function as a place for trustees and other meetings" comprising what she referred to as an "architectural mixed bag of essentially conflicting uses."

All of these concerns were incorporated into the design of the structure by I. M. Pei's firm. Pei brought into the project John L. Sullivan III, a 1962 graduate of Cornell's architecture program. He worked on the design for the Museum in close consultation with Pei. Reflecting on the evolution of the building shortly after the Museum opened in 1973, Sullivan noted that the limited size of the site dictated a vertical structure, and the open space in the middle was meant to preserve the view from East Avenue, the site of the A. D. White Mansion, and to avoid a walled-off feeling on the west side of the Arts Quad. This idea of transparency was also reflected in the lobby of the building, surrounded on three sides by glass walls.

Following budgetary adjustments (the overall scale of the building was shrunk, and a second passenger elevator and a lobby cloakroom were eliminated), the plans were finalized and construction began in August of 1970 and continued for nearly three years. The William C. Pahl Construction Company of Syracuse, the same firm used for the construction of the Everson Museum, won the bid. The vertical structure would stand 110 feet high and would be constructed of board-formed reinforced concrete and glass. With approximately 61,000 square feet, the building consisted of ten floors, three below ground, and windows facing in all four directions on the fifth floor. The building was constructed to allow for the future addition of an underground wing that would face Fall Creek Gorge.

I. M. Pei and Herbert F. Johnson greet each other at the opening of the Museum on May 23, 1973. President Dale R. Corson looks on.

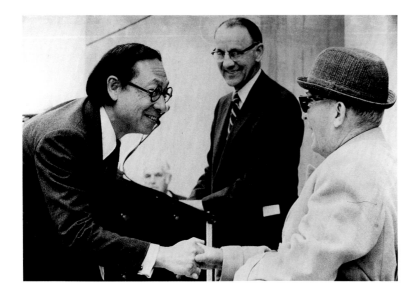

THE HERBERT F. JOHNSON MUSEUM OF ART

Named after its benefactor, the Johnson Museum opened its doors on May 23, 1973; nearly a thousand guests attended the opening festivities. At the dedication ceremony, Johnson expressed the "hope that the new museum will serve the students of Cornell, present and future, as a wider window on the world of fine arts, enabling them to add a broader dimension to their lives no matter what their fields of study might be." His son, Samuel C. Johnson, Class of 1950, and a member of the Board of Trustees, formally turned the building over to the University on behalf of his father. Quoting him he said, "A full appreciation and understanding of the arts can provide a deep enrichment of one's own life and especially, in today's world, can help us strengthen our respect for the dignity and individual creativity of man."

Nancy Hanks, director of the National Endowment for the Arts, was keynote speaker at the dedication luncheon. President Dale R. Corson introduced I. M. Pei, who spoke of his concerns in designing an appropriate building for perhaps the University's most sacred site. Leavitt also spoke, stressing that the Museum would be used as a teaching facility for the Cornell community and as a cultural focal point for the residents of the Finger Lakes region. In the first year, attendance reached 70,000, nearly the population of Ithaca and the surrounding area. Ada Louise Huxtable wrote that Pei's design was "an elegantly refined solution of its purposes [as a teaching museum]." Two years after the Museum opened, the building received the American Institute of Architects award for distinguished design.

THE COLLECTIONS

At the time the new museum opened, the collection of American art was growing stronger, with special emphasis on nineteenth- and early twentieth-century painting. These holdings were significantly enhanced with gifts from Dr. and Mrs. Milton Lurie Kramer. The Kramer collection contained work by many of the major artists of the first half of the twentieth century – Stuart Davis, John Marin, Arthur Dove, Georgia O'Keeffe, Abraham Rattner, Charles Sheeler, and Jacob Lawrence, among others. Included in the decorative arts were 200 pieces of Tiffany glass donated by Edythe de Lorenzi and Arthur L. Nash.

The strongest of the European holdings, then and today, was the print collection. The nucleus of this collection was the Chapman bequest, and by 1974 the collection had grown to more than 7,000 prints, including works by Mantegna, Dürer, Callot, Hogarth, Canaletto, Piranesi, Goya, and Whistler, as well as nineteenth-century French artists and British and American printmakers from the turn of the century.

At the same time, many friends of Cornell, such as Mr. and Mrs. Louis V. Keeler, David Solinger, and Mr. and Mrs. Herman Metzger, among many others, were instrumental in the growth of the European painting collection. Included here were such distinguished works as *Fields in the Month of June* by Charles-François Daubigny, *Woman Lying on a Leopard Skin* by Otto Dix, and *Smiling Face* by Jean Dubuffet. In the early 1970s the Museum acquired several pieces of medieval sculpture from Flanders, Germany, France, and Italy, as well as drawings and watercolors by Whistler, Nolde, Kirchner, Grosz, Léger, Matta, Matisse, and Picasso. The fledgling photography collection also grew, with works by Eugène Atget, Alfred Stieglitz, Lewis Hine, and Ansel Adams as well as such younger photographers as Harry Callahan, Paul Caponigro, and Les Krims. A major component of the collection was a large body of work by photojournalist and Cornell alumna, Margaret Bourke-White. The most notable works in the small sculpture collection were *Walking Man II* by Alberto Giacometti and pieces by Jacques Lipchitz and Auguste Rodin. Holdings in Pre-Columbian, African, and Oceanic art added to the richness and diversity of the collections.

THE MUSEUM REACHES OUT

When the Johnson Museum opened in 1973, it became a primary center for visual arts in central New York. Leavitt felt that with this distinction came the responsibility to make the collections and exhibitions accessible to the campus and the region. In 1975, he hired the first coordinator of education to develop public programs for the Museum. A storage area on the second lower level was converted to house the newly formed education department, and the *Museum in the Schools* program was soon initiated. The staff had grown to 21 full-time employees, plus part-time graduate student assistants and undergraduate student guards.

The Museum continued to offer exhibitions of contemporary art that often traveled to other institutions, balanced with a wide

range of shows to meet the teaching needs of the campus and the interests of central New York residents. Among the exhibitions that received national attention were *Far Eastern Art in Upstate New York, Directions in Afro-American Art,* and *Abstract Expressionism: The Formative Years,* which traveled to the Whitney Museum and the Seibu Museum of Art in Tokyo.

Building a collection of high quality in all periods of the history of art continued to be a priority for the staff. Leavitt felt that "an active museum with a good collection and a series of changing exhibitions can alter the whole tenor of campus life." Interest in the Museum was strong, and by 1979 attendance reached 96,000. With limited funds for the purchase of art, the Museum relied heavily on gifts from alumni and friends. By 1980 Museum holdings had grown to 12,000 works of art, and the first *Handbook of the Collections* was published; 231 of the most important works were illustrated.

The 1980s were marked by significant growth in the print collection, through purchases and gifts from donors such as Paul and Elizabeth Ehrenfest, Paul and Helen Anbinder, Bill and Martha Eustis, Professor Robert and Joan Bechhofer, and Dr. Bruce Allyn Eissner and Judith Pick Eissner. The body of work by Francisco Goya, already significant with *The Disasters of War* and *Caprichos,* was enhanced by the addition of the *Proverbios.* Matisse's *Jazz* and Wassily Kandinsky's *Kleine Welten* were acquired, as were important Pop and contemporary prints. Among the new photographs were works by Robert Frank and Berenice Abbott, given by Arthur and Marilyn Penn, and several nineteenth-century photographers, including Julia Margaret Cameron, Timothy O'Sullivan, William Henry Fox Talbot, and David Octavius Hill and Robert Adamson.

During this period, the Museum continued its tradition of organizing traveling exhibitions, several of which revisited the theme of environmental art. *Robert Smithson: Sculpture,* a retrospective organized by the Museum in 1980, traveled to the Walker Art Center, the Museum of Contemporary Art in Chicago, and the Whitney Museum, among other institutions. *The Lagoon Cycle* in 1985 had begun as a research project on the potential of developing a crab from Sri Lanka as a world food source. It grew into a large-scale artistic record of the project by Helen Mayer Harrison and Newton Harrison. Contemporary painting was showcased in *Painting Up Front* in 1981, and in a major retrospective of the work of Joan Mitchell in 1988 that traveled to the Corcoran Gallery, the Museum of Modern Art in San Francisco, the La Jolla Museum of Contemporary Art, and the Albright-Knox Art Gallery.

In the mid-1980s the Museum began showing video and film with Expanding Cinema, as well as exhibitions such as *Media Buffs,* drawing new audiences to the Johnson. *Cornell Collects: A Celebration of Art from the Collections of Alumni and Friends* in 1990, presented 162 works from 72 lenders at the time of the University's 125th anniversary.

INTO THE 21ST CENTURY

Leavitt retired as director of the Johnson Museum in 1991 after 23 years of distinguished service. As a director, he sought to humanize the Museum, making art truly accessible to the individual. Reflecting on his career, Leavitt said he "strove to keep the Museum flexible, and respond to new ideas"; he wanted to create "a thinking museum that worked with artists and historians."

Following Leavitt's retirement, Martie Young once again served as interim director while a national search was conducted to find a replacement. In 1992 Frank Robinson was hired as director. Robinson came to the Johnson from the Museum of the Rhode Island School of Design, where he served as director for 13 years. An authority on Dutch art, he had taught at Dartmouth, Williams, and Wellesley Colleges. During the last several years, Richard J. Schwartz, the dynamic chair of the Museum's Advisory Council, and Robinson have recommitted the institution to serve as an educational resource for all Cornell students, strengthening ties to the university community while maintaining outreach to area schools and residents of the Finger Lakes region. Embracing new technologies and recognizing their potential for increasing access to works of art, the Museum has begun to create digitized images and on-line information on the collections. Coming to terms with the economic realities of the 1990s, an endowment campaign was launched in 1996 by the Advisory Council, now chaired by Steven Ames, ensuring that the Herbert F. Johnson Museum of Art will continue to be a vital, active learning resource in the next century and beyond.

CATHY ROSA KLIMASZEWSKI
The Harriett Ames Charitable Trust Assistant Director for Education

NOTE:

The sources used for this history include Morris Bishop, *A History of Cornell* (Ithaca: Cornell University Press, 1962), Elaine D. Engst, "Remembering Cornell: An Exhibition in the Cornell University Library" (Ithaca: Cornell University Library, 1995), and "125 Years of Achievement: The History of Cornell's College of Architecture, Art, and Planning" (Ithaca: Cornell University Library, 1996), Ada Louise Huxtable, "Pei's Bold Gem," *The New York Times*, June 11, 1973, Jane Marcham, "Museum is Special to Architect," *Ithaca Journal*, May 24, 1973, Katherine Campbell Mattes, "Master of Art," *Cornell Alumni News*, July, 1980, Society for the Humanities, *Andrew Dickson White and His House* (Cornell University, August 1991), Carole Stone, *Cornell Chronicle*, January 17, 1991, and annual reports, brochures, correspondence, interviews, and other materials in the Johnson Museum files.

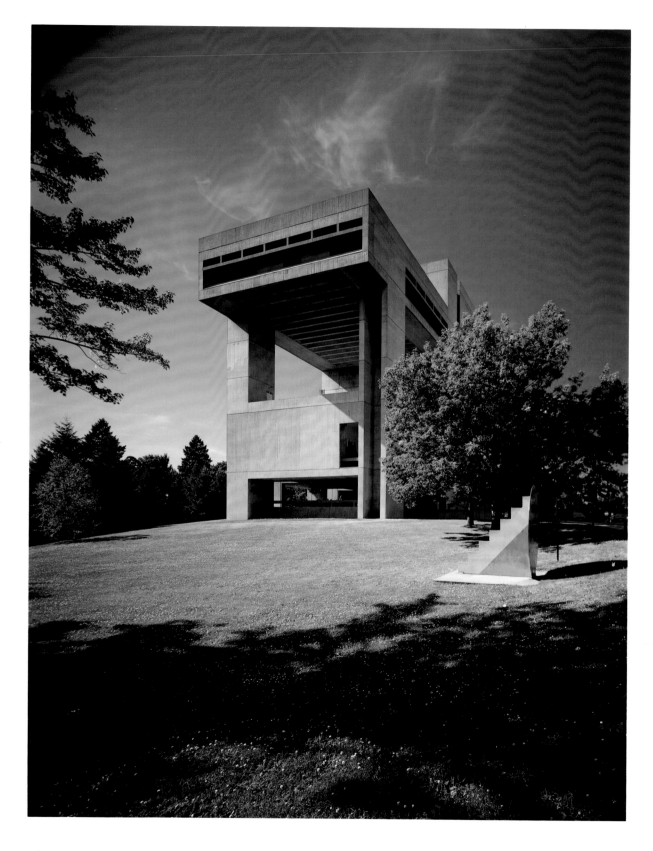

The Design of the
Herbert F. Johnson Museum
of Art: A Recollection

IN THE SPRING OF 1968, I. M. Pei & Partners (now Pei Cobb Freed & Partners) received the commission from the Trustees of Cornell University to design the Herbert F. Johnson Museum of Art. It was to be the third museum building created by the ten-year-old firm, and the largest, most complex one to that date. It was singular as a building type: a museum and teaching facility, one that would serve the educational needs of the University and enrich the cultural life of the surrounding community.

The program compiled by the University Planning Office for the 60,000 square foot building was a 35-page booklet encompassing the Museum's background and goals; the uses and their space needs; technical considerations; site description, plans, and photographs; project standards, schedule, and budget. A two-dimensional diagram defined desired relationships without prejudice to architectural disposition. It was a well-devised document produced jointly by the Museum directorship and the University administration, communicating ideas and fundamentals while leaving open the design concept and its resolution. A brief section devoted to the University's philosophy toward the introduction of new buildings into the harmonious fabric of campus structures and spaces paralleled the analytical approach we pursue in the development of all our projects: an overview of the larger picture, studying the impact of the new upon the existing while evaluating possibilities in design direction through ideas prompted by the context.

This complete listing of museum spaces, with their areas and explicit individual requirements, provided us with a valuable guide throughout the two-year design documentation process. Among the physical considerations that would influence the design concept were the need for latitude in the display arrangement of the diverse scope of existing collections, the provision for a variety of gallery ceiling heights, and the restriction of direct natural light from most, if not all, of the galleries. The massing would also be affected by the large amount of space required for support facilities: the storage and work rooms; the mechanical system; the

offices and meeting room; and those auxiliary spaces required for its teaching role. Tucked in was the request to consider future expansion.

SITE AND CONTEXT

The design concept of the Johnson Museum is first about response to the site: its great expanse, its limitations, its orientation, its relationships, and the resultant accountability. The initial assessment came during a lengthy walk in early summer of 1968 with University officials, Thomas W. Leavitt, the museum director, and Dan Kiley, the noted landscape architect. The site, at the crest of the spectacular 1000′ long sweep of Library Slope before it plummets into Fall Creek Gorge, had been the location of a long-demolished classroom building and was occupied then by two parking lots. But this knoll was, as history has passed on to us, the spot upon which Ezra Cornell had determined the location for his new University. At that time there was a panoramic view of Lake Cayuga from ground level; a similar view was now possible only from the roof of adjacent Tjaden Hall.

The site was found to have two distinct aspects, each requiring a unique response; a conundrum, as the two were in opposition. The dynamic, upward movement of Library Slope required a building of compact volume to provide visual termination, while the approach to the site through an opening in the wall of buildings forming the west side of the Arts Quadrangle required spatial definition without closing off the view beyond. The site was well-oriented, being open to the sun and to views east, south and west, while trees screened the gorge on the north.

It was observed that the nearby classroom buildings, including the three original University buildings, have a basic similarity of concept: a rectangular, block-like form resting on a basement plinth with the entry several steps above grade. From this kinship each of the Arts Quad buildings develops its distinct personality, defined by the roofline – dome, tower, turrets, gables, mansards, and dormers – and by a subtle play of receding and projecting facade planes.

BUILDING: CONCEPT AND FORM

The design process began by testing the programmed area on a site model which included all of Libe Slope, the gorge, and the Arts Quad, using clusters of volumes to represent the main components of the Museum. It was estimated which of the support areas might be placed below grade for convenience, and for the reduction of the building volume. Starting from a scheme with a low, broad massing, the idea evolved quickly into a slim tower: open to the south, perforated east and west, solid to the north. We discovered immediately that engaging the site with a terraced low block was not successful; the actual *buildable* site area was not large, and terracing required a breadth of surrounding green space to give a sense of the building emerging from the land. Whatever its strength and interest, the benefits of a stepped block were negated by its density at grade, choking the view from the Arts Quad. This exercise revealed that by raising and dispersing some of the volumes seen from the Arts Quad, while maintaining the simple, rectangular silhouette seen from the bottom of Libe Slope, transparency could be achieved without losing the bold statement. The fragility of the site, in tandem with the amount of functional space required above ground, war-ranted the tower concept. The development of the scheme was to be a continuation of this testing process, and one of simplification; a joint strategy incumbent upon a building type that allows – and *requires* – so much design freedom in its creation.

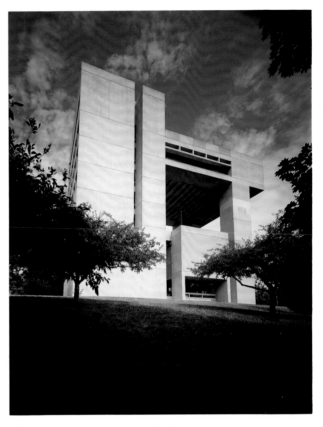

West facade

 A new abstract block representing a realistic diagram of the program's components was then studied at the small scale of the contextual model. Functions were grouped into above-grade and below-grade categories; those above grade were further split into gallery (low zone) and "other" (high zone). The areas were compared and the uses assessed for stackability (convenience and appropriateness). This analysis produced a stacking diagram to complement the one in the original program illustrating plan rela-tionships.

 A scenario was formulated for the disposition of the program spaces, defining a rough framework for the vertical massing within

a tight, rectangular ground plan. From an entry court, one would ascend in gradual levels through the permanent collection galleries, or descend in similar steps through the temporary exhibition galleries. The upward sequence would conclude with the exterior sculpture terrace, the limit of the public access. It was intended that each of the independent galleries surrounding the central court would float in space – in and out of a crystal cube encasing the lobby – thus allowing the transparency to be vertical as well as lateral. Basements below the temporary galleries would contain the large storage spaces and various types of work areas, mechanical rooms, and a loading dock accessed by tunnel.

North facade

The program provided for semi-public spaces – the study galleries – which would be for classes, with exhibits curated by professors to accompany their courses. These spaces, in conjunction with the print room which would have similar student orientation, formed a stack of floors that established the tower. The administrative areas had been programmed as a single grouping, producing a large "footprint" – the perfect volume to complete the overall rectangular shape and, with its supporting piers, to define a void that would frame the galleries and sculpture court, giving focus to the central element of the Museum.

The restriction of natural light in the galleries led us to continue our exploration of a spatial concept to address "museum fatigue," which had begun with the design of the first museum, the Everson Museum in Syracuse: modulating the museum exhibition circuit by creating individual and varied gallery volumes separated by open links. This approach to orchestrating space and movement was to fully evolve in our subsequent design of the East Wing of the National Gallery of Art in Washington, D.C. A string of windowless boxes, while archivally conscientious, is one of the contributors to fatigue; lack of orientation and sameness of spaces are other factors leading to visual strain and physical discomfort. To provide relief, we proposed interjections of daylight, views to a central court, and glimpses of distant landscape. These interruptions, with change of light and view, provide a needed pause for the visitor to refresh the senses. For a small museum with diverse collections this strategy also facilitates a transition between different periods of art and scale of display. Architectural critic Wolf von Eckhardt was quoted in an article on the Johnson Museum in

Museum News, September 1974, as saying it is "a perfect museum… You don't suffer museum fatigue, because the gallery spaces vary in size and height. There is always a point of rest – a place to look out the window or some other little 'intermission'."

The consequence of this idea to the museum exterior was its potential to articulate parts of the building, giving scale and animating a silent block to welcome the visitor. The facades of classical museum buildings resolved this design issue with stone pilasters or colonnades, empty or statuary-filled niches, and blind windows. These options, however, provide no internal relief.

The critical issue in developing this scheme was the creation of an engaging, exciting spatial structuring of the vertical gallery sequences. Programmatic requirements assisted the conceptual resolution: at polar ends were the lecture room (total enclosure) and the secure sculpture court (exterior space), each requiring the same public access as the galleries. By linking them to the vari-sized galleries, and spiraling this loose chain of rooms vertically as a three-dimensional jigsaw puzzle of volumetric shapes in a pinwheel around four sides of the central open-space, it was conceivable to move in gradual increments of quarter- and half-levels through the sequence of exhibition spaces and achieve the desired spatial interpenetration. The lobby was fashioned as a neutral zone, separating the permanent collection galleries from the temporary exhibition galleries. The validity of the scheme was confirmed by the forthright circulation system, with a maximum distance of two floors for the visitors to travel up or down from the lobby.

The lobby space, like an overture, establishes the themes and mood of the building. In this instance the prelude identifies the

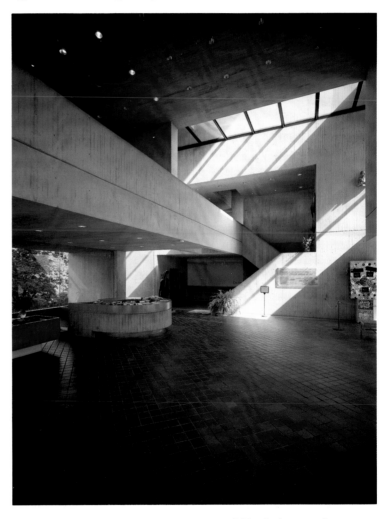

Museum lobby, looking north

ambiguity of enclosure: it is both an interior and an exterior space. And it defines the building concept: an articulated assembly of

enclosures joined by glass, where the focus alternates between the functional spaces and views of the landscape.

The fourth side of the pinwheel became the base of the tower, anchored to the elevator core and the counter-weight to the floating galleries. A simple block, its stacked layers of working spaces were the background to the shaped elements catching the sun. From the north its upright form appeared as an extension of the sheer wall of the gorge beyond; from the south it arrested the sweep of Libe Slope. As the tower rose, its engaged core was defined by a long, vertical, recessed glass slot providing glimpses east and west from the upper levels.

It was established at the outset that the meeting room should be a highly glazed space to celebrate the historic view. By capping the tower with a penthouse in the form of a glass-enclosed loggia, it was possible to enjoy Ezra Cornell's view without any intervening vertical structure: tall, broad sheets of glass, stretching wall-to-wall, and joined by thin lines of translucent silicone sealant, would capture the panorama as a photograph.

In designing a complex building form it is crucial to create a framework, or *modular* grid, for an organized development of the plans. This unit of measure, and armature for planning, is vital for establishing order during the sometimes chaotic design process. It is a useful tool for the coordination of plan with elevations, inherently providing a rhythm to the structure. It becomes an indispensable method for facilitating communication with the builder at the end of the design phase, and provides a base for systemization which may significantly reduce cost. Buildings designed by Pei Cobb Freed & Partners are structured by a plan module, shaped and sized to the particular needs of the building design. For the East Wing of the National Gallery, the module was a triangle. For the Johnson Museum it is a 4' 6" square. For example, the vertical slot window in the tower is 4' 6" wide, the piers supporting the cantilevered fifth floor are 13' 6" wide, and the great opening defining the lobby is 45' wide.

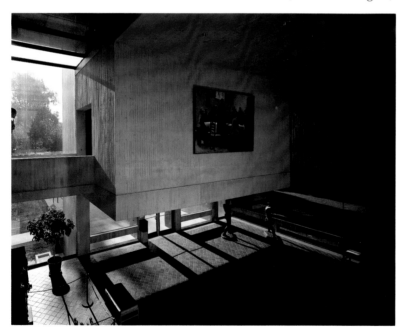

View of the lobby from the first floor

BUILDING: DEVELOPMENT

The first presentation of the conceptual scheme was well-received, and led the client team to propose that the large cantilevered floor was too attractive not to be enjoyed by the public. Its use was therefore modified to provide for internal galleries ringed by viewing areas and a visitor lounge. The subsequent evolution of this floor into the Rockwell galleries occurred after it was determined that a separate Asian wing would be postponed. The study galleries on the tower floors were relocated to the top and bottom gallery levels, making their exhibits accessible to visitors when not used as classrooms; the administrative offices assumed their former floors. By virtue of these changes, it became possible to remove one tower level, which helped maintain the budget. The displaced program area was recaptured by filling out areas below grade, expanding beyond the building footprint on the east and west sides.

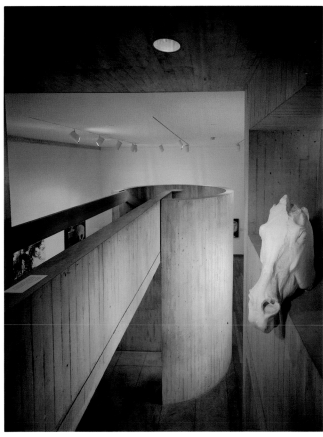

View of the circular stairwell from the mezzanine level

As scheme became building, a series of modifications occurred to simplify and refine the structure, the visitor access, and building servicing. Options were formulated and compared for cost and value. In a small, spare, building every gesture had to be considered for its efficiency and benefit. Although initially each gallery defined its own level, this intriguing and spatially exciting scheme had disadvantages stemming from the complicated structure and massing, with accompanying restricted service and handicapped access, and a probable premium for construction cost. The small change of working only to half-levels of vertical movement enabled us to maintain spatial animation without compromising function or a practical structural system, and facilitated the integration of the mechanical systems.

The pinwheel plan was modified by aligning the cantilevered galleries to structurally link their roofs and reduce the extent of skylight. This expanded the area of the sculpture court and increased the light-protected wall surface in the lobby. Incising the grand stair into the core block introduced a bold, sculptural link to the first gallery level without loss of lobby area, while drawing the visitor into the gallery sequence.

Several gestures were made during the refinement of the design to insure that the building was inextricably one with the site, fulfilling the initial goal of transparency with spatial enclosure for the area between White and Tjaden Halls. The Museum was situated so that the pathway in front of Tjaden and Sibley Halls would be on axis with the 9' wide glass slot running through the lobby and framing the view across to West Hill – a transparency dramatized by the setting sun. The concrete edge of the tall glass slot in the tower was aligned with the Arts Quad entry facades of Tjaden and Sibley, linking the three blocks which form the north edge of the Quad. The sculpture court was placed at approximately the same elevation as East Avenue where the street passes Sibley and Lincoln Halls allowing that view to remain open, although it is now veiled by new landscaping.

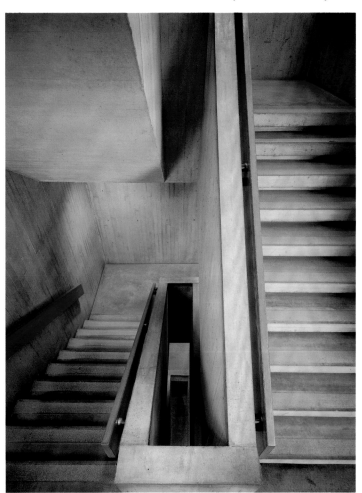

Grand stairwell

EXTENSION:
THE ASIAN WING

It was hoped that the Rockwell Collection of Asian art would be housed in its own 8,000 square foot wing; the task was to create an element that could coexist with the main building, functionally and visually. The proposed solution incorporated underground space with an above-grade identity. Located on the north side of the building and accessed from the lower gallery level, the wing was identified by an independently situated, two-story high square block covered by a single, sloping skylight. It was centered on a Japanese garden below, which was surrounded by galleries. The exhibition space then narrowed as it continued under University Avenue, emerging from the rock wall of Fall Creek Gorge as an intimate aerie, much as one sees in Chinese landscape paintings. A "knock-out panel" was formed in the concrete foundation wall near the study galleries on the lower gallery level to accommodate the future connection.

ARCHITECTURAL CONCRETE

Poured in-place architectural concrete was considered uniquely suited to complement the plasticity of the building form and satisfy the technical resolution of the cantilevered volumes and long span of the canopy level. By 1968 we were leading pioneers in the development and use of high quality architectural concrete as a visually pleasing and economical material for the construction of designs which integrate structure with the building envelope.

American galleries on the second floor

At this time we had executed more than twenty buildings using a variety of concrete mixes to achieve the desired finishes; some were in upstate New York. An extensive investigation into the sources of concrete mix materials in the Finger Lakes region was undertaken at the onset of the project, in conjunction with on-going concrete research by several of our architects. Material analyses and sample concrete castings were produced specifically for the Museum, resulting in the selection of a concrete mix which yielded a buff-colored concrete. This would be used for all exposed concrete surfaces, complementing the surrounding masonry buildings. However, the hidden floor slabs and below-grade walls were constructed of a standard grey structural concrete for economy. This combination required tight coordination to keep the grey from tainting the buff.

The modifying term *architectural* defines a form of finished concrete with a more controlled mix, a more refined surface, and a more exacting tolerance than structural concrete. The construction key words are cleanliness, consistency, control, and precision – a challenge for a material composed of several components and subject to many variables. Concrete is basically a combination of sand and small coarse stone aggregate mixed with cement and water. Architectural concrete stresses the color and texture of the finished surface, and the stone, sand, and cement types are selected, and the formula balanced, to help achieve that goal. The method of mixing and pouring the batter-like concrete must be highly controlled as color and value may change in each pour sequence. Water must be pure. Temperature and humidity changes can affect the results unless considered in advance. Architectural concrete is poured into special formwork, constructed of fine boards or specifically-sized

View of Lake Cayuga from the fifth-floor Asian galleries

panels used to create a surface pattern, and held together by steel "ties," whose placement is visible on the concrete surface as a residual grid of small circular recesses.

A system of narrow (three-inch) tongue-and-groove boards of Douglas fir was used for the Museum formwork to create a light pattern which would not compete with the building form or details. The individual boards were assembled into units (typically nine-foot wide segments) relating to the 4′ 6″ building module, and stretching from floor to floor. This systematic and practical approach allowed for the re-use of the forms. Several nine-foot units would be ganged together to form one pour; in the case of the north and south walls of the tower this meant a form almost the full width of the building, and 12′ 6″ or 20′ 5″ in height, to make certain the full expanse of each floor would be of the same color and tone. The strong reveal line at each floor provides a visual break to minimize the variation between the consecutive vertical pours; architecturally, it is a rhythmic scaling device giving order to the sculpted elevation. The board pattern helps to mitigate small imperfections in the concrete, and also provides for visually splicing adjacent pours. The location of the pour joints, determined by the building design in conjunction with a concrete pour of reasonable size and configuration, was an extensive study in itself and was worked out in close collaboration with the contractor.

Our concrete experts maintained their involvement during the construction phase, and were present on site as necessary for assistance. The surface of the concrete was left without any further finish after the forms were removed, and it appears today much the same as it did then. It was of benefit to the process and the result that the contractor who had built the Everson Museum in bush-hammered concrete, William C. Pahl Construction Company, was the contractor for the Johnson Museum. Harold Uris, University trustee, and builder, commented during a building tour with Sam Johnson that the concrete was the best he had ever seen.

INTERIOR: FINISHES AND SYSTEMS

The building was conceived as having one continuous, flowing surface of board-formed concrete, wrapping from outside to inside without distinction between the two. The lobby is designed as an exterior space – a pavilion, or viewing platform, at the apex of Libe Slope – and the sculpture court above is just another level of the lobby, reached by stairs and bridges. Thus, the clear, polished plate glass, required to provide protection from the elements, was inserted directly into the concrete shell to further the ambiguity. This detail is maintained everywhere except at the lobby skylight and its contiguous vertical glass slots; these are framed in bronze-finished aluminum to handle drainage.

The concrete surface of the outer walls and core was turned inward to frame the entrances of the main galleries, continuing the impression of the galleries as this series of pavilions linked by exterior spaces. The other interior finishes and their palette were selected to provide a neutral, and easily maintained, backdrop for the diverse range of the Museum's collections and one appropriate to the University setting. Detailing was kept simple, but precise and refined, to frame the art without intrusion. The galleries were all originally lined with a beige linen fabric stretched over plywood walls. This warm, textured material had the advantage of closing its weave after the nails of one exhibit were removed for another. It was a practical move

Sculpture court, looking south

which provided an always-finished space; each new exhibit would not have to consider re-painting the walls of the previous exhibit. After the wear of many years, the linen in several of the galleries was removed, giving the opportunity to vary the "lining" color to specifically enhance a particular exhibit.

The floor surfaces are transformed as one moves from lobby through the building, the material changing to complement the space and its use. The lobby is paved with a natural, fired-clay tile

with concrete borders; the grand stair, the bridge links, and core area vestibules are the same buff concrete as the walls but with a hard-trowelled finish, and gridded to the module; the galleries have white oak floors, using boards the same width as the concrete form-work; and the lecture room and the Asian galleries are carpeted for a sense of quiet.

The Museum has a combination of mechanical systems for ventilation, supplying humidified air to the areas where art is displayed and stored, and providing normally heated or cooled air for the offices and at all the glass surfaces. The building, like an office tower, is fed from fan rooms in the basement and in the penthouse through ductwork rising in the elevator/stair core. The heat generated by lighting and people in the galleries requires those spaces to be supplied with cool air for most of the year. The air is introduced into the galleries through a slotted band at the top of the wall and extracted through a continuous slot just above the oak baseboard. By locating the thermostatic sensors and lines of electrical outlets in this slot, we were able to remove these usual distractions from the walls, leaving an unencumbered display surface.

THE OPENING

At the opening ceremony in 1973, I. M. Pei focused his remarks on the significant role the site played in the design solution, noting he was not certain at the outset whether it was viable to place a building on this site which could balance deference with presence, while relating to the dramatic landscape and to the historic buildings on the Arts Quad. He said that he no longer had any doubt as to the appropriateness of the solution. It had engaged the site with its interplay of solid and void, and maintained an architectural relationship with the buildings of the Quad through its basically rectangular form.

The Museum was awarded the American Institute of Architects Honor Award in 1975.

JOHN L. SULLIVAN III
Pei Cobb Freed & Partners
Architect-in-charge, Johnson Museum

The Collection

All dimensions are given in inches and centimeters; height is followed by width, and, where appropriate, by depth.

The entries are arranged chronologically by the work's date of execution within the sections on Africa, Europe, and the Americas, except when there are two works by the same artist; in that case, they are placed together. The entries in the Asian section are arranged chronologically by the work's date of execution within each culture, e.g., China.

Large Urn
China, Late Neolithic Period
(ca. 2300–2000 B.C.)

Painted earthenware.
Height: 18½ in. (47 cm)
Gift of the Wunsch Foundation.
94.45

Strikingly painted Stone Age pottery vessels like this one were once referred to as mortuary urns because they were originally found in cemeteries. However, recent evidence from excavations of complete Neolithic habitation sites in northern China indicates that large urns like this example functioned first in the real world as communal granary vessels before they assumed their symbolic role in the afterlife.

Hand-built with great care by the coil process, this handsomely crafted large urn is made of the characteristic buff-colored clays found throughout a large area of northern China. The checkerboard-like pattern within a circle painted on the shoulder, and the cross-hatch strokes on the neck are design features common to pottery vessels from Banshan and Machang, two excavated sites in northwest China that can be dated to the last phase of the Neolithic, around 2000 B.C., just before the dawn of the Bronze Age.

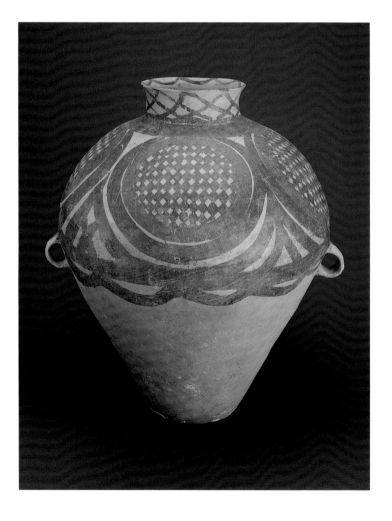

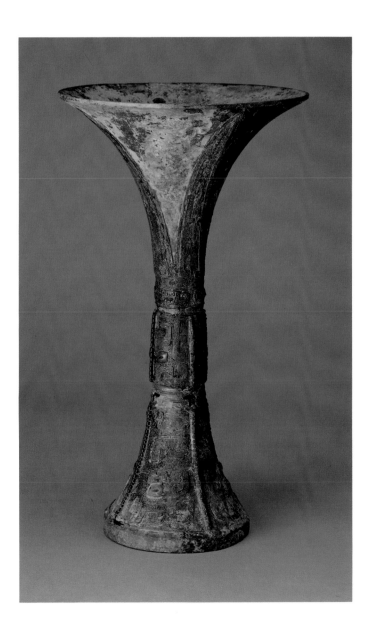

Ceremonial Drinking Vessel
China, Shang Dynasty
(ca. 1600–1030 B.C.)

Bronze with patina.
Height: 10¾ in. (27 cm)
George and Mary Rockwell
Collection. 69.1

Exactly where and when bronze, an alloy of copper and tin, was first cast in ancient China remain open questions, but it is generally agreed that by 1600 B.C. bronze vessels were widely used in the numerous rituals that were distinctive characteristics of China's first urban civilization. The ritual practices are not recorded in detail, but the various shapes of surviving bronzes make it evident that feasting and wine drinking were major components of the ceremonies, and inscriptions on some of the vessels indicate that they were frequently cast in honor of particular ancestors.

Elegant goblet-shaped drinking vessels like this example are among the most durable of Chinese Bronze Age forms. They were made throughout the Shang period and continued to be popular in the early decades of the subsequent Zhou Dynasty, before disappearing quite abruptly around 900 B.C. The bottom section of the goblet features raised elements of an animal mask – horns, eyes, jaws – organized symmetrically around a central flange. The blade-like shapes that rise from the waist of the vessel give added emphasis to the dramatic flaring trumpet mouth. The precision of casting and the orderly arrangement of design motifs seen in this vessel are signal features of Shang Dynasty bronzes.

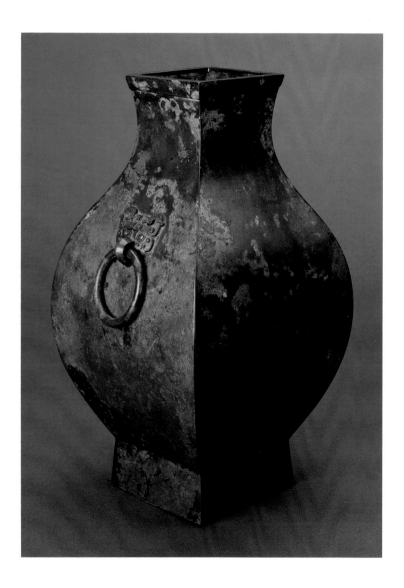

Square Wine Vessel
China, Han Dynasty
(206 B.C.–A.D. 220)

Bronze with patina.
Height: 13 in. (33 cm)
George and Mary Rockwell
Collection. 91.69.1

In traditional Chinese historiography the Bronze Age is brought to a close with the unification of the country in 221 B.C. under the first Qin emperor. But the casting of bronze vessels continued well into the Han Dynasty, and the square-shaped vessel of the type seen here seems to have been especially popular, to judge by the number of extant examples. It is still referred to as a container for wine, but there is no longer any substantive connection to the symbol-laden ceremonial wine vessels made centuries earlier. The more functional, utilitarian nature of this container is aptly reflected in its sharp-edged, swelling form. All ornamentation has been eliminated except for the small animal masks that serve as clasps for the ring handles. The visual appeal of this vessel comes, instead, from its handsome proportions and its simple purity of surface. It stands in sharp contrast to the richly textured bronzes of the Shang, but it is no less a testimonial to fine craftsmanship and sensitive feeling for form.

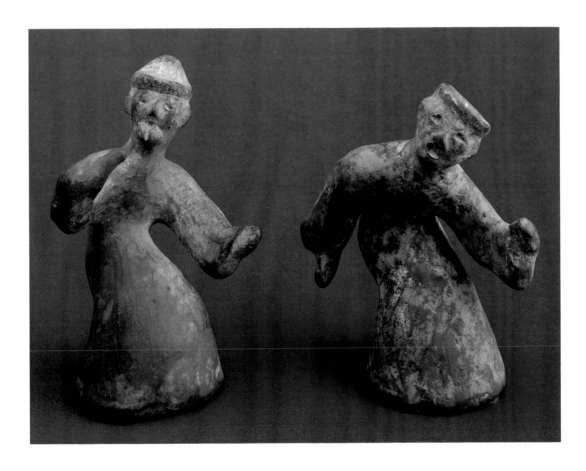

Pair of Dancers
China, Han Dynasty
(206 B.C.–A.D. 220)

Painted earthenware.
Height: 4⅛ in. (10.5 cm)
George and Mary Rockwell
Collection. 88.2.140–141

The practice of placing wooden or clay figurines in tombs to accompany the deceased into the next world began in the late Bronze Age, and the practice became widespread during the four centuries that constitute the Han Dynasty. Because many of the burials associated with the Han are of high-ranking officials, it is not surprising that figures of musicians, dancers, acrobats, and other entertainers who made up the rich court life of the nobility in ancient China are so well represented among surviving examples of Han Dynasty tomb art.

This pair of dancers captures much of the free and easy spirit of the Han age. They were likely part of a large tomb set that may have included instrument players and courtly attendants as well. Done with a deceptive simplicity that emphasizes contours and outline over inner details, these figurines capture the very essence of graceful and effortless movement. They have a timeless appeal, and they are among the most popular works of art in our Chinese galleries today.

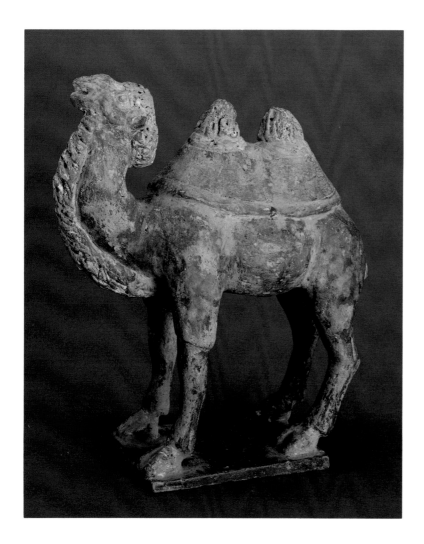

Bactrian Camel
China, Northern Wei Dynasty
(A.D. 386–535)

Earthenware with traces of slip and pigment. Height: 9¼ in. (23.5 cm) George and Mary Rockwell Collection. 88.2.129

The Bactrian, or double-humped, camel was not native to China but was introduced by Turkic traders who first traveled the vast Central Asian desert during Roman times. The camel was to prove very valuable to the economic well-being of the Chinese, who came to prize highly its extraordinary ability to carry large and heavy loads across some of the most difficult terrain in the world. The importance they gave the camel is demonstrated by the frequency of its encounter among the tomb figurines of the fourth century and later.

The camels produced during the Northern Wei period are smaller and less flamboyant than their better-known glazed counterparts of the following Tang Dynasty, but they possess a stately grace and presence just as imposing. Especially noteworthy in this example is the careful detailing of the facial features, which combines with the delicate modelling of the neck to give the sculpture an understated but uncanny feeling of realism. Traces of slip and pigment suggest that at one time the surface had a much more colorful appearance than the sober grey clay conveys to us today.

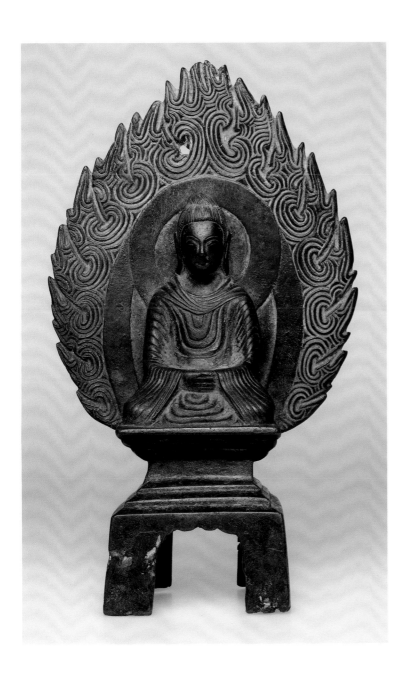

Seated Buddha
China, Liu Song Dynasty (420–479)

Bronze. Height: 11¼ in. (29 cm)
George and Mary Rockwell
Collection. 96.16

This small bronze altarpiece depicts the Buddha seated in a meditating pose before a flaming halo, his hands placed in front and his crossed legs hidden under an apron-like fold of drapery. The head and hands are oversized, in keeping with early iconographic standards. Those standards and the stylistic conventions for implementing them were developed first in the ancient region of Gandhara, in northwest India, during the second century. Portable bronzes like this example helped spread both the Gandhara style and the Buddhist doctrine of compassion and salvation throughout China.

Cast into the back of the halo is a dedicatory inscription that dates the image to 444 A.D. Two decades later, under state patronage, the rock-cut sanctuaries of Buddhism began on an immense scale at several mountain sites in northern China. Unlike these later testimonials to permanence and enduring power, the smaller portable bronzes like the Cornell example evoked feelings of gentleness, grace, and intimacy, qualities that initially did much to help launch the religion and prepare the way for the later, more awe-inspiring works in stone.

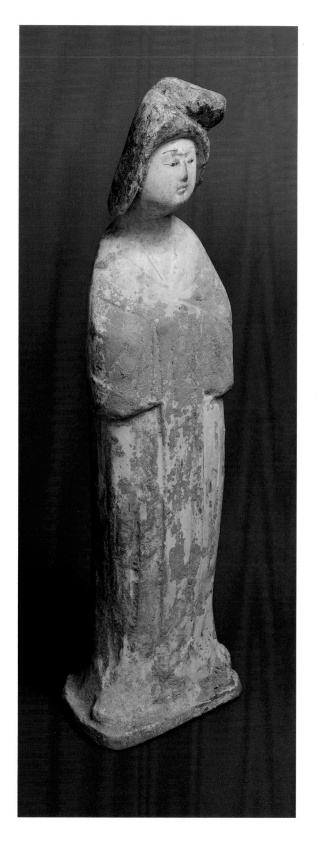

Court Lady
China, Tang Dynasty (618–906)

Earthenware with traces of slip and pigment. Height: 14¼ in. (36 cm)
Gift of Simone L. Schloss. 86.64

The round-faced, hefty court lady portrayed in this tomb sculpture represents a standard of feminine beauty that was widely admired throughout east Asia in the first half of the eighth century. The historic model for this new canon of proportions is sometimes considered to be one of the favorite concubines of the Emperor Ming Huang (reigned 712–756), but there is little evidence to support this tradition. Whatever the reason, it is clear that plumpness was not only accepted at the court but was celebrated, especially in mortuary sculpture, during the height of the Tang Dynasty.

The Johnson Museum figurine compares favorably with a large number of similar tomb sculptures found around the area of Xian, the site of the old Tang capital. The lady stands erect, hands folded under long sleeves, her face turned slightly, framed by a large hairdo that serves to call attention to the heaviness of her cheeks. Traces of pigment on the slip-coated body indicate that she was draped in richly colored garments. Her pose is remarkably graceful, and her facial features are rendered with delicacy and care. She seems alert, calm, and dignified – a grand court lady in every sense.

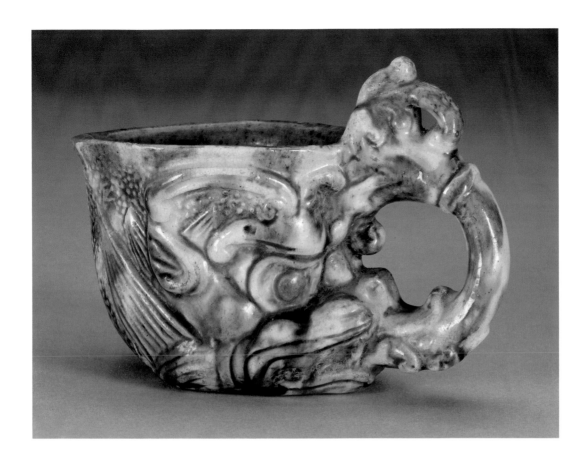

Drinking Cup
China, Tang Dynasty (618–906)

Earthenware with three-color glaze.
Height: 3½ in. (8.9 cm)
George and Mary Rockwell
Collection. 88.2.9

In its basic form this fascinating cup distantly echoes the rhyton, or drinking horn, that was widely used in the Near East in ancient times and imported to China during the Tang Dynasty. However, the design of the bulging-eyed fanciful creature whose tongue protrudes outward to form the handle of the vessel stems clearly from the Chinese imagination, and it reminds us of the many mythical half-human, half-animal forms found in tomb burials from the Han Dynasty onward.

The cup is covered with the amber, yellow, and green glazes typical of Tang Dynasty three-color ware. The background to the raised animal mask consists of small circular dots clustered tightly together, and it is highly reminiscent of the surface texture found on metalwork pieces imported into China from the Near East during Tang times.

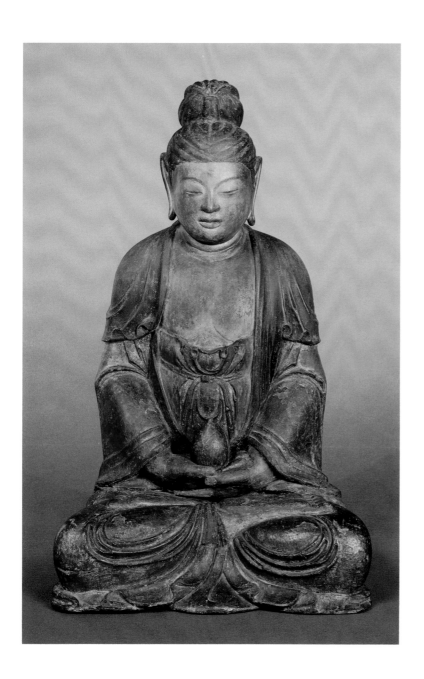

Seated Buddha
China, Northern Song Dynasty
(960–1127)

Wood with traces of gilding and polychrome. Height: 24½ in. (62 cm) George and Mary Rockwell Collection. 88.2.139

The Buddha sits in a serene meditative pose, legs crossed with the soles of the feet facing up, the hands placed in front and holding a peach-shaped lotus. The realistic proportions of the body and the lightly contoured features of the face reflect earlier Tang Dynasty canons of taste in Buddhist image-making, but by the early decades of the Song Dynasty the desire for richer surface effects began to assert itself. This desire is visible here in the decorative handling of the drapery folds and in the traces of polychrome that indicate that at one time this figure was clothed in a visually striking brocade-like garment. The face and bared chest were likely painted in flesh tones, which would have added further to the sensuous feeling surrounding this beautifully carved example of Song wood sculpture.

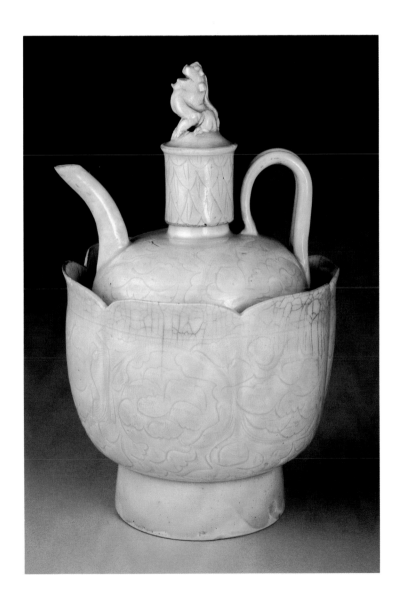

Wine Ewer and Warming Bowl
China, Southern Song Dynasty
(1127–1279)

Porcelain, Qingbai ware.
Height: 7½ in. (19.1 cm)
George and Mary Rockwell
Collection. 81.110

The term *qingbai*, or "clear white,"
was first used by the Chinese in
the thirteenth century to describe
the hard, thin white-bodied wares
that we call porcelain today. Traces
of iron oxides in the glazes of *qing-
bai* ware cause the faint blue-green
tone that is one of the great attrac-
tions of this group of early ceram-
ics, and the lightly incised lines
enable the glaze to thicken slightly
and allow us to see a delicate over-
all floral pattern on the clay body
of both the bowl and the ewer.

 This type of wine ewer, with
its own warming bowl shaped
like a lotus that gently envelops its
occupant, was first used in the
Northern Song period, but it was
in the Southern Song that these
ewers and bowls reached the high
level of refinement made possible
by the discovery of new deposits of
white-burning clays in the south
of China.

Covered Jar
China, Southern Song Dynasty
(1127–1279)

Porcelaneous stoneware, Longquan ware. Height: 2⅞ in. (7.3 cm) George and Mary Rockwell Collection. 80.113.5

The numerous wares once called celadons in the West are now usually collected under the term Longquan, after the name of the chief market town in south central China where the ware was assembled for shipping. The site was very active from the twelfth century onward, and the celadons produced in the region were shipped to many parts of the world to become widely admired not only for their wonderful shades of green, blue-green, and grey-green, but for their opacity and lustre as well.

This covered jar, a typical example of Southern Song Longquan ware, swells outward in a graceful silhouette that seems to capture the essence of an organic shape without looking quite like anything actually found in nature. The glaze has thinned out over the raised ribs to reveal the white of the body beneath; and the curled lotus-shaped lid appears to float gently on the rim, adding to the feeling of magic that surrounds this fine example of celadon.

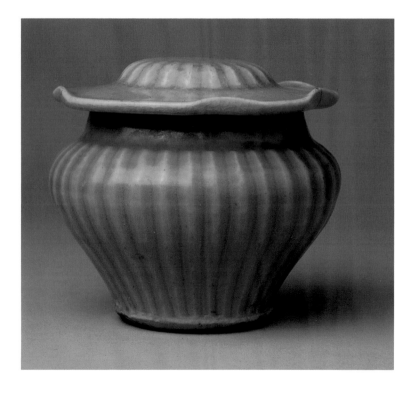

WU WEI
Chinese, 1459–1508
The Gathering at the Orchid Pavilion

Album leaf, ink and slight colors on paper 13 × 26 in. (33 × 66 cm) Gift of Mr. and Mrs. Ned Owyang. 67.21

Depicted in this painting is one of the most celebrated events in Chinese literary history: the poetry contest held in the year 353 at the Orchid Pavilion and recorded for posterity by the great calligrapher Wang Xizhi. On a spring day that year, the leading scholars in the region were assembled along the banks of a garden stream to practice the arts of poetry and calligraphy in a friendly competition, assisted by attendants who floated cups of wine on lotus leaves downstream to provide the necessary stimulation. The subject of this gathering was especially popular with certain painters of the Ming Dynasty who took an avid interest in reviving literati themes. Wu Wei was one such painter.

This painting comes from an album where each leaf was dedicated to one of the famous contestants at the Orchid Pavilion gathering (the Museum has two other leaves from this album). In the leaf reproduced here Wu Wei has chosen to show this particular bemused scholar-poet with his brush raised at the ready and his eyes focused directly ahead in concentration, as if purposefully ignoring the wine cups that have begun to gather nearby. Wu's brushwork is equally purposeful – his strokes swiftly define forms with a crispness and sureness that suggest the mood of the contest itself.

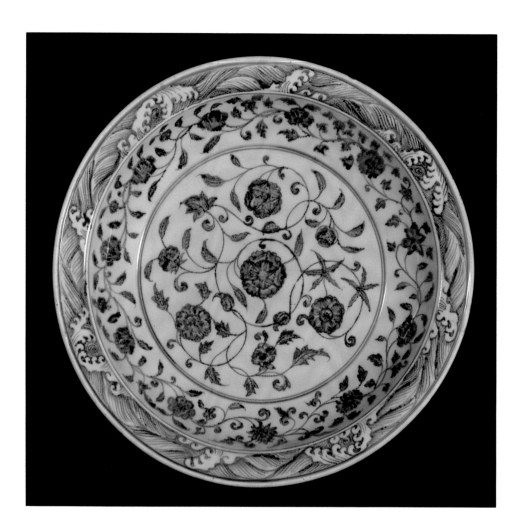

Large Dish
China, Ming Dynasty, Yongle
Period (1403–1424)

Porcelain with underglaze blue
design. Diameter: 16¼ in. (41 cm)
George and Mary Rockwell
Collection. 78.89.3

Among porcelain wares, probably
no single type has been as widely
admired as Chinese blue-and-white.
The technique of painting with
cobalt on a hard white porcelain
body that was then covered with a
clear glaze and fired at very high
temperatures was perfected during
the Ming Dynasty. The Cornell
dish belongs early in the tradition;
the surface is mottled here and
there with blackish spots, the result
of a supersaturation of cobalt
resulting in what collectors call the
"heaped and piled effect" charac-
teristic of much blue-and-white
of the early fifteenth century.

In contrast to the monochrome-
glazed stonewares of the earlier
Song Dynasty, which relied for
their appeal primarily on elegance
of form and subtle effects of single-
color glazes, Ming blue-and-white
introduced a rich decorative vocab-
ulary of floral and other motifs
into the art of ceramics, and strong
brushwork became as important
as careful potting and glazing.
Blue-and-white dishes of the size
seen here have been eagerly sought
worldwide ever since they first
appeared as triumphant testimoni-
als to the technological mastery
of Chinese potters.

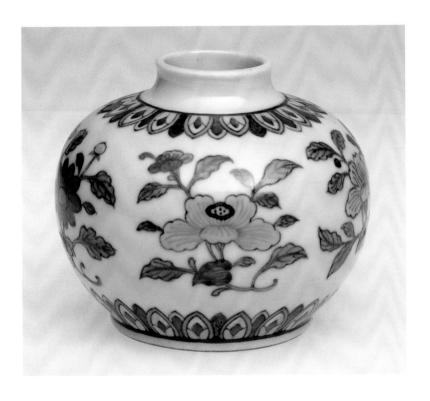

Small Jar
China, Ming Dynasty, Chenghua
Reign (1465–1487)

Porcelain with underglaze
blue and overglaze enamels.
Diameter: 3½ in. (8.9 cm)
George and Mary Rockwell
Collection. 76.88.22

This nicely shaped small jar is a
fine example of what the Chinese
have called *doucai* ("contending
colors"), a ceramic ware that used
the new developments in blue-and-
white porcelain production as a
springboard into a sparkling world
of coloristic splendor. In *doucai*
ware the decoration is painted in
cobalt on the white body, then
glazed and fired like traditional
blue-and-white. Semi-transparent
enamel colors, usually red, yellow,
green, and aubergine, were subse-
quently applied over the glaze,
tracing the underlying outline of
blue, and the piece was fired a sec-
ond time at a lower temperature,
causing the enamels to harden and
fuse with the surface glaze. The
final effect can be enchanting, with
transparent gemlike colors gleam-
ing over the softly muted blue out-
line underneath. In this small jar
the potter has exploited the tech-
nique beautifully with a design of
lotus petals framing five differ-
ently colored flowers.

Covered Box
China, Ming Dynasty, Jiajing
period (1522–1566)

Carved cinnabar lacquer on wood
frame. Height: 8 in. (20.3 cm)
George and Mary Rockwell
Collection. 68.249

As a protective coating over wood,
leather, or bamboo, lacquer was
used extensively in China by the
early Han Dynasty, but it was
not until the Ming Dynasty that
the decorative possibilities inherent
in the carving of lacquer were
exploited. In this particular tech-
nique multiple layers of lacquer
colored with cinnabar are built up
slowly over an initial coating of
black lacquer before being carved
so that the design shows in sharp
relief against the darker back-
ground.

This striking example of carved
lacquer demonstrates the technique
at its best: the design is quite dense
and active, rich and varied in its
total effect. The reign mark of the
Emperor Jiajing on the bottom of
the box and the appearance of the
five-clawed dragon on the sides
and top of the box indicate that at
one time this was an imperial piece.
The lid is neatly hinged, and
fittings are of polished and tooled
brass, details one would expect of
products from the imperial work-
shops of the middle Ming period.

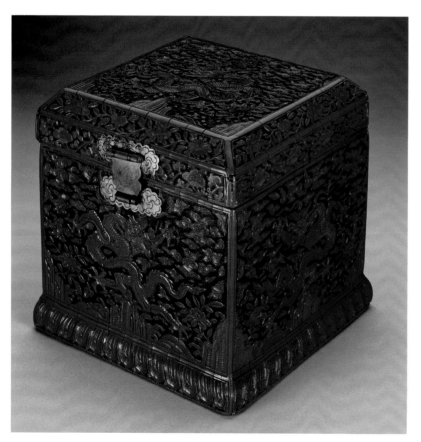

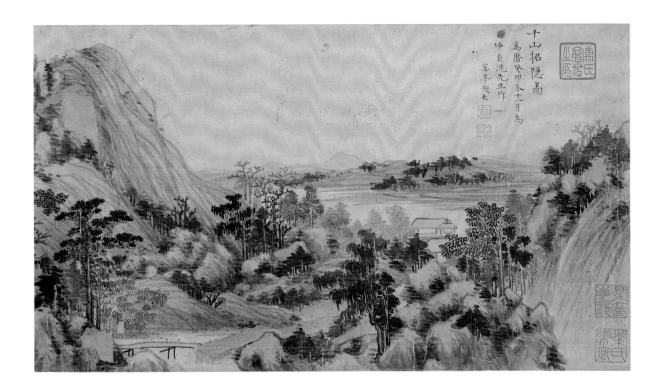

ZHAO ZUO
Chinese, 1570–1633
*Endless Mountains Invite the
Hermit Scholar*, 1603
(opening section)

Handscroll, ink on silk.
10⅞ × 105¼ in. (27 × 267 cm)
Gift of Norbert Schimmel. 55.88

Zhao Zuo did not realize any
great success in his lifetime (he
died in poverty), but nonetheless he
occupies an important place in the
history of seventeenth-century
painting. He was one of a small
group of painters who helped to
shift the center of Chinese painting
from the Suzhou region to the
neighboring town of Songjiang,
where a new way of thinking about
landscape painting was evolving.
In this long handscroll by Zhao
Zuo, we see the essential outlines of
the new style: a carefully structured
treatment of the landscape, with
each element carefully positioned
to link closely with what comes
before and after. Despite the lofty

title given this long handscroll by
Zhao Zuo, the tightly organized
composition suggests a more intel-
lectual than lyrical approach to
describing the physical world, an
approach fundamentally different
from that used by Zhao's contem-
poraries, like Sheng Maoye, who
were still painting in Suzhou in a
more gentle, poetic style.

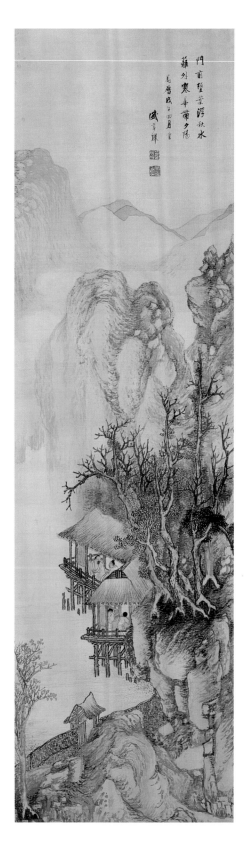

Two men are shown sitting in
conversation in a thatched-roof open
pavilion that is perched on pilings
set into the riverbank. In an enjoin-
ing pavilion two servants are in
attendance. In the foreground is
a rustic fence and a gate left open
to welcome the next visitor.
Described here is the perfect idyllic
retreat, a place isolated from the
clamor of ordinary life, and fit for
the quiet contemplation of nature
– the perfect life, as defined by the
gentlemen-scholars of China.

When Sheng Maoye painted
this hanging scroll, the region of
Suzhou was no longer the vital
center of intellectual activity that it
had been for more than a century.
Thus there is an air of nostalgia in
Sheng's treatment of the scene: a
soft enveloping mist gently obscures
the distant mountains, and the
muted autumnal colors add to the
feeling of past glories kept alive.
The mood is reinforced by the poem
Sheng has added: "In front of the
gate, falling leaves float on autumn
waters/ Outside the fence, the
mynah bird brings forth the set-
ting sun."

WU LI
Chinese, 1632–1718
The Lute Song, dated 1681 (section)

Handscroll, ink and colors on paper. 10 × 39¼ in. (25 × 100 cm) George and Mary Rockwell Collection. 65.665

The subject of this short handscroll is taken from one the best-known poems of the famous Tang poet Bo Zhuyi. Composed in 816, the poem tells the tale of the exiled poet who late one autumn evening hears the sounds of the lute from a boat moored by the riverside and finds a former lady of the court, now married to a country merchant, playing songs on the lute that remind them both of their former years at the court. The age-old themes of loneliness, political exile, remoteness from civilized pleasures, along with the lyrical enchantment of an autumn evening with moonlight on a misty river, are described by Wu Li with understated elegance in this deft handling of a great poem.

Among Wu Li's distinctions was his conversion to Christianity, a rarity among Chinese painters, and in 1680 he was baptized under the name Simon Xavier. In 1681 he started out on a journey to Rome but got only as far as the Portuguese colony of Macao, where he remained for a number of years. This painting was done shortly after his arrival in Macao, and according to his inscription he did the painting "thinking of the past." Despite Wu Li's exposure to Western works of art, this painting betrays no Western influence, and in this sense, in both subject matter and style, it is indeed a true tribute to the Chinese past.

GAO QIPEI
Chinese, 1672–1734
Quail, ca. 1730

Leaf from an album of finger
paintings. 11¾ × 13¾ in.
(30 × 35 cm)
George and Mary Rockwell
Collection. 75.62.3

A Manchu by birth, Gao Qipei was one of the few foreigners in the Qing period able not only to absorb Chinese culture but to gain a measure of respect from other Chinese painters for his accomplishments. Gao found the new expansive, individualistic style that had emerged around the Jiangnan region in the second half of the seventeenth century especially congenial, and by exploiting a special technique of painting that employed the fingers and fingernails in place of the brush, he won widespread recognition for his highly expressive works of art.

This painting of a solitary quail, from an album of bird-and-flower studies after earlier masters, is typical of his finger painting style: in places the finger dipped in ink is evident, in others the sharper, scratchy lines of the fingernail are apparent. The subject of a lone, fretful-looking quail seemingly isolated in a stark environment is one that earlier painters had explored using the traditional brush technique. Under Gao's fingers, the subject seems fresh and charged with a new energy.

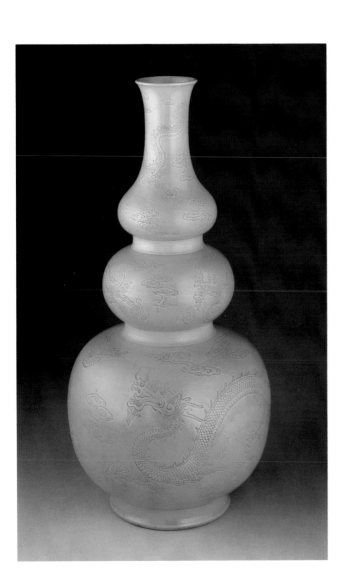

Gourd-Shaped Vase
China, Qing Dynasty (1644–1912)

Porcelain with yellow glaze.
Height: 19⅜ in. (49 cm)
Gift of Mr. and Mrs. James Stein.
77·73

From the time of the earliest emperor, yellow has been associated with the imperial family. Later, in the Ming period, yellow became the dominant color of objects and decorations used at the Altar of Earth, where the emperor performed his annual ceremonies dedicated to the patron god of agriculture. Eventually the term imperial yellow was coined by modern collectors to refer to the fine porcelains produced in the Qing Dynasty, especially during the reign of Kangsi (1662–1722), where the yellow has a rich egg-yolk-like tone.

This very large vase in the striking form of a triple gourd does not bear a reign mark, but the presence of the lively five-clawed dragons in the decoration suggests that at one time it probably graced some part of the imperial quarters. The special brilliance of the yellow in this case was probably achieved by applying the yellow glaze (derived from antimony and lead oxide) over a previously glazed white porcelain body.

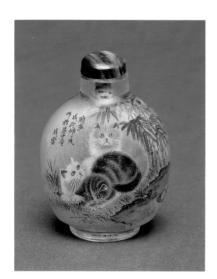

Snuff Bottle
China, Qing Dynasty (1644–1912)

Frosted glass with ink and light
colors. Height: 2 in. (6.4 cm)
Gift of Drs. Lee and Connie
Koppelman. 90.49.7

Portuguese traders most likely
introduced snuff to the Manchu
court in the late seventeenth
century, and for most of the eigh-
teenth century the taking of snuff
was primarily a courtly pleasure.
In the nineteenth century it spread
throughout China, and the con-
tainer for the snuff, which
the Chinese preferred in a bottle
form with a small ivory spoon
inside, became a common object
that was eventually collected
widely.

The Chinese used snuff bottles
of every imaginable description
and carved them out of all types of
materials. Of the many types of
bottles the Chinese created, none
seems more intriguing than those
that were inside-painted on glass.
In this technique the painting is
done with a tiny brush inserted
through the small opening at the
neck, with the artist manipulating
the brush from the bottom up while
painting the subject in reverse. The
subject matter of inside-painted
bottles was varied and included
ambitious landscape paintings as
well as small-scale themes of birds
and flowers. In this late nineteenth-
century bottle, the artist has
turned to a subject popular since
the Song Dynasty and has lovingly
portrayed several cats crouched
together in a garden corner.

QI BAISHI
Chinese, 1863–1957
Portrait of Lin Daiyu

Hanging scroll, ink and colors on paper. 26¾ × 13¼ in. (68 × 34 cm) George and Mary Rockwell Collection. 88.2.184

Qi Baishi is perhaps China's best-known twentieth-century painter. He was a prolific artist whose long career spanned the most turbulent periods of Chinese history. He was witness to his country's great efforts at modernization and to the protracted wars that culminated in the emergence of Communism at mid-century. Yet the paintings that gained him recognition reflect nothing of these titanic struggles. His popularity rested on his captivating renderings of small-scale life: shrimps and crabs, fruits and vegetables, birds and flowers, all caught with a vibrant, bold brush and lively colors that appeal very much to the modern sensibility and eye.

In this painting we see Qi Baishi as a figure painter, a category for which he is less well-known in the West. He has taken inspiration from one of China's great eighteenth-century novels, the *Dream of the Red Chamber*, and caught its heroine Lin Daiyu at a particularly sympathetic moment in the story when she rakes up dead flowers and recites a poem that ends poignantly with the lament: "men laugh at me for burying fallen flowers, but who will bury me when I die?" Although the novel took place in the Qing period, it retained its popularity into the modern era, especially in Shanghai, where Qi most likely painted this work. Clearly, he has depicted a twentieth-century woman here, wearing rouge and lipstick, looking coy but hardly demure.

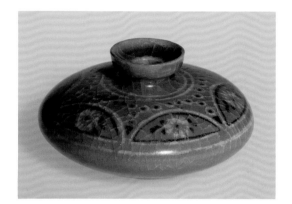

Oil Bottle
Korea, Koryo Dynasty
(A.D. 918–1392)

Stoneware with celadon glaze
and incised decoration.
Height: 1½ in. (3.8 cm)
George and Mary Rockwell
Collection. 88.2.110

Korean celadons of the Koryo
Dynasty rank among the finest
ceramics in the world, long admired
for the wonderful color of glaze
that matched in beauty the more
famous celadons produced at the
same time in China. In addition to
perfecting the celadon color, Korean
potters developed a special tech-
nique of inlay whereby a design
incised on the clay was filled with
white and black slip, the excess
brushed off, and the piece fired to
produce a sharp contrasting pattern
underglaze.

This small oil bottle is an
especially fine example of Koryo
period inlay workmanship, com-
bined in this case with a delicacy
of shaping and potting that pro-
duced a miniature vessel of exquis-
ite proportions. Notable decorative
devices used by the potter here
are the lunette containing a white
chrysanthemum and black leaves,
and the strand of pearl-like dots
with black centers that rings the
neck and shoulders of the jar.

Bottle
Korea, Yi Dynasty (1392–1910)

Porcelain with underglaze blue decoration. Height: 9½ in (24.1 cm) Gift of Colonel John R. Fox. 65.227

Because it had to be imported from China, cobalt was an expensive commodity for Korean potters, and the early blue-and-white porcelains were restricted to use by the court and nobles. It was not until late in the eighteenth century that cobalt became available in sufficient quantities and at low enough cost for common use, resulting in such pieces as this pear-shaped wine bottle of the early nineteenth century.

The decoration is drawn from traditional Chinese subject matter – a crane, some bamboo, and a few drifting clouds – but the treatment is essentially Korean. The brushwork is swift and sure, and the design elements neatly spaced across the surface in a casual, almost understated way. The sober shape of the bottle adds to the feeling of restraint that is one of the chief characteristics of Korean blue-and-white.

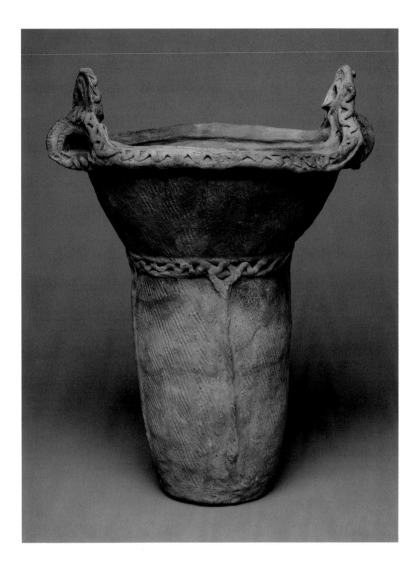

Storage Vessel
Japan, Middle Jōmon Period
(2500–1500 B.C.)

Cord-impressed earthenware.
Height: 13¾ in. (35 cm)
George and Mary Rockwell
Collection. 91.24

The name Jōmon (literally "cord pattern") is given to the period from about 10,500 to 400 B.C. in Japan, and derives from the cord-impressions found on the earthenware pottery produced throughout this long period. Jōmon potters hand-built their wares using the coil method, and they decorated the surface by pressing strands of knotted cord against the wet clay to give a distinctive texture to the surface. For thousands of years the people of the Jōmon culture produced simple cooking vessels using this technique for decoration, but around 2500 B.C. the pottery underwent a startling change in style. The Johnson Museum vessel belongs to this period, generally referred to as Middle Jōmon.

The flattened bottom of this vessel suggests its use as a storage container, with a columnar lower part joined to a dramatic, wide-flaring mouth that gives a sense of expansive freedom to the form of the vessel. Cord impressions continue to be used for texturing the body, but now clay strips are applied in a zigzag manner around the neck and along the rim. The clay strips decorating the neck meet as pendants at four points. The two handles at the rim are strong sculptural forms in the shape of trefoils with three perforated loops.

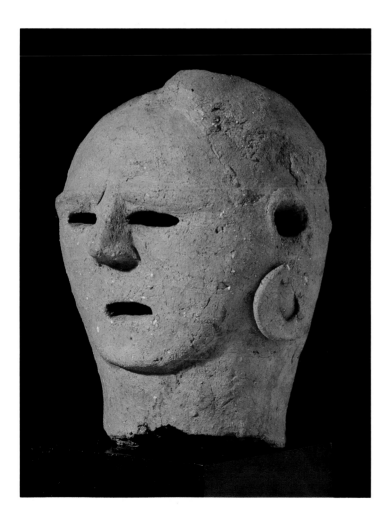

Head of a Man
Japan, Kofun Period
(ca. A.D. 250–ca. 600)

Terra cotta. Height: 6¼ in.
(15.2 cm)
George and Mary Rockwell
Collection. 63.263

Kofun were large, mounded tombs that, seen from above, appear in the form of a circle joined to a rectangle, suggesting the shape of the modern keyhole. On and around the tomb mound, hundreds of clay cylinders topped with sculpted images were inserted. The function of these clay cylinders, or *haniwa*, is still debated, but generally it is believed they were attempts to console the dead by providing a reassuring environment for their spirits, who continued to dwell in the sacred precincts of the tomb. Hence *haniwa* drew their subject matter from the familiar world of the living: animals, houses, weapons, ritual objects, and human figures.

Although this piece is missing the rest of the body and the cylinder base, it is nonetheless a vivid image of a *haniwa* head. With great boldness and simplicity, the sculptor has conveyed the sense of a human caught in a moment of great seriousness. Despite the roughness of the clay and the quickness of handling, the image seems remarkably sophisticated and appealing.

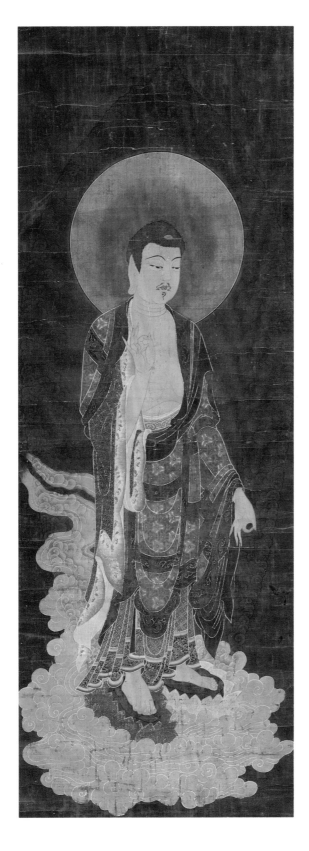

Descent of Amida Nyorai
Japan, Kamakura Period
(1185–1333)

Hanging scroll, ink and colors on
silk. 42 × 15¼ in. (107 × 39 cm)
Gift of Norbert Schimmel. 55.86

Amida Nyorai, or Amitābha Buddha
in Sanskrit, one of the most popu-
lar Buddha images in Japan, is
depicted here descending into this
world in order to lead the souls of
true believers to his Western
Paradise. His hands are shown with
the gestures *(mudras)* associated
with reassurance and welcome. He
stands on clouds that spiral down-
ward diagonally from left to right,
and the trailing cloud tails add a
dramatic sense of speed and urgency
to his descent. His eyes are cast
downward as he compassionately
seeks the dying believer below him.
His garment and halo are delin-
eated in gold, done in the *kirikane*
(cut gold leaf) technique that had
become very popular during the
Kamakura period. In this method,
thin strips of gold are adhered to
certain parts of the painting in place
of brush strokes, resulting in a
surface that is visually exciting and
compelling. Amida's robes are
refined and embellished with elab-
orate patterns, reinforcing the
sense of richness and splendor to
be found in the paradise that will be
the home of those who follow him.

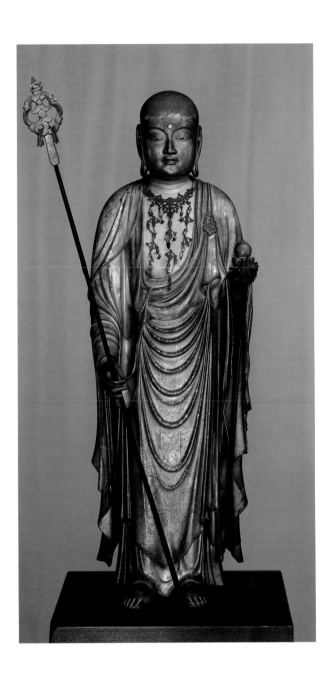

Bodhisattva Jizō
Japan, Muromachi Period
(1392–1573)

Carved wood with lacquer and
gold. Height: 19½ in. (50 cm)
University Special Purchase Fund.
76.56

The veneration of the Bodhisattva
Jizō (Kshitigarbha in Sanskrit)
became popular in Japan from the
Kamakura period (1185–1333)
onward. Jizō appears as a monk
traveling the Six Realms of
Existence and carrying the wish-
granting jewel and the golden
shakujo, a staff with jangling rings.
Among Jizō's roles as the compas-
sionate Bodhisattva is the salvation
of suffering believers from the
various Buddhist hells, and their
guidance to paradise. He also pro-
tects children and travelers.

Small images of Jizō were
increasingly produced during the
Kamakura period for private wor-
ship. The Kei school artists, partic-
ularly Kaikei (active 1185–1223),
developed the small-scale sculptural
style of Jizō, in which realistic and
decorative aspects are integrated.
Our Jizō sculpture, embellished in
gold, reveals a continuation of the
Kei style in the Muromachi period,
when changes in sculptural styles
came very slowly.

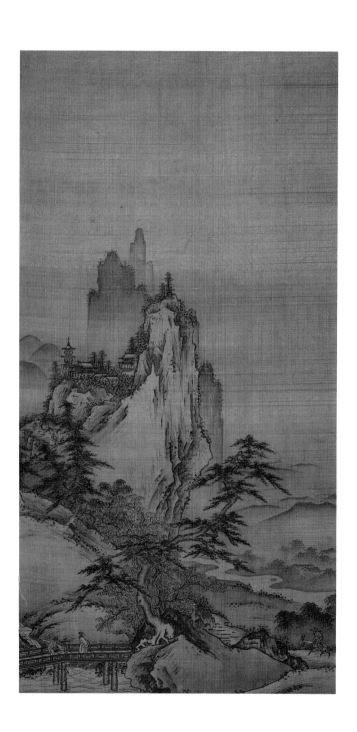

UNKOKU TŌTEKI
Japanese, 1606–1664
Landscape

Hanging scroll, ink and light
colors on silk. 27¾ × 13⅞ in.
(71 × 35 cm)
Gift of Martie and Alice Young.
88.55

Unkoku Tōteki was a grandson of
Unkoku Togan (1547–1618), who
founded the Unkoku school under
the patronage of the feudal lord
Mōri Terumoto in Suō Province
(presently Yamaguchi Prefecture).
The Unkoku school began with ink
paintings during the Muromachi
period (1392–1573) and claimed
artistic descent from the great
painter Sesshū (1520–1606).

Tōteki, after the death of his
father Tō'oku (1582?–1615), learned
painting from his uncle Tōeki
(1591–1644). This painting depicts
an idealized Chinese landscape and
continues the typical Muromachi
compositions that used the vertical
hanging scroll format made popu-
lar during the Song and Yuan
dynasties in China. Here a Chinese
scholar with his servant crosses a
bridge at the left, and another
scholar rides a mule while traveling
along a path leading up to the
temple in the towering mountains.
The distant mountains and villages
beyond the river in the background
are dramatically contrasted with
the tall pine firmly rooted to the
rock at the center of the foreground.

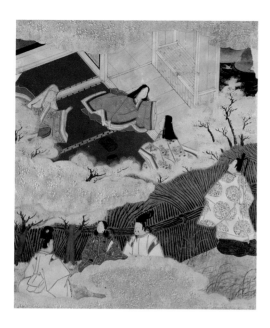

The Tale of Genji: Chapter 5:
Waka Murasaki (Lavender)
Japan, Edo Period (1615–1868)

Album leaf, ink and colors
with gold leaf on paper.
Illustration: 10½ × 9 in.
(26.7 × 22.9 cm);
inscription: 10 × 8⅛ in.
(25.4 × 20.6 cm)
Gift of Dr. William E. Leistner.
84.52.1-54a,b

The Tale of Genji, the world-renowned romantic novel written by Lady Murasaki Shikibu in the early eleventh century, was a popular theme in the Edo period. The Johnson Museum album leaves of the illustrations and accompanying inscriptions have been recently identified as a complete set of the fifty-four chapters that make up the *Genji* tale.

The decorative style of embellished paper sheets on which short excerpts from each chapter are presented is close to the albums of *The Tale of Genji* inscribed by the second Shōgun, Tokugawa Hidetada (1578–1632), now owned by the Tokugawa Museum of Art in Nagoya. The paintings follow the traditional Tosa school style in which figures are depicted in a simple and motionless manner in bright colors and gold leaf, based on pictorial codes from the classic

Heian and Kamakura periods (eleventh to fourteenth centuries). They are especially reminiscent of the painting style of Tosa Mitsuyoshi (1539–1613), but they are more simplistic and probably datable to the middle of the seventeenth century.

The illustration reproduced here is of the "Lavender" chapter. In the cherry blossom season the hero Genji spies, through a gap in the fence, a little girl, Murasaki, crying because her sparrow has flown away. He adopts Murasaki, who eventually becomes his greatest love.

*Scenes in and around the Capital
(Rakuchū rakugai zu)*
Japan, Edo period (1615–1868)

Six-fold screen, ink and colors on
gold-leafed paper. 47⅝ × 104⅛ in.
(121 × 264 cm)
George and Mary Rockwell
Collection. 92.51

The production of paintings depict-
ing scenes in and around Kyoto,
the ancient capital, increased during
the sixteenth and seventeenth
centuries, commissioned by feudal
lords and statesmen. *Rakuchū
rakugai zu* not only present an
accurate, almost photographic,
overview of the capital but also
reflect something of the political
atmosphere in the ancient city in
the period just prior to the stability
of the Tokugawa regime. A scene
from the imperial court dominates
the two panels on the left side of
the screen, and a second screen,
originally paired with this screen
but now missing, probably included
a view of the Nijō palace of the
Tokugawa family.

All of Kyoto's famous sites,
important monuments, festivals
and events are arranged from
south/right to north/left along the
Kamo river and are seen through
golden clouds. This screen presents a
view of the eastern section of Kyoto
and suburban areas, and depicts,
among others, the Shijōgawara
entertainment district; the Gion
Festival in the metropolitan district;
temples on the East Hills, including
the famous Kiyomizudera; and the
Kamo Shrine in the upper section
of the leftmost panel.

Attributed to TOSA MITSUYOSHI
Japanese, 1700–1772
Eight Views of Nara (section)

Handscroll, ink and light colors
on paper. 11¾ × 144⁷⁄₁₆ in.
(30 × 367 cm)
George and Mary Rockwell
Collection. 95.18

The idea of celebrating a particular locale by depicting it with eight different views originated in China with such series as the "Eight Views of the Xiao and Xiang Rivers" and then became popular in Japan. In this handscroll the "Eight Views" are chosen as poetic imagery evoking Nara, the ancient capital of Japan. The eight views are "The Moon on the Sarusawa Pond," "The Bell of the Todaiji Temple," "Snow on Mount Mikasa," "Travelers at the Todoroki Bridge," "Fireflies along the Sahogawa," "Wisteria at Nan'endō," "Deer at the Kasugano Field," and "Rain at Kumoizaka."

The scene reproduced here is an illustration of "Fireflies along the Sahogawa" with an accompanying poem by Fujiwara no Kintada (1323–1383):

> Flickering fireflies reflected
> in the shallows
> of the Saho River reveal the
> depth of my emotions.

The painter Tosa Mitsuyoshi, the grandson of Mitsunari (1646–1710), served the court as a leading Tosa school painter. This handscroll reflects the more restrained side of the Tosa style that emerged in the eighteenth century under his hand: he has given us a purely Japanese subject done in a muted, understated manner, utilizing soft washes and gentle brushstrokes to suggest rather than describe a place charged with great sentiment to those who knew the ancient capital well.

Painting by SUZUKI KIITSU
Japanese, 1796–1858
Calligraphy by Sakai Hōitsu
Japanese, 1761–1828
The Poetess Ono no Komachi

Hanging scroll, ink and colors on silk. 38½ × 13 in. (98 × 33 cm) Museum Associates Purchase. 63.377

This scroll is an example of a collaborative work between a master and his disciple. The artist Suzuki Kiitsu has painted the poetess Ono no Komachi, while his master Sakai Hōitsu has inscribed Komachi's poem on the upper section of the scroll. Hōitsu, son of a high-ranking *daimyo* from the Himeji castle, was a haiku poet and a leading Rimpa school artist. Kiitsu became a pupil of Hōitsu in 1813. This painting is close to Hōitsu's work in the pose of Komachi, her flowing hair, the patterns on her robes, and the refined treatment of color and ink outlines.

Ono no Komachi, whose life is shrouded in mystery, is believed to have been active in the tenth century. She is a legendary figure, a woman of great beauty and passion, who has been dramatized in many genres.

The poem in this scroll reads:

Wretched that I am –
A floating water weed
Broken from its roots –
If a stream should beckon,
I would follow it, I think.

YAMAGUCHI SOKEN
Japanese, 1759–1818
The Legend of Dōjōji Temple (detail)

Pair of six-fold screens, ink and colors on paper. 67 × 24¼ in. (170 × 62 cm)
Gift of Dr. and Mrs. Frederick Baekeland. 82.47a, b

Yamaguchi Soken, one of the ten best pupils of Maruyama Ōkyo (1733–1795), was well-known not only for his figure paintings but also for his woodblock printed books of traditional Japanese narrative paintings.

This pair of six-fold screens depicts *The Legend of Dōjōji Temple;* each of the twelve panels illustrates a significant moment in the tale, presented in a narrative sequence. Briefly, the legend tells the story of Kiyohime, the daughter of a wealthy man, who falls in love with the monk Anchin and, although he does not return her love, pursues him with unfortunate consequences for both. The detail reproduced here shows Kiyohime, in the heat of lust and rage, transforming herself into a serpent by growing horns, claws, and a scaled tail. A nearby ferryman is shocked to see her. Toward the end of the story, Kiyohime, as the snake apparition, coils herself around a bell in which Anchin hides, burning the bell, the monk and herself together.

As told by temple priests, the story is clearly didactic in its intent. Soken treats this supernatural story as another aspect of basic human emotions, and depicts the subject with an energetic, quick brush, enhancing the feeling of the mysterious and the ethereal with a judicious use of light color washes that suggest something of the mist enshrouding much of the action.

UTAGAWA HIROSHIGE
Japanese, 1797–1858
Horikiri Iris Garden, fifth month
of 1857
From the series *One Hundred
Famous Views of Edo*

Polychrome woodblock print.
14 × 9⅜ in. (36 × 24 cm)
Bequest of William P. Chapman, Jr.,
Class of 1895. 57.56

Toward the end of his life, Utagawa
Hiroshige, one of the most prolific
and gifted Ukiyo-e landscapists of
the late Edo period, produced a set
of woodblock prints entitled *One
Hundred Famous Views of Edo*
(today Tokyo). In this immensely
popular series, he conveyed a vivid
vision of nature and man through
his depictions of daily life in Edo
that included famous sites, annual
festivals, and seasonal spectaculars.

In the middle of the nine-
teenth century, the Iris Garden at
Horikiri was a well-known site to
the people of Edo. In his portrayal
of this garden, Hiroshige demon-
strates his penchant for radical
cropping of the composition: the
iris are seen in a striking close-up
arrangement, severed by the bor-
der frame, and superimposed on
the pictorial surface. A view through
the enlarged iris, like a camera's
third eye, leads the viewer to the
sightseers in the distant back-
ground, who are separated from
the iris by a canal.

The new method of breeding
iris developed at this garden was
introduced to the West in 1852 and
became an internationally famous
process. In addition to conveying
the visual beauty of the iris to hor-
ticulturalists, such a striking print
could also have inspired such
artists as Vincent van Gogh.

Writing Box (Suzuribako)
Japan, Edo Period (1615–1868)

Lacquer on wood.
1½ × 7⅛ × 10¼ in.
(3.8 × 18.1 × 26.0 cm)
George and Mary Rockwell
Collection. 88.2.251

Lacquer had been used widely as a protective coating on different surfaces since ancient times throughout Asia. One of the most distinctive techniques of handling lacquer emerged in Japan during the Heian period. Known as *maki-e* (literally "sprinkled picture"), this technique employed gold or silver powder sprinkled on a damp lacquered ground. In the Johnson Museum writing box, typical *maki-e* methods are employed: coarse and flat flakes of gold have been speckled over the surface of the half-dry lacquered ground, creating a pattern resembling the skin of a pear (called *nashijj* in Japanese). A particular method of sprinkling the gold powder, known as *hiramaki-e,* is

superbly demonstrated here in the design of the autumn grasses.

The design of these grasses, *ominaeshi* and *susuki*, a kind of pampus reed, continues on the side of the cover, evoking the feeling of pathos, which is also common in Japanese classical poetry. The ceremonial activity of composing poetry is suggested in the writing box by the ordered display of the brush, knife, inkstone, inkstick, and water dropper.

Fisherman with Basket and Net
Japan, Meiji Period (1868–1912)

Carved ivory. Height: 16¾ in.
(43 cm)
Gift of Dr. and Mrs. Frederick
Baekeland. 78.104.1

After the Meiji Restoration (1868), many traditional artisans lost their patrons and were forced to re-shape their artistic activities in order to adjust to Western concepts of art that began to affect late nineteenth-century Japanese aesthetics. Among the most popular new artisans in the Meiji era were the ivory carvers. Large ivory carving quickly developed in the 1880s and lasted for about a decade. Especially welcomed by foreigners, Meiji ivory sculpture became the most popular Japanese craft at the world expositions as well as in the Western market. This particular piece was most likely an export object made in response to these new demands.

The fisherman with basket depicted here is a typical example of Meiji period hyperrealism, as witness the very subtle expression on the face and the clearly tense musculature of the body. The Meiji artists used their highly skilled techniques to simulate the texture of real objects: a slab of wood, the net, baskets, robes, and reed-plaited outer wrapping. The fisherman is carved from a single large block of ivory, while the basket, fishnet, and base are separately carved and added.

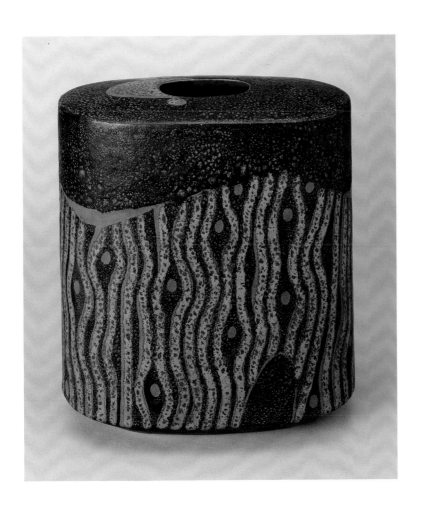

MORINO HIROAKI (TAIMEI)
Japanese, born 1934
Oval Vase, ca. 1991–1992

Stoneware with navy, aqua, and
gold glaze. Height: 13 in. (33 cm)
George and Mary Rockwell
Collection. 96.3

Morino Hiroaki, well-known in
the United States as well as in Japan,
was born the son of the potter
Morino Kako (1879–1987) and
studied at Kyoto Art University
under Tominoto Kenkichi
(1886–1963), one of the leading
potters of this century.

Morino taught pottery at the
University of Chicago in the 1960s.
This experience encouraged him
to unite both contemporary and
traditional Japanese aesthetics.
Morino's vase is here undercoated
with an aqua blue glaze, seen
through a finely pitted, dark, dull
blue overcoating. Muted, abstract
gold designs add a sumptuous
touch. His works are characterized
by a virtuoso integration of design
and color, form and ornamentation.
His recent works, which were
exhibited in New York in 1995,
demonstrate the movement of his
style in a new direction, exploring
abstract and sculptural possibilities
in the field of pottery.

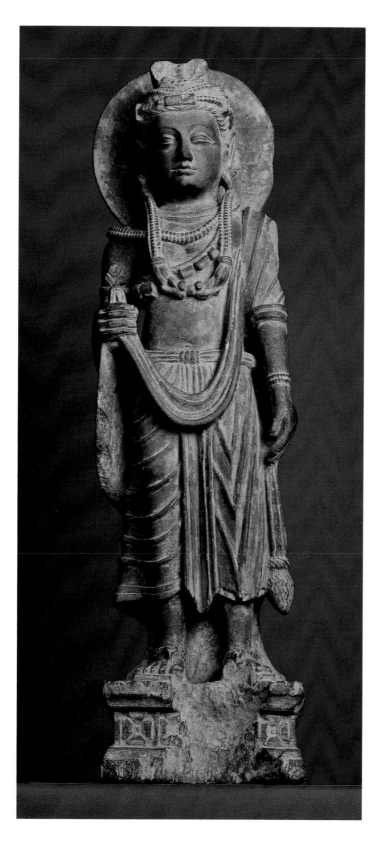

Standing Bodhisattva
India, Gandhara region,
ca. 3rd century A.D.

Grey schist. Height: 25¼ in. (64 cm)
Gift of Mr. and Mrs. N. Battle Hales.
81.109.12

Art historians generally credit the sculptors of Gandhara with the first representations of the Buddha in human form. Previously, the Buddha was represented in symbols derived from episodes of his life, such as a wheel, a footprint, or a tree, symbolizing respectively his teachings, his travels, and his achieving enlightenment as he meditated under the Bodhi tree. The region of Gandhara, located in northwest India and Pakistan, bordered the Silk Road that ran from northern China to Mesopotamia and the Greco-Roman Empire. It is thought that the figure of the Buddha originated from representations of Greeks and Romans as they appeared on coins used along the Silk Road. The Buddha is draped in a cascade of pleats, much like the togas of Roman emperors seen in sculpture and on gold coins.

Representations of Bodhisattvas, enlightened disciples of the Buddha who chose to forgo the final step to Buddhahood in order to preach the Buddha's doctrine on Earth, appeared around the middle of the third century. Carved from the soft bluish slate or schist quarried from the hills north of Peshawar in modern Pakistan, our Bodhisattva is adorned like a prince in order to remind worshipers of his earthly nature as opposed to the supernatural aspect of the Buddha. His jewels may have been fashioned after representations of Persian and Sassanian deities.

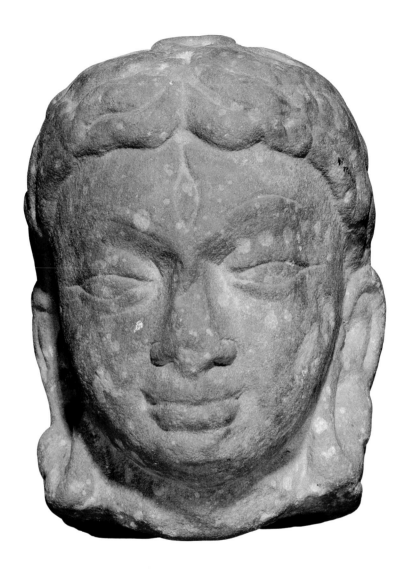

Head of a Deity
India, Gupta Dynasty (ca. 320–600)

Red sandstone. Height: 6⅜ in.
(16.2 cm)
George and Mary Rockwell
Collection. 72.109.13

This fragment of a sculpture dates
to the Gupta Dynasty of northern
India, established in the fourth
century and marked by a number
of styles that are difficult to char-
acterize. The most distinct feature
of this piece is the red sandstone
material from which it is made.
The stone is speckled with white
spots, a feature common to the
sandstone in the region of Mathura,
where much religious carving was
done. The Gupta rulers commis-
sioned temples in honor of the
Hindu deities they closely associ-
ated with, and these temples,
constructed of local stone, were
heavily decorated with statues.
This piece was undoubtedly taken
out of its architectural setting,
leaving no evidence as to which
temple it came from or which deity
it was intended to represent.

The softness of the sandstone,
an easy prey for water damage
from long periods of rain, as well
as the mottled red hue of its mate-
rial, gives Gupta art a unique
quality. It has a subtlety and com-
posure that blends well with its
architectural support and provides
viewers with the illusion of a godly
presence.

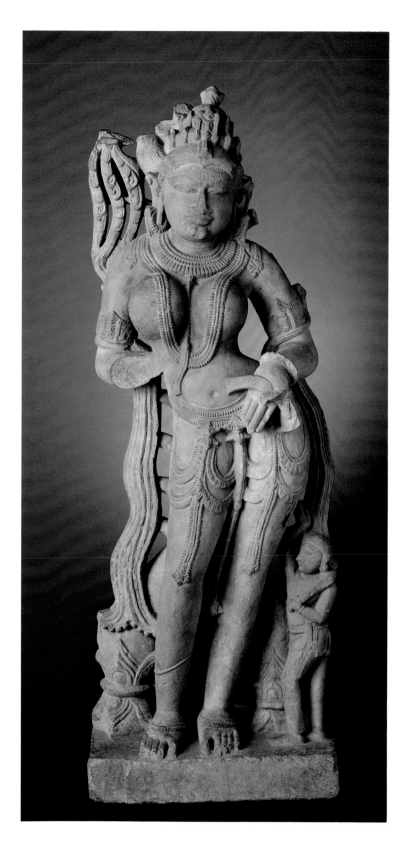

Yakshi with a Love Letter in Her Hand
India, ca. 11th–12th century

Buff sandstone. Height: 33 in. (84 cm)
Museum Associates Purchase. 67.37

While this figure with its extravagantly rounded volumes, elaborate jewelry, and exaggerated serpentine pose makes a powerful impression when encountered in the Museum, it was not a separate cult image, but a part of the very fabric of the temple. In its plan and elevation, the temple is both a symbolic diagram of the cosmos, and its actualization. The walls are thronged with the richly carved forms of all the teeming delight and variety of the universe. It is in this setting, warmed by the sun and shadowed by the projecting enframements, that this feminine goddess regains her full power. She blossoms from the vertical architectural wall surface to modulate and activate the surrounding space. Her function is to embody fruitfulness and delight. She is either a celestial maiden (Surasundari) or one of the Alasakanyas, the indolent maidens whose grace and beauty make a heavenly palace of the temple.

This figure is carved in a style that was common in mid-India and Rajastan during the tenth and eleventh centuries. It is a sustained exploration in the power of roundness, with its entirely convex surfaces, and the deeply exaggerated, continuous recessions from the frontal planes to the rear plane. The precisely articulated units of jewelry and girdle also serve to emphasize the softness and fullness of the figure.

Seated Shiva
South India, ca. 14–15th century

Bronze. Height: 20¾ in. (53 cm)
Museum Associates Purchase.
67.27

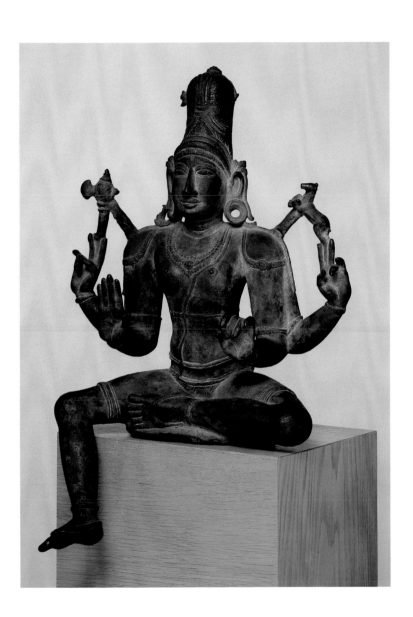

South Indian bronzes have long been regarded as one of the great achievements of the metalworker's art. With their abstract tubular limbs, elongated proportions, heart-shaped faces, and melodic gestures, these bronzes seem pervaded with a mystic gravity of spirit. Most of them were created in the service of Hinduism. The greatest period of achievement spans roughly the eighth to the twelfth centuries; our sculpture may date a century or two later, and represents the great Hindu god of creation and destruction, Shiva. He was originally seated together with his feminine consort Uma on a rectangular bronze pedestal, a common pairing in Hindu iconography. These pairs are touched with a serene and timeless domesticity, and are in polar contrast to the many other guises of Shiva as ascetic or destroyer.

It is these contradictions between diametrically opposed conditions and qualities that make the mythology of Shiva so enigmatic. He is at once the fountain of eroticism and the desert of asceticism, and his mythology enacts a world process based on the dynamic interpenetration and permutation of desire and withdrawal, becoming and dissolution, terror and joy. In South India, Shiva is usually represented, as here, carrying in his upper hands an axe and a deer. According to the legend of the Pine Tree Forest, Shiva seduced, or created the impression that he seduced, the wives of a group of ascetic sages. The angry sages attacked Shiva by throwing a hatchet that he caught and now holds in his right hand. They then sent an antelope against him, which he captured in his left hand.

A King Pays Homage to Rama
India, Kangra School, Punjab Hills,
late 18th century

Opaque watercolors on paper.
8⅛ × 11⅞ in. (21 × 30 cm)
Gift of Dr. and Mrs. Frederick
Baekeland. 87.11.2

This miniature originates from
the Punjab Hills region, which,
until the nineteenth century, was
divided into thirty-five feudal
states, each ruled by a Rajput and
each supporting its own separate
painting school. The Kangra region
was a central state within the
Punjab Hills. The Rajput were a
warrior caste devoted to the cults
of Vishnu and Siva, but they also
were deeply interested in literature
and commissioned numerous copies
of the great Indian epic poems like
the Ramayana. The Ramayana tells
the story of Rama and his consort
Sita, who was abducted by an evil
spirit. Rama enlists Hanuman,
the king of the monkeys, and his
army to help rescue Sita from the
demon Ravana. Rama is popularly

considered a protagonist of right-
eous conduct and is often wor-
shiped in his own right. The Rajput
felt that they could earn merit if
they devoted themselves to Rama.

Our illustration here of the
Ramayana is a narrative scene in
two episodes, both depicted within
the same frame. A king, accompa-
nied by his attendants, pays homage
to Rama, the hero of the epic, and
his brother Lakshmana. The king
is represented twice, in front of
Rama, then receiving a blessing
from Lakshmana. Both scenes take
place by a river and are witnessed
by Rama's army of monkeys and
bears.

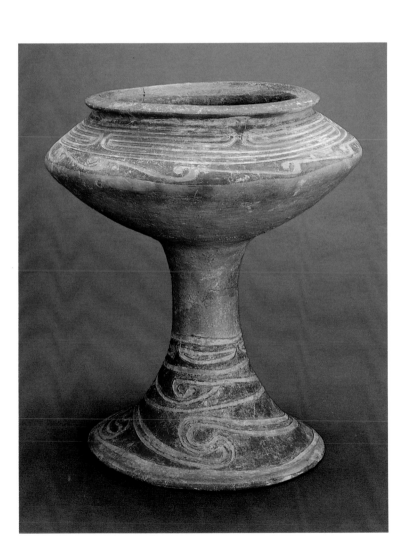

Bowl
Thailand, Ban Chiang,
ca. 4th–1st century B.C.

Earthenware with incised decoration. Height: 9¼ in. (23.5 cm)
Gift of Jonathan Morse in honor of Irene Levitt Morse, Class of 1929.
78.86

Ban Chiang pottery is among the earliest pottery produced in Southeast Asia, the most ancient examples dating to as early as the fifteenth century B.C. The site of Ban Chiang is considered one of the most important discoveries of the Bronze Age in Southeast Asia, with burials containing iron fragments, knives, axes, spears, glass beads, and clay rollers. The best-known objects are the red painted pottery vessels that feature varying degrees of intricate decoration consisting of swirls and incised curving lines. This handsome stem cup is most likely from the late stage of the Ban Chiang period, when most of the more elaborately decorated vessels were made. The vessel might not have been made for use in temporal life, but instead crafted for a person of high social rank to accompany him into the afterlife.

Buddha Seated under the Naga
Thailand, Lopburi,
ca. 13th–14th century A.D.

Red sandstone. Height: 37^{13}⁄$_{16}$ in.
(96 cm)
Gift of Alexander B. Griswold.
78.98.37

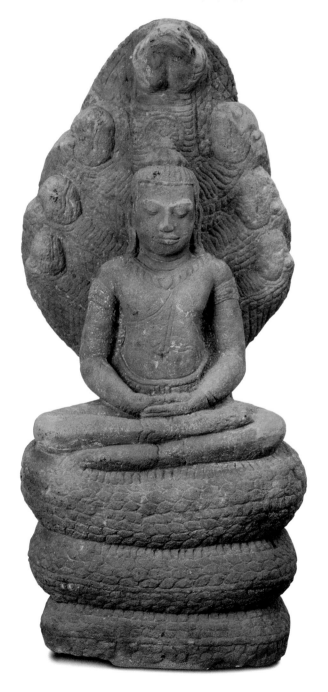

The name Lopburi has generally been used to designate the Khmer-inspired art of Thailand. The region of Lopburi, in the northeastern part of Thailand bordering on Cambodia, came under Khmer domination from the eleventh to thirteenth centuries, but sculptural styles inspired by Khmer models continued well into the fifteenth century in the region. Sculpture from Lopburi, especially from the later part of the period, has often been considered to be of lesser quality than its Khmer counterpart, perhaps due to its remoteness in time and space from Cambodia.

This sculpture is an example of the late style of Lopburi art. This period was characterized by its use of sandstone and featured both Hindu and Buddhist iconography, which accounts for the representation of the Naga, a multi-headed water snake associated with Hinduism. The image of the Buddha under the protective hood of the Naga is a common motif in Lopburi art. A major characteristic of the Lopburi style is the elimination of all adornment. The Buddha's robe is represented only by a faint line across his chest and a thin strip of cloth over one shoulder. Unlike the Buddha images found at such places as Sukhothai, the Buddha here does not display a flaming finial above the head, nor are his curls elaborately carved. He remains sober in his outlook, quite reminiscent of the Buddhas of the Bayon in Cambodia.

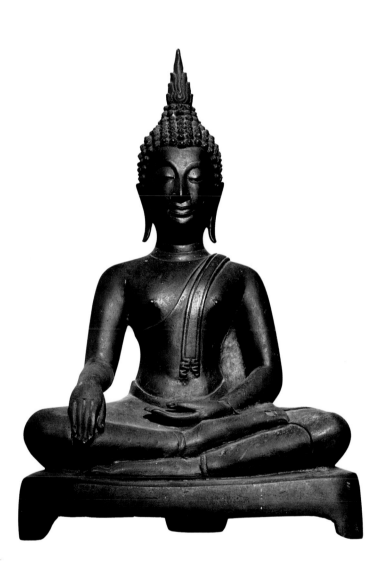

Seated Buddha
Thailand, Sukhothai Period,
ca. 14th–16th century

Bronze. Height: 11⁷⁄₁₆ in. (29 cm)
Gift of Alexander B. Griswold.
76.63.3

According to the sacred Pali scriptures of Theravada Buddhism, the Buddha had thirty-two major and eight minor characteristics. Starting in the thirteenth century, the kings of Thailand, who reigned at Sukhothai, embraced Theravada Buddhism and commissioned statues that adhered closely to the Pali canon. The Museum's statue contains many of the features of the Buddha as they are listed in these scriptures. He was said to have an *ushnisha*, or a protuberance on the top of his head, curls of hair spiralling in a clockwise direction, and distended earlobes adorned with heavy jewelry, reminders of his earlier life as a prince. The Sukhothai carvers added other distinctive features that drew on similes used in Sanskrit poetry.

The gesture of calling the earth to witness, the pose in which the Buddha is represented, seated cross-legged with his fingertips touching the ground, is common in Sukhothai art. It is the charged moment before the Buddha attained enlightenment, when meditating under the Bodhi tree he was visited suddenly by the evil Mara, who attempted to disrupt the meditation and shook the earth with great force. By touching the ground with his hand, the Buddha called on the earth goddess to witness his lifetime of accumulated merits. She then caused water to gush forward, chasing Mara away and enabling the Buddha to attain enlightenment.

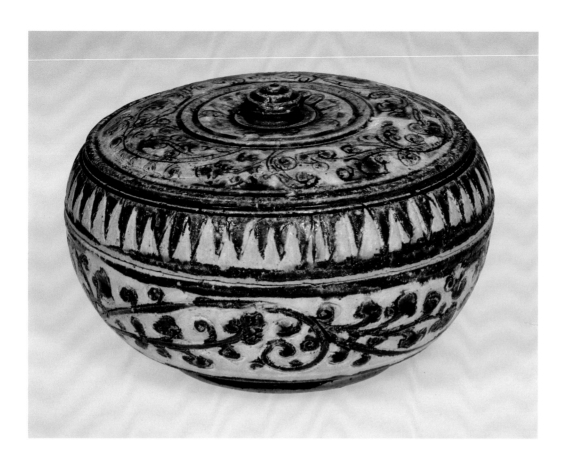

Globular Box
Thailand, Sawankhalok Period,
ca. 14th century

Stoneware with iron brown over-
glaze, 3 × 5 in. (7.6 × 12.7 cm)
Gift of Dean F. Frasché. 71.169

Of all the ceramics produced
in Thailand, those from the
Sawankhalok kilns have been found
in the greatest numbers through-
out Southeast Asia. This indicates
they were produced for export
rather than for domestic use. The
export of Thai ceramics to other
parts of Southeast Asia and beyond
to the Arab world and Japan was
at its peak in the fourteenth cen-
tury, when Chinese wares were
unavailable for export due to the
disruption of the Mongol conquest.
Hence the large numbers of
Sawankhalok wares found in sites
and shipwrecks in Malaysia and
the Philippines. They were tradi-

tionally made of a high-fired
coarse grey paste. This particular
piece is part of a series of painted
wares that have been found at
different kiln sites. The ceramics
were shaped, dried, painted in
brown iron overglaze, and then
fired.

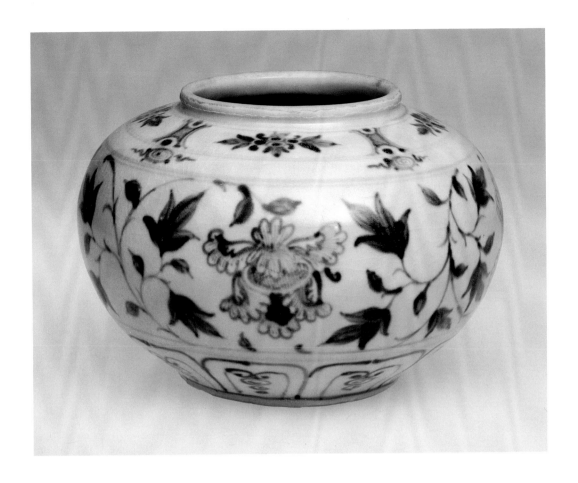

Small Jar
Vietnam, Bat Trang,
ca. 15th century A.D.

Porcelaneous stoneware, under-
glaze blue. Height: 6 in. (15.2 cm)
Gift of Dean F. Frasché. 76.74.3

Although often confused with or considered to be offspring of Chinese Ming Dynasty blue-and-white wares, the ceramics of Vietnam differ from their Chinese counterparts in many ways. A creamier, more opaque glaze and a looser pattern in the underglaze decoration are the two most common features that set these wares apart from Chinese blue-and-white. This particular jar displays some of the most common motifs of Vietnamese underglaze blue wares, such as the peony spray on the body of the jar and the lotus petals above the foot rim.

Since the fourteenth century, Bat Trang, located in northern Vietnam along the Red River, some thirteen kilometers from Hanoi, has been the center of Vietnamese ceramic production, which still continues today with some five hundred family kilns. It rose to prominence in the fifteenth century when the export of Chinese ceramics from southern ports was temporarily halted. It is possible that many potters from southern China came to Bat Trang at that time. Bat Trang jars were traded and prized throughout Southeast Asia, and have been found in sites as far away as Japan and the Philippines. This jar is an especially fine example and was most likely used for ceremonial or burial purposes, for it displays no sign of extensive use.

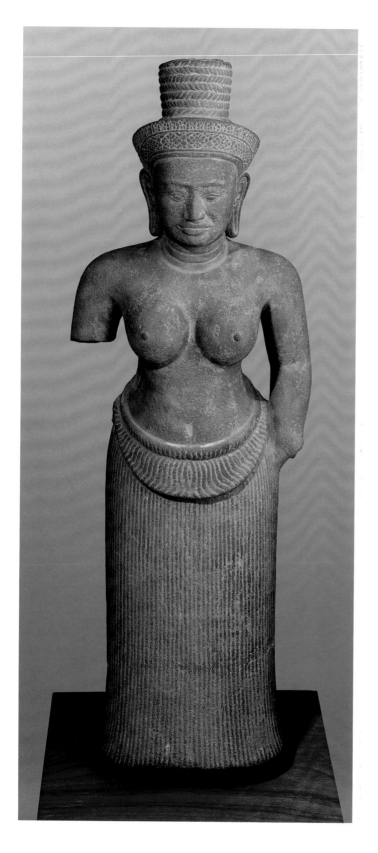

The Goddess Uma
Cambodia, Koh Ker,
ca. 10th century A.D.

Sandstone. Height: 25¾ in. (65 cm)
Gift of Dr. and Mrs. Frederick
Baekeland. 79.92.1

This statue displays the sober, graceful style of Khmer statuary found at Koh Ker and is a testimony to the skill and workmanship of Khmer sculptors during this period. Located some eighty-five kilometers northeast of Angkor, Koh Ker was the site of a short-lived royal capital established from 921 to 944 A.D. Statuary from this period is characterized by wide hips and full breasts as well as long, tight, incisions on the figure's dhoti or sarong, marking the folds of the full-length cloth. Although beautiful and majestic in its own right, Koh Ker art lacks the refined elegance of the sculpture found at Angkor, which dates a century later. The Koh Ker period allows us to witness the evolution of Khmer art from the simplicity of its beginnings to the extreme sophistication of later twelfth- and thirteenth-century Angkor.

This statue is a representation of Uma, otherwise known as Parvati, or Shiva's consort. She is usually represented at his side in Indian sculpture, but is here seen as a divinity in her own right, although she certainly was part of the architectural structure of a temple and meant to be viewed in conjunction with the other deities of the Hindu canon.

Lime Pot
Cambodia, ca. 13th century

Stoneware with green-beige glaze.
Height: 3⅛ in. (7.9 cm)
Gift of Dean F. Frasché. 69.121

Khmer potters commonly used whimsical zoomorphic and anthropomorphic jars and bottles as lime containers in the preparation of betel nut. The lustrous, rich brown glaze that covers the surface of this pot is also a common characteristic of wares dated to the Angkor period, (twelfth to thirteenth centuries). The brown glaze is the result of a high iron content. The shape of this pot has been likened to an owl, which is also a common shape in Khmer wares, as the owl is a familiar inhabitant of Southeast Asia and tends to reside near temple compounds. Bird shapes in ceramics, statuary, or architectural motifs in general have been equated with celestial beings because of their ability to fly. They are seen as intermediaries between the earth and the heavenly realms or as messengers to the gods.

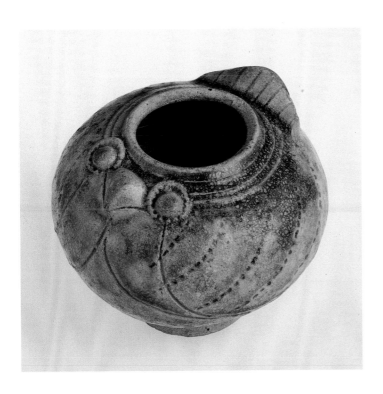

Standing Avalokitesvara
Indonesia, Java, ca. 10th century A.D.

Bronze. Height: 6⅝ in. (16.8 cm)
George and Mary Rockwell
Collection. 88.2.165

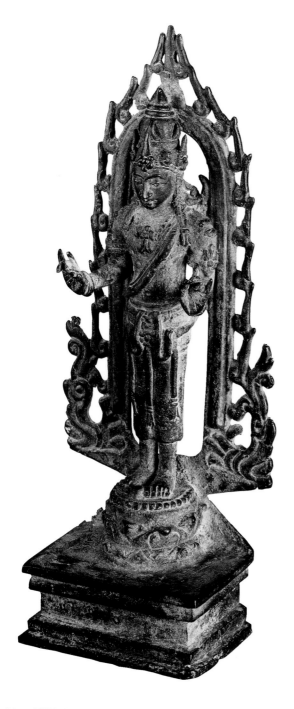

The Bodhisattva Avalokitesvara is seen here standing with his arms raised in the *vitarksa* mudra, or argument gesture. This emphasizes the Bodhisattva's role as a disciple of the Buddha and a teacher of the Buddha's doctrine. The Bodhisattva is essentially a 'Buddha' or sentient being who has chosen to forego the final step to Buddhahood or nirvana in order to remain on earth to teach the principles of Buddhism. There are many Bodhisattvas, but four in particular, Avalokitesvara among them, stand out and are commonly portrayed in sculpture as symbols of every person's ability to attain spiritual salvation. Avalokitesvara is also known as the Lord of Compassion, and is commonly represented in the islands of Southeast Asia, especially during the Srivijaya period (eighth to ninth centuries), as a prince adorned with lavish jewelry and crowned with an elaborate headdress.

The Museum's example is framed with a band of ornaments consisting of open flames on the sides and the top of the figure, and at the bottom left and right by two stylized *makara* or dragon heads. These decorations can be found on other representations of the standing Avalokitesvara, and are residues of Hindu motifs and typical of Javanese sculpture in particular. Small portable bronze images of this type have been found throughout Java and were used as votive images or icons. They were not meant to be housed in shrines; rather, they enabled individual patrons and worshipers to gain access to spiritual merit.

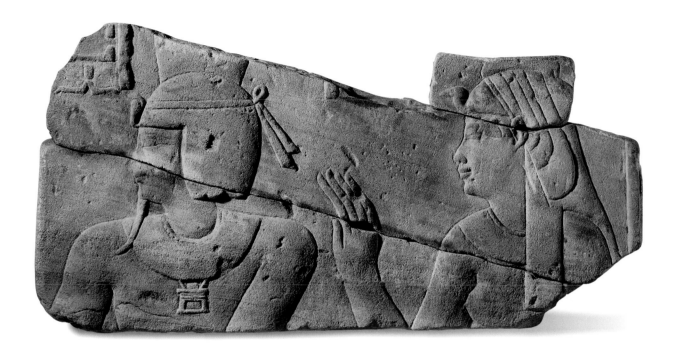

Relief Depicting Two Figures.
Egypt, Middle Ptolemaic
(ca. 200–100 B.C.)

Limestone. 12½ × 23½ in.
(32 × 60 cm)
Gift of the Cornell Women's Club
of New York and Membership
Purchase Fund. 64.2

Most Egyptian art, such as this relief, was never intended for public display. The Egyptians poured their creative energies into the construction of temples for the gods and tombs for themselves, both considered holy places that would not have been entered after they were completed. However, grave robbing was so rampant that, by the Eleventh Dynasty (ca. 2035–1991 B.C.), pharaohs stopped using pyramids and had their coffins hidden in chambers carved into cliffs.

Tomb walls were painted or carved with shallow reliefs depicting funerary rituals as well as images of the deceased, family members and daily life. Portraits of the deceased were to serve as an abode for the spirit, or *ka*, of the deceased, should the mummy be destroyed. Depictions of family members and daily life functioned to both entertain and provide for the *ka* in the hereafter. Color would have been added to the relief carvings.

Despite the relatively late date of this relief, the depiction of the figures remains consistent with the centuries-old traditional manner of Egyptian representation. The two figures are seen with their heads in profile, and torsos depicted frontally. This manner of representation gives the viewer the most recognizable way of seeing each part of the body, a convention that dates back to the beginnings of Egyptian art, some three thousand years earlier.

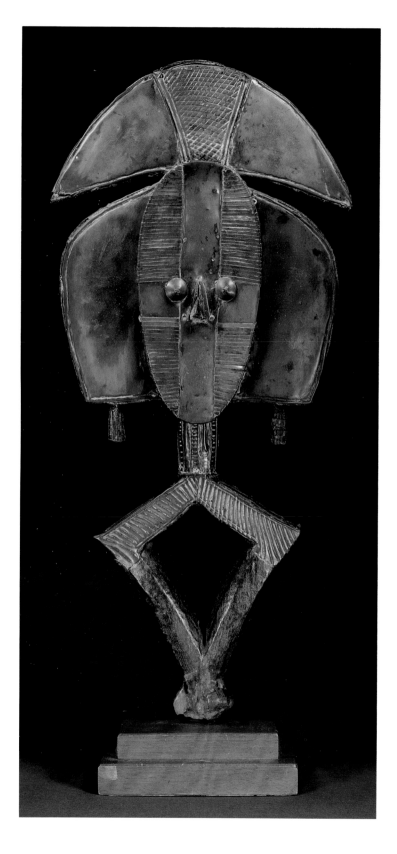

Reliquary or Spirit Guardian (Mbulungulu)
Gabon, Bakota-Obanma, late 19th to early 20th century A.D.

Brass, copper and wood.
Height: 20 in. (51 cm)
Estate of Hilda Brand Jaffe.
81.12.11

This figure (also known as a *Bwete* or *Biwiti* figure) is typical of the relic statuary of the Kota and Mahongwe people who live mainly in the east of Gabon and to a lesser extent in the Congo, where the Mahongwe also live. Such figures are used as guardians for relic containers where the skulls and bones of revered and prominent ancestors are kept. The containers, normally wickerwork baskets or bark barrels, are part of family or village shrines called *Biwitii*. The guardian figure was expected to work for the benefit of the owner or the community. The same figures are also used as a dance mask when attached to a raffia disguise during the annual *Biwiti* rites. The guardian figure's lower end is normally stuck into the relic container. The head rests on a cylindrical neck with its lower part split to form the lozenge-shaped base, hypothesized to be a stylized representation of the arms. The front part of the figure is covered with brass and copper sheets or strips, and with iron sheets applied to create an aesthetically pleasing color contrast. The use of metals such as copper or brass, considered expensive, is probably meant to display wealth as well as to honor the ancestors or to ward off the evil spirits at night. Their shining and brilliant surfaces recall daylight, which is considered anathema to the presence of evil spirits.

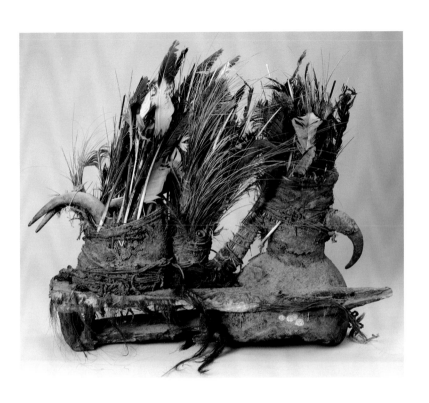

Komo Society Headdress
Mali, Bamana (Bambara),
20th century

Feathers, quills, horns, and encrustation. Height: 23 in. (58 cm)
Gift of William W. Brill. 89.15.15

Typical of the Mande association masks, the sacrificial material seen in the encrustation on the surfaces of this headdress (also known as a helmet mask) is an indication of its connection with one of the three main Bamana power societies: *Komo, Kono* and *Nama.* This specific headdress is typical of the *Komo* society, which functions as the custodian of tradition and is concerned with all aspects of community life – agriculture, judicial processes, and passage rites. The Bamana, an ethnolinguistic group of the upper Niger region of Mali, are distinguished by their indigenous method of writing and a remarkable system of metaphysics and cosmology, encompassing associated societies, prayers, myths, and rituals. The *Komo* is a secret power association of priests, knowledgeable elders, and blacksmiths that forms the central Bamana social institution. Members of the blacksmith clan are born into the *Komo* society because of their ability to employ the forbidden power of fire to transform matter from one form into another. Its masks and headdresses are of elongated animal form decorated with actual antelope horns, porcupine quills, bird skulls, and other objects as vessels of power. Blacksmiths of the *Komo* society wear the society headdress or *komo-kun* during a dance to invoke *nyama,* the force that activates the universe.

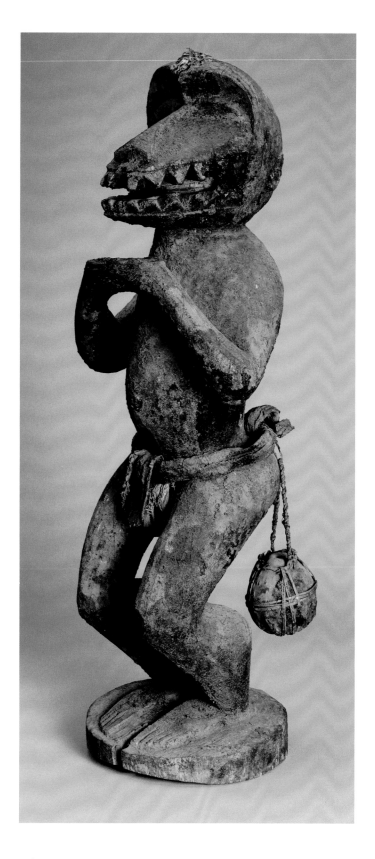

Baboon (Gbekre)
Ivory Coast, Baule, 20th century

Wood, mixed media, and sacrificial material. Height: 28 in. (71 cm)
Gift of Dr. and Mrs. Leroy S. Lavine. 81.86.5

The *gbekre* or baboon figures are popular among the Baule people of the Ivory Coast, an Akan group, speaking a Twi language of the Kwa branch of the Niger-Congo family. The function of the *gbekre* figures is understood in terms of the centrality of agriculture in Baule life demonstrated in the annual harvest festival in rural areas, in which the first yam, the major staple food, is symbolically offered to the ancestors. *Gbekre* are placed as guardians at the gates of villages, but they are also considered the patron of the farmers. According to Baule mythology, the baboon and other ape figures symbolize the son of the god of heaven. It receives the offerings for this deity to ensure the protection and fertility of the farmers' crops. The Baule use of the baboon figure can be attributed to the apes' closeness to humankind, alluding to a higher, spiritual being.

Carved in natural unstained wood with minimal details and projecting jaws, the *gbekre* figures are in contrast to the smooth and shiny surfaces, intricate stylization, meticulous attention to anatomical description, and coiffure and body decoration considered to be characteristic of traditional Baule sculpture. *Gbekre* figures are often portrayed with open hands or holding small cups for sacrificial offerings; their surfaces are often encrusted with the sacrifices poured directly over them.

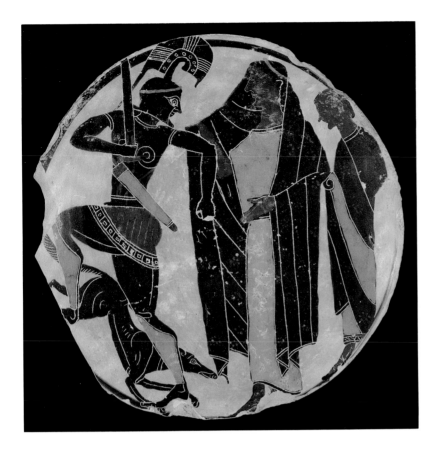

Attributed to LYDOS
Greek, active ca. 560–540 B.C.
The Recovery of Helen by Menelaos

Tondo from a black-figure plate.
Diameter: 5⅞ in. (14.9 cm)
Gift of the Class of 1930;
The Frank and Rosa Rhodes
Collection. 95.47

The sixth century B.C. in Athens
is the classic moment in ancient
Greek vase painting; this composi-
tion was executed about 560 B.C. by
Lydos, a major figure in Athenian
painting, in black paint on the nat-
ural red of the plate itself. Details
were scratched through the black
with a needle, and other colors were
added on top.

Lydos shows us here the
Greek king Menelaos forcibly
bringing Helen, his unfaithful wife,
back to Greece after the Trojan
War. Menelaos, in sword and armor,
climbs up the side of the plate,
grasping the hem of Helen's robe,
while she stands quietly, dignified
and calm, and her servant waits
modestly to the right. At the bot-
tom, the king's dog – a favorite

animal in Lydos's work – sniffs
curiously at Helen, perhaps antici-
pating the couple's reconciliation
and future happy years together.
Much of the composition of the
plate is based on an amphora in the
Staatliche Museen, Berlin.

In sixth century B.C. Greece,
painting on vases was one of the
most important ways in which
problems of representation and
narrative were worked out. This
process is apparent in Lydos's lively
scene, with each character given
its own distinctive personality. The
story of the Trojan War itself is
told in Homer's *Iliad*, the touch-
stone for ancient Greek and Roman
epic poetry and one of the great
sources for writers and painters for
the last three thousand years.

Tetradrachm Coin
Sicily (Magna Graecia), ca. 440 B.C.

Silver. Diameter: 1 1/16 in. (2.7 cm)
Gift of Jerry Theodorou. 97.18

Before the advent of coinage, gold and silver rings, iron rods, electrum (an alloy of gold and silver), and gold were traded for needed goods and services. Coinage first appeared around the 7th century B.C. in the Mediterranean world. The first use of state-issued coins seems to have been about a century later, and a coin's origin can usually be identified by the symbols it carries. Athena is depicted on the coins from Athens, for example, and the sea turtle is found on the coins produced on the island of Aegina. The coin presented here has the head of the god Apollo wearing a laurel, a symbol of victory, on the obverse and a lion's head on the reverse. The inscription on the reverse, "VE ON TI NION," refers to "Leontinoi," a city in Sicily and part of the wide-reaching Greek civilization. The representation of Apollo's head in profile was also adopted by various rulers, not only for coinage but also in other art forms as well. This tradition was continued through the Roman and subsequent civilizations to the present day where it can still be found, for instance, in the profile of Lincoln's head on the American penny.

Head of Caesar Augustus
Rome, ca. A.D. 30–50

Marble. Height: 21½ in. (55 cm)
Transfer from University
Collections. 68.277

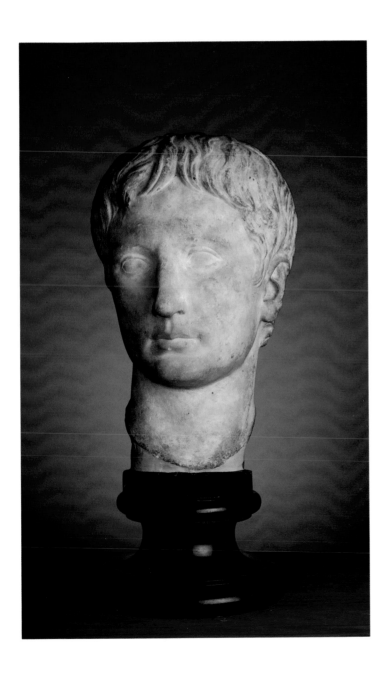

Octavian Caesar (63 B.C.–A.D. 14),
great-nephew and heir to Julius
Caesar (assassinated in 44 B.C.),
defeated the troops of Marc Antony
and Queen Cleopatra of Egypt in
31 B.C., marking the end of the
Roman Republic. A grateful Roman
Senate bestowed upon him the
name "Augustus." He ruled Rome
from 31 B.C. until his death in
A.D. 14 as its first emperor.
Augustus strove to return peace
and prosperity to the empire, and
the period was characterized by a
series of new laws he instituted.

Portraits of Augustus were
many, and two general types have
emerged: the earlier "Octavian,"
and the later "Augustan." This por-
trait is an example of the latter,
noticeably lacking the wide cra-
nium, heavy brow, and prominent
ears of the "Octavian." "Augustan"
portraits derive their less individu-
alized and more idealized features
from earlier Greek sculpture and
mostly date from shortly after
Augustus's death and subsequent
deification. This sedate, idealizing
form of representation continued in
various forms during the remain-
der of the Early Empire, which
came to an end in A.D. 284 with the
rule of Diocletian.

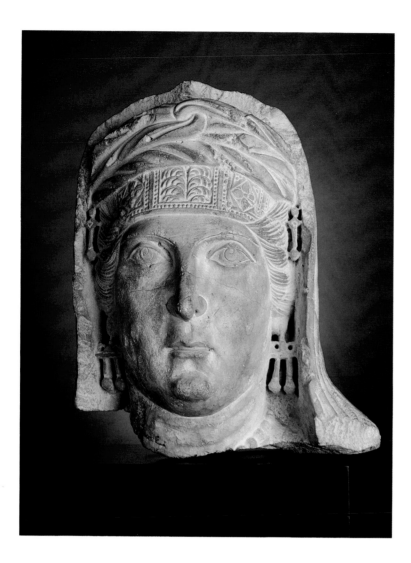

Palmyrene Head
Roman Syria, ca. 150–200

Carved and polished limestone.
Height: 11¾ in. (30 cm)
Harold L. Bache, Class of 1916,
Memorial Endowment Fund. 72.21

An oasis in the Syrian desert, Palmyra was a main stop along the caravan route that brought luxurious merchandise from the Orient to the Roman world. Palmyra was annexed to Roman Syria and its citizens were granted independence in many matters. However, in 273 Zenobia, Queen of Palmyra, challenged Rome for control over the eastern part of the Roman Empire, and Palmyra was destroyed by Roman troops.

Palmyrene citizens placed sculpted figures in family tombs located outside the city. This sculpture is striking both as portraiture and as decoration, reflecting the mixture of Roman and Near Eastern heritages of the city. The head, factual and stern, is typically Roman, but the large almond-shaped eyes with heavy lids and the abbreviated eyebrows reflect the abstracting tendencies of Near Eastern art.

This portrait would have been placed on the outside of a compartment, called a cubiculum, holding the remains of the person portrayed; four or five cubicula were usually arranged in a row, one above the other, inside a large tomb.

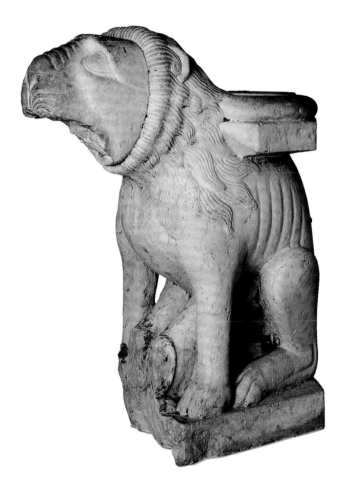

Attributed to the workshop of
MASTER PIETRO DI ALBERIGO
Italian, active 1164–ca. 1210
Romanesque Portal Lioness with Cubs, ca. 1200

Pink marble. 33½ × 15½ × 26 in. (85 × 66 × 39 cm)
Robert Sterling Clark Foundation Fund. 73.11

The term "Romanesque" refers to a style that dominated art and architecture in Europe from around 1000 to 1200; it was especially prevalent in churches and ecclesiastical buildings. Romanesque sculpture, such as this lioness, often served as both decorative and supporting elements in architecture. The lioness, for example, supported a column on her back and is thought to have come from one of the side entrances, called the Portal of the Lions, of the Cathedral of San Pietro in Bologna. This doorway is thought to have been carved by Master Pietro di Alberigo, who is also credited with carving the figured capitals of columns in Santo Stefano in Bologna. The Portal of the Lions was dismantled at some point in time, but an extremely similar *Lioness with Cubs* still exists, now in the interior of the Cathedral of San Pietro in Bologna.

This sculpture represents a seated lioness suckling two cubs between her front legs. Parts of the two cubs are missing, as is the lower jaw of the lioness. Several related pieces are now in the collection of the Cleveland Museum of Art.

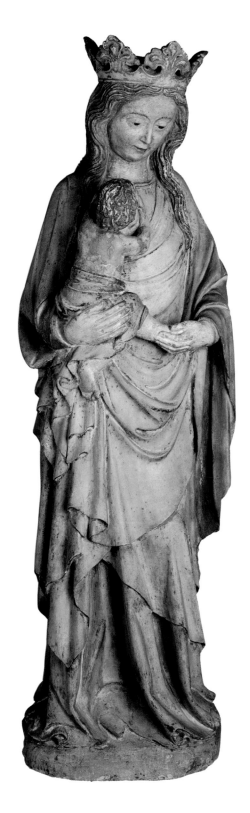

Madonna and Child,
France, ca. 1380

Limestone with traces of poly-
chrome. Height: 36½ in. (93 cm)
Robert Sterling Clark Foundation
Fund. 71.91

In the twelfth and thirteenth
centuries, the Virgin became the
object of intense and widespread
devotion. As the cult of the Virgin
spread in the Gothic period, she
came to be regarded as the youth-
ful and aristocratic embodiment of
both Christian and chivalric ideals.
Particularly after the middle of the
thirteenth century, the Virgin was
represented not only as a delicate,
smiling Queen of Heaven, but also
as tender and maternal.

This standing Virgin and Child
represents one of the more affec-
tionate variants of this maternal
image, called a *Virgo lactans* because
she is nursing the child as she cod-
dles him. The gently swaying pos-
ture, voluminous drapery folds,
and cascading curvilinear hemlines
conform to the characteristics of
French sculpture of the Ile de France
in the middle of the fourteenth
century. The long tresses of hair
falling well below the shoulders,
and the squat face with heavy lid-
ded eyes and high cheekbones,
however, suggest a more provincial
origin and possibly a later date.

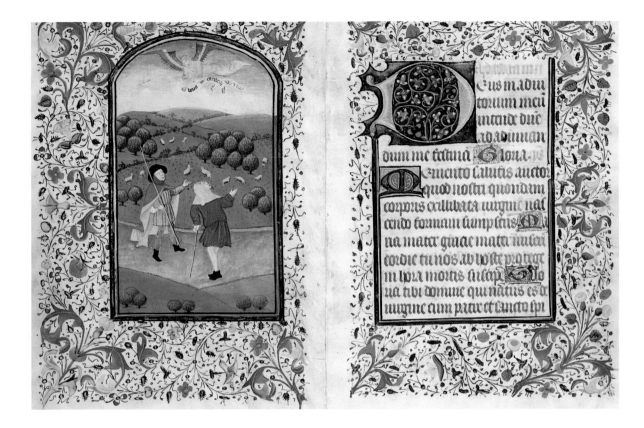

The Annunciation to the Shepherds
France, ca. 1460–1470

Ink, egg tempera, and gold leaf on vellum. 7 × 4⅞ in. (17.8 × 12.4 cm)
Gift of Miriam Saunders. 86.40.1

These two leaves, framed as a facing pair, are from a late fifteenth century Book of Hours. Books of Hours increasingly became the principal manuscript used for personal devotion beginning in the later thirteenth century. They are so named because the daily devotions were divided into eight segments to be read at specific times during the day.

The text page on the right opens the devotions of the Hours of the Blessed Virgin for "Tierce" to be read at 9:00 in the morning. The page on the left contains a miniature of the Annunciation to

the Shepherds, which traditionally illustrated this hour. The style of the decorated initials, elaborate borders with acanthus sprays, and the miniature with its flat landscape and ball-like stippled trees are all consistent with the style of illumination current in northern France in about the 1460s.

MARTIN SCHONGAUER
German, ca. 1450–1491
Christ before Pilate, ca. 1480

Engraving. 6⅜ × 4⅝ in.
(16.2 × 11.8 cm)
Membership Purchase Fund. 78.82

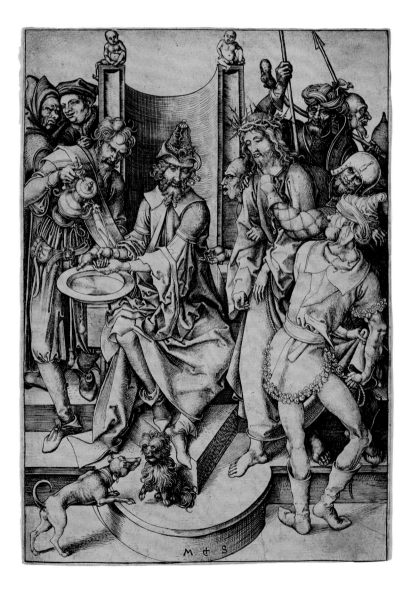

Like his contemporary Andrea Mantegna in Italy, Martin Schongauer was a technical innovator in northern printmaking, codifying in his *oeuvre* a new language of burin strokes that presented a naturalistic gradation from light to shadow, and leaving behind the more schematic engraving techniques of his predecessors. Also, as suggested by the parallel semicircular lines on the back of Pilate's throne, Schongauer is thought to have initiated the practice of keeping the burin still while rotating the plate in order to achieve curved lines, a practice which was widely adopted by subsequent engravers like Albrecht Dürer. It was these skills that allowed northern engraving for the first time to approach the subtlety of painting, bringing a verisimilitude and psychological range to prints.

In this scene from the Passion narrative, Christ is brought before the Roman governor Pontius Pilate, who holds the ultimate power of life or death over him. Although he fails to find any compelling reason why Christ should be put to death, Pilate gives Christ over to his persecutors by washing his hands of him. Drawing on a familiar technique for depicting Christ's captivity before his crucifixion, Schongauer contrasts the humble yet upright figure of Christ with the twisted and bent poses of his captors, casting their faces as boorish caricatures.

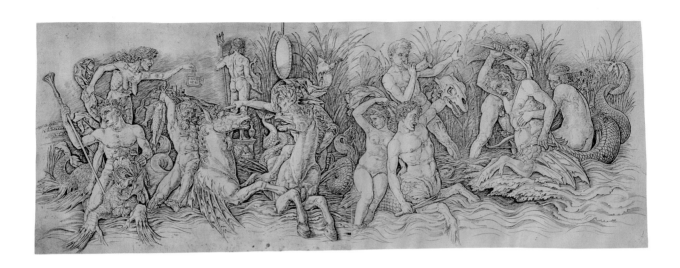

ANDREA MANTEGNA
Italian, 1431–1506
The Battle of the Sea Gods,
ca. 1485–1488

Engraving and drypoint.
12$\frac{1}{16}$ × 32$\frac{7}{8}$ in. (31 × 84 cm)
Gift of Paul Ehrenfest, Class of
1932, and Elizabeth K. Ehrenfest.
73.19.1-2

Andrea Mantegna, the court painter of the Gonzaga family of Mantua, was also an ambitious and inventive printmaker, and the first Italian artist to realize the potential of engraving to reproduce the subtle gradations of light and shadow possible in painting and drawing. Though only seven plates are attributed to Mantegna with certainty, his prints received greater distribution and were copied more widely than those of any other Italian printmaker of the fifteenth century.

The Battle of the Sea Gods seems to be an *invenzione* based partially on an antique relief fragment that Mantegna would have seen during a stay in Rome in 1488. The theme of this print is unclear, and it may be an esoteric subject supplied to Mantegna by a court humanist. Crucial to any interpre-

tation of the composition, however, is the haggard woman who stands at left; her identity is revealed as "Envy" by the tablet she holds in her left hand.

The print's large size was achieved by engraving the composition on two separate copper plates, thus avoiding the problems common to printing on oversize plates. The impressive linear control and parallel hatching of *The Battle of the Sea Gods* show that Mantegna was concerned with approximating his drawing technique in engraved form, making each impression from the plate as fresh a document from the artist's own hand as possible.

ALBRECHT DÜRER
German, 1471–1528
The Four Horsemen of the Apocalypse, from *The Apocalypse,* 1496–98

Woodcut. 11⅛ × 15½ in.
(28 × 39 cm)
Herbert F. Johnson, Class of 1922,
Acquisition Fund. 82.38.5

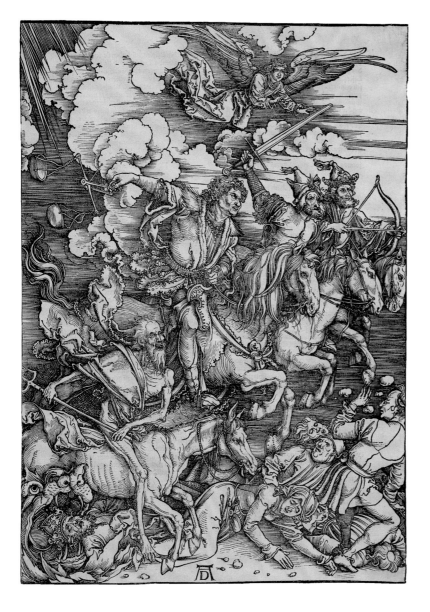

Apprenticed to the Nuremberg illustrator and publisher Michael Wolgemut in the 1480's, Dürer quickly learned the techniques of woodcut book illustration. His *Apocalypse* series is certainly indebted to similar series found in the Cologne Bible of 1479 and the Koberger Bible of 1493, but shows a new grandness of conception. Rather than combining text and illustration on the same sheet, Dürer placed the text on the reverse of his folio-sized sheets, composing a unified collection of multifaceted narratives that encapsulates the prophecy, bringing it vividly to life even to those unable to read the texts.

The best-known of Dürer's *Apocalypse* woodcuts, *The Four Horsemen* illustrates the point in St. John's prophecy when four figures representing power over humanity, including the emaciated Death at lower left, appear as ghastly riders laying waste to the earth and its inhabitants. Dürer's compelling composition, as well as his rhythmic use of sinuous and curving lines learned from his study of the engravings of Martin Schongauer, engraves this riveting scene on our eye, just as it must have done to viewers five hundred years ago. Although in 1500 the Armageddon presaged in these vivid prints did not arrive, Dürer managed successfully to reprint the series in 1511.

ALBRECHT DÜRER
German, 1471–1528
Melencolia I, 1514

Engraving. 9½ × 7⅜ in.
(24.1 × 18.8 cm)
Bequest of William P. Chapman, Jr.,
Class of 1895. 57.122

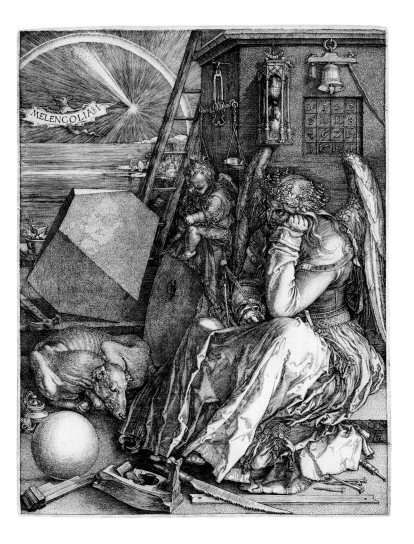

Perhaps Dürer's most enigmatic composition, *Melencolia I* is grouped with his two other "master" engravings of 1513 and 1514, *Knight, Death and the Devil, and St. Jerome in His Study*, which represent the pinnacle of his engraved art. These prints are noted in technical terms for their achievement of greys and planes of shadow, the result of innumerable fine marks of the burin, an effect that in this case contributes greatly to the somber mood of the subject.

Dürer presents the personification of Melancholy surrounded by a collection of tools for creative and intellectual pursuits such as goldsmithing (the crucible and scales), geometry (the polyhedron and sphere), and woodworking (the plane, ruler, and saw). Most important are the dividers she holds, placed at the very center of the composition; this instrument, used by geometricians and architects, symbolizes the ultimate creative act – God's shaping of the world.

In Renaissance humanistic thought, people of melancholic temperament were seen as the most creative members of society; however, it was believed that their genius also made them able to see a still higher level of achievement that they could not attain and were therefore frequently subject to depression. Dürer's figure of Melancholy, and by extension Dürer himself, broods while symbols of the artists's success, keys for power and a purse for wealth, dangle in a useless jumble from her waist.

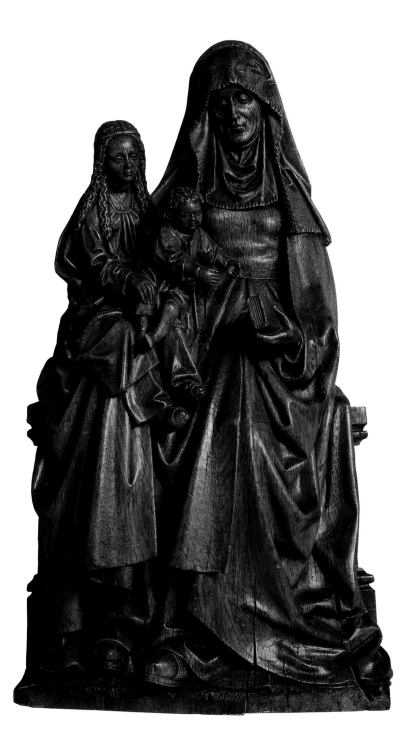

Seated Saint Anne, with the Virgin and Child
Flanders, perhaps Brussels, ca. 1500

Oak. Height: 34½ in. (88 cm)
Membership Purchase Fund. 73.8

Representations of the Holy Family with Saint Anne, the mother of the Virgin, in the late Middle Ages emphasized the human genealogy of the Virgin and Christ, direct descendants from David. In the statue of Saint Anne, Virgin, and Child, Saint Anne is shown as a wizened old lady, reflecting her great age at the time she conceived the Virgin, while her daughter is shown as a young girl, perhaps to emphasize her innocence and purity. A playful Christ child reaches for the book held by his grandmother. Imposing and monumental in its pyramidal form, the statue reflects a tradition of wood carving that was current in the Lowlands at the end of the fifteenth and beginning of the sixteenth centuries. The back of the stool is hollowed out, and impressions, possibly from hinges, suggest that this statue might have served some reliquary function. The guildmark of Brussels is purported to be stamped on the head of Saint Anne, but an examination reveals only random marks.

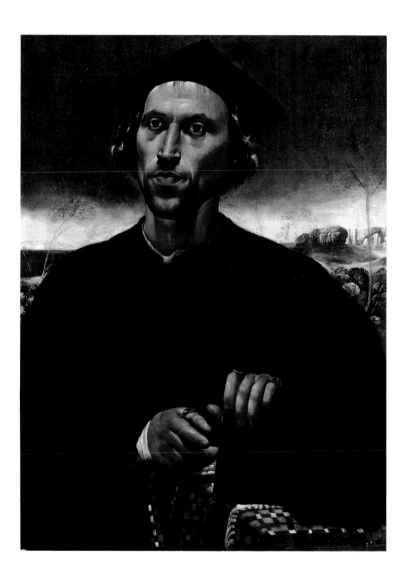

Portrait of an Ecclesiastic
Italy, 16th century

Oil on panel. 27¼ × 20¼ in.
(69 × 51 cm)
Gift of Michael W. Straight.
81.130.1

Although the artist is still uniden-
tified, the *Portrait of an Ecclesiastic*
is a fine example of Florentine
painting of the early sixteenth
century. The overall sense of ele-
gance and strength is typical. The
ecclesiastic, identified as such by his
garments, is positioned before a
natural landscape whose sky is
carefully graded, although now it
has darkened considerably with
age, as has his cloak. A tiny uniden-
tified city is located in the distance
to the right.

Once attributed to the likes
of Raphael, Pordenone, and Genga,
the most likely attribution is to the
circle of the late Piero di Cosimo or
the early Ridolfo Ghirlandaio. Late
Piero and early Ridolfo are often
confused, and attributions continue
to go back and forth. The more
monumental style, and the handling
of hair and other features, seem to
point to an attribution to the circle
of Piero more than any other
artist. Similarly, the identity of the
sitter has never been determined,
although it has been suggested that
he is Evangelista Andrea Tarasconi,
secretary to Pope Julius II from
1503 to 1513 and Pope Leo X from
1513 to 1521.

MARCANTONIO RAIMONDI
Italian, ca. 1480–ca. 1534
Mars, Venus, and Cupid, 1508

Engraving. 11⅝ × 8⅜ in.
(29 × 21 cm)
Herbert F. Johnson, Class of 1922,
Acquisition Fund. 87.19.2

A pastiche of Marcantonio's visual influences, this rich impression of *Mars, Venus, and Cupid* shows his ability to blend seamlessly borrowings from differing visual and artistic styles into an extremely original – and lucrative – style of printmaking. Here northern Italian art is mingled with the Roman idiom; in the foreground we see a Venus culled from the imagery of Giorgione, whom Marcantonio knew in Venice, and beside her a Mars whose trunk clearly emulates the Belvedere Torso in Rome, probably known from a drawing by Michelangelo. Supporting the foreground is a detailed Germanic landscape whose buildings and trees belong to the engravings of Dürer, whose work Marcantonio collected and copied avidly.

Although relatively little is known about the life of Marcantonio aside from his engravings, it is clear that from early in his career he was a student of antique art. Executed in 1508, *Mars, Venus, and Cupid* shows the growing importance of classicizing figural engravings in the print world of the early sixteenth century. In the innovative shading and sculptural modeling of the figures, one can easily see the skill that was to make Marcantonio's collaboration with Raphael in Rome such a fruitful one.

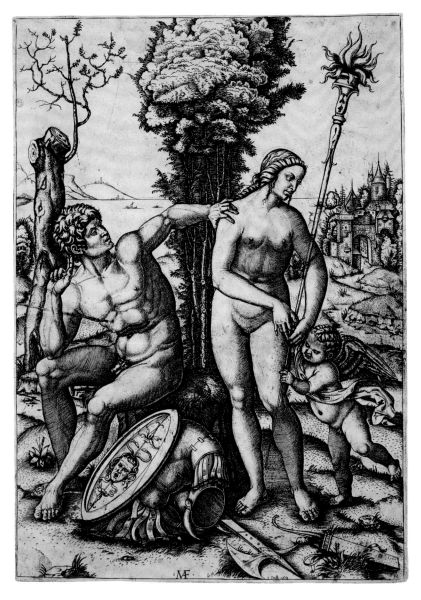

DIRK JACOBSZ. VELLERT
Flemish, active ca. 1511– ca. 1547
The Calling of St. Peter and St. Andrew, 1523

Engraving. 5¹³⁄₁₆ × 4¹⁵⁄₁₆ in.
(14.8 × 12.6 cm)
Gift of Professor and Mrs. Meyer Abrams and, by exchange, the Goodstein Estate. 90.28.1

Antwerp in the first half of the sixteenth century was the most important city in what is now Belgium and the Netherlands. A port with trading connections throughout Europe, it was the artistic center of the Lowlands, where a group of artists called the Antwerp Mannerists flourished in the second decade of the century. In the 1520s and 1530s, the bright, decorative colors, exotic settings, and energetic, elongated figures of the Mannerists were moderated, and the power and dignity of the Italian Renaissance masters were infused into their style.

Dirk Vellert responded to this synthesis. Although he made a number of panel paintings, the major part of his work seems to have been paintings on small glass panels and roundels, prints, and the preparatory drawings for these works. He had a love of everyday subjects, such as a drunken drummer or students and adults in a schoolroom, that betrays his northern roots.

This engraving, however, shows a profound debt to Albrecht Dürer, especially in the landscape, as well as echoes of the Antwerp Mannerists in the profusion of detail covering the whole sheet and the formalized, wonderfully decorative waves spreading out in front of the boat. This design was copied, perhaps by Vellert himself, in a glass roundel dated 1537.

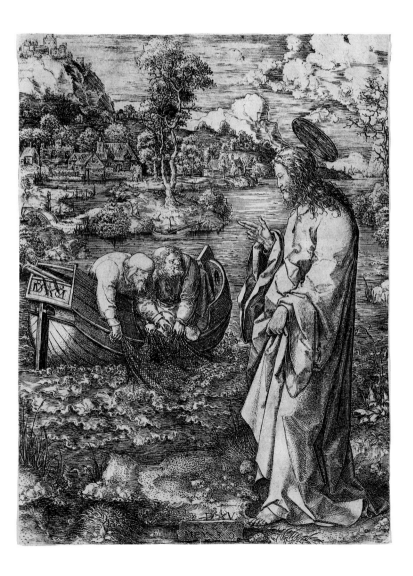

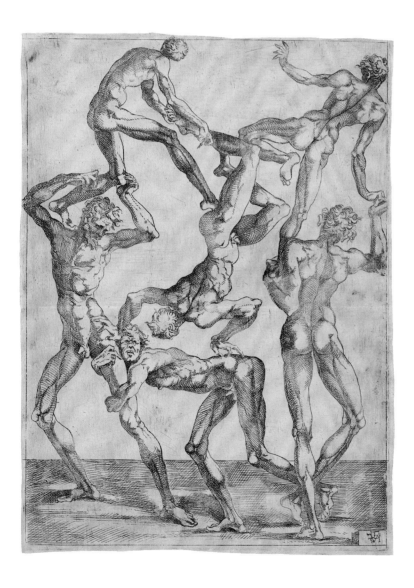

JUSTE DE JUSTE
French, 1505–before 1559
Pyramid of Six Nude Men, ca. 1543

Etching. 11¼ × 8⅜ in. (29 × 21 cm)
Membership Purchase Fund.
87.20.3

Juste de Juste came from a family
of artists of Florentine extraction,
and worked under Rosso Fiorentino,
the artist charged with the deco-
ration of Francis I's palace at
Fontainebleau in the 1530s. Like
other artists in Rosso's employ at
this time, Juste was trained as a
draftsman and painter and not as a
printmaker. Partly for this reason,
unlike the skilled and measured
technique of prominent Italian and
German engravers of this decade,
Juste de Juste and the other print-
makers at Fontainebleau seem
to have been given much greater
license in the creation of their
etchings. To be sure, in technical
terms these prints often demon-
strate an incomplete understanding
of printmaking methods; however,
the immediacy and artistic verve
of the prints of Fontainebleau were
unparalleled in their day and
caused them to be distributed all
over Europe.

This amusing jumble of bodies
is not related to any of the palace
decorations at Fontainebleau;
rather, Juste seems simply to have
turned his long study of human
anatomy into a freely interpreted
academic exercise, creating a com-
plex recombination of muscular
human forms that barely fit (bump-
ing heads, hands, knees, and
elbows) within the dimensions
of his copper plate.

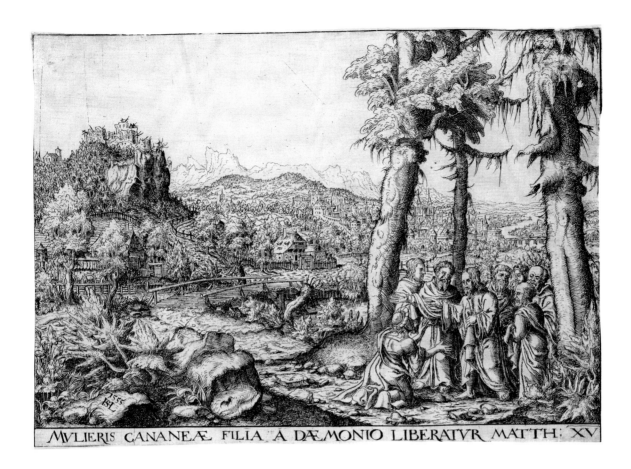

MVLIERIS CANANEÆ FILIA A DÆMONIO LIBERATVR MATTH: XV

Hans Lautensack
German, 1524–1560
Christ and the Canaanite Woman,
1555

Etching. 6⅛ × 8⁹⁄₁₆ in.
(15.6 × 21.7 cm)
Professor and Mrs. Meyer Abrams
Purchase Fund and, by exchange,
the Goodstein and Woods Estates.
90.28.2

Born the son of a painter in Bamberg, Hans Lautensack and his family moved in 1525, because of his father's Protestantism, to Nuremberg, a city still in the thrall of its most famous artist, Albrecht Dürer. Trained in this atmosphere and familiar with Dürer's engravings, Lautensack was among the first German artists to practice etching instead of engraving. As the legend below the image relates, in this story from the Gospel of Matthew, Christ liberates the Canaanite woman's daughter from a demonic possession; at the lower right, the woman prays to Christ to save her daughter's life.

The story is, however, clearly secondary to the landscape in Lautensack's etching; he has effected a maneuvering of the background into the foreground in the manner of many artists of this period when executing traditional religious narrative scenes. From the carefully observed fir trees surrounding the figure group to the picturesque and quite fantastic valley spread out behind them, Lautensack creates a visual feast of mountains, rivers, vegetation, and architecture, all crisscrossed with roads that permit the eye to travel deep into the background.

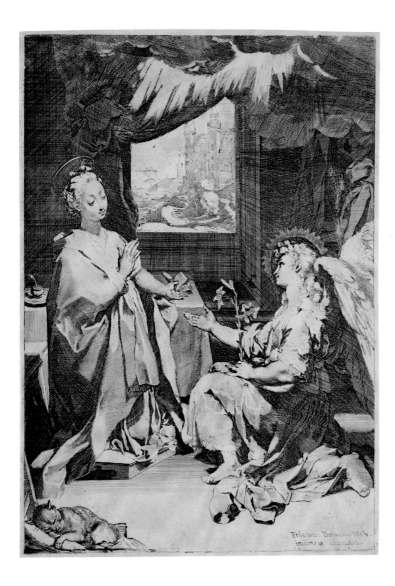

FEDERICO BAROCCI
Italian, ca. 1526–1612
The Annunciation, ca. 1585

Etching with engraving and dry-point. 17½ × 12¼ in. (44 × 31 cm)
Membership Purchase Fund. 62.413

This extremely sensitive rendering of one of the pivotal moments in the Christian narrative is one of only four plates that Barocci worked, all of which reproduce his own paintings. Despite his small production, however, Barocci was able to master the process of etching, as the technical range from vigorously hatched shadows to subtly stippled modeling of faces and hands attests. This print is generally recognized as the finest etched reproduction of a painting from the sixteenth century.

Barocci's representation of the Annunciation, after his altarpiece for the Basilica of the Holy Virgin of Loreto, makes the traditional analogy of Mary as the vessel of God with the room itself, whose open window permits the Holy Spirit to enter and conceive the Christ child. Despite this nod to tradition, the actual lighting in the scene does not come from this window but from the burst of heavenly brilliance above the figures' heads, a vibrant combination of etched and engraved lines that aptly renders the splendor of Barocci's altarpiece in graphic form. Barocci has chosen to set the scene in his native Urbino; the fifteenth-century ducal palace, home to his patron Francesco Maria della Rovere, is visible through the window.

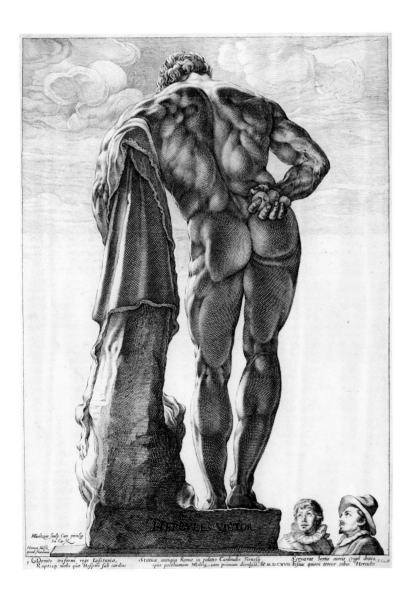

HENDRIK GOLTZIUS
Dutch, 1558–1617
The Farnese Hercules, ca. 1592

Engraving. 16¼ × 11⅝ in.
(41 × 30 cm)
Gift of Paul Ehrenfest, Class of 1932,
and Elizabeth K. Ehrenfest. 77.28.7

Hendrik Goltzius, who spent most of his career in Haarlem, a city just west of Amsterdam, was by far the most influential Dutch Mannerist printmaker. He responded, by turns, to the exaggerated High Mannerism of Bartholomeus Spranger in Antwerp, the classical sculpture he saw in Rome, and the work of the great Renaissance masters of engraving, Albrecht Dürer and Lucas van Leyden; even the latter "imitations," however, are infused with Goltzius's technical and emotional intensity, expressed in highly concentrated swirls of engraved lines that communicate an equally energetic inner life.

During his stay in Italy in 1590–91, Goltzius was particularly impressed by the ancient Roman sculpture he saw there, of which he made many copies. The most dramatic of these was his engraving of the Farnese Hercules, executed shortly after his return to Haarlem, but not published until after his death. The virtuoso handling of the burin here is as complex and engrossing, as masterful, as the all-powerful muscles they describe.

The Farnese Hercules was discovered in the Baths of Caracalla in Rome in 1540 and was soon installed within the arcade around the courtyard of the Farnese Palace, where Goltzius would have seen it.

JACQUES BELLANGE
French, active ca. 1595–1616
Military Scene, ca. 1610–15

Etching. 11 × 8⅝ in. (28 × 22 cm)
Herbert F. Johnson, Class of 1922,
Acquisition Fund. 85.35.2

A native of Lorraine, this enigmatic
artist served as painter to the ducal
court at Nancy, whose elegance and
opulence are reflected in his works.
Bellange's compositions, with their
attenuated forms and flame-like
draperies, are a late interpretation
of the courtly Mannerist style that
swept the European continent dur-
ing the middle of the sixteenth
century. He often playfully inverts
his unique combination of sensi-
tive stippling and rhythmic line in
order to present draperies that
seem like flesh, as in the soldier's
doublet at right.

Many scholars have noted the
theatrical qualities of Bellange's
etchings – the plumed hats on the
soldier on the right and the woman
on the left, for example, as well as
the way in which the composition
divides itself into separate planes
reminiscent of stage flats. When
we consider that as court painter
Bellange was frequently called
upon to create costumes and scenery
for festivals and plays, these facets
of his graphic technique are better
understood.

As its title suggests, the sub-
ject matter of this etching has
proved elusive. However, the vogue
around 1600 for depicting groups
of figures in antique military
costumes at least provides a sure
context for the image.

LEONAERT BRAMER
Dutch, 1596–1674
Judith in the Tent of Holofernes

Pen and ink and wash with white heightening. 14¾ × 12⅛ in. (38 × 31 cm)
Acquired through the generosity of Gale, Ira, and Jennifer Drukier. 96.5

Leonaert Bramer is one of the most intriguing personalities in seventeenth-century Dutch art. A predecessor of Vermeer in Delft – and perhaps his teacher – he lived there and in Rome, where he was involved in several street brawls. He had a wide-ranging interest in European literature and illustrated Virgil's *Aeneid, Till Uilenspiegel,* and various Spanish novels, always in a style as much Italian and French in origin as Dutch.

This large and beautifully preserved drawing exemplifies the Baroque not only in its subject but also in its penmanship. We see here the Old Testament heroine, Judith, with her revealing décolletage, confronting the Assyrian general Holofernes, just before cutting off his head to save her people; this is part of a long tradition in Dutch art showing the woman as victor, triumphant over cruel usurers or lecherous teachers or wayward husbands.

At the same time, the drawing embodies the Baroque in its fresh and open pen- and brushwork, the spontaneity of its touch, the melodrama of its light and shadow, its large size, and the very idea that such a work as this could be considered "finished" and ready to sell.

DAVID BAILLY
Dutch, 1584–1657
Vanitas Still Life with Portrait,
ca. 1650

Oil on canvas. 37¼ × 45¾ in.
(95 × 116 cm)
Gift of Mr. and Mrs. Louis V. Keeler,
Class of 1911, by exchange. 86.6

This painting is an unusually
large and splendid example of the
vanitas still life. *Vanitas,* in Latin,
refers to the "vanity" of all worldly
things, such as riches, beauty, pas-
times, learning, and the arts. In this
painting by David Bailly, a Dutch
artist who worked in Leiden, where
Rembrandt was born, the skull in
the center reminds us of the vanity
of music (the lute and flute), the
visual arts (the palette and brushes
and the small sculpture), the plea-
sures of the flesh (dice, cards, pipe,
and tobacco), learning (books),
and natural beauty (flowers). The
hourglass, sundial, and guttering

candle all emphasize the passing of
time; the rising bubbles epitomize
the fragility of life; the barely legi-
ble letter beneath the skull refers
to death and war; and the black
servant, elegantly dressed and with
a gold chain (symbolizing loyalty)
around his neck, is one more accou-
terment of a wealth that must
inevitably pass away. The servant
holds a miniature portrait of the
(unknown) patron who commis-
sioned the painting, appropriately
small, to indicate his lack of preten-
sion and rejection of ostentation.

REMBRANDT HARMENSZ.
VAN RIJN
Dutch, 1606–1669
*Woman Sitting Half-Dressed
beside a Stove*, 1658

Etching. 9 × 7¼ (22.9 × 18.4 cm)
Museum Associates Purchase. 65.68

This etching from 1658 is perhaps Rembrandt's finest print of a nude, and certainly embodies an unusual and touching aspect of his treatment of this subject, a kind of shy eroticism, a chaste nakedness, overt and tentative at the same time. His other etchings in the 1650s of women in various stages of undress show them sleeping, turned away from us, or in profile, very different from the explicit and dramatic versions of this subject from more than a quarter century earlier, in the early 1630s. This radiant image is an intimate and domestic successor, as it were, to the monumental painting of Bathsheba from 1654, in the Louvre; both figures are in profile, looking down without expression, thereby gaining greatly in gravity and spiritual depth.

This impression is from the final state of the print; there are two primary differences from the earlier states: the removal of the woman's cap, and the addition of a key on the chimney of the stove. The first change allows the niche (or closed window) behind the woman's head to reverberate around her; the second adds a tactile, down-to-earth detail to the scene that makes it more domestic and immediate. This is a beautiful, lifetime impression of one of Rembrandt's most sensitive prints, with a remarkably subtle play of light and shadow throughout the room.

ADAM PYNACKER
Dutch, 1622–1673
Landscape with Trees, ca. 1660

Pen and golden ink and grey ink, grey wash, over pencil and, perhaps, black chalk. 15⅞ × 11½ in. (40 × 29 cm)
Gift of the Wunsch Foundation. 95.3

This ambitious, carefully composed drawing is an unusually finished example of Adam Pynacker's vision of landscape as a highly decorative, perfect ornament. He seems to have spent three years in Italy, from 1645 to 1648, before returning to live in Delft and, finally, Amsterdam, and that southern sojourn was crucial to his stylistic development.

He was a member of a generation of Dutch artists, many born around 1620, who visited Italy and were deeply influenced by its unique mixture of ancient monuments and contemporary peasants, mountainous countryside, and warm golden light. Pynacker uses one of his favorite compositional devices here; the lively, twisting trees in the foreground form a rectangle that echoes the shape of the sheet as a whole.

Interestingly, the artist repeated this composition in another drawing, of the same size, in the Courtauld Institute, in London. In the London work, which is signed, the freshness and variety of light and shadow are gone; various details, like the woman on the right, are deleted; and the whole scene has less of the spontaneity and almost rococo decorativeness that characterize Pynacker at his best.

FRANS POST
Dutch, 1612–1680
Brazilian Landscape, 1665

Oil on canvas. 18¾ × 23⅜ in.
(48 × 59 cm)
Gift of Mr. and Mrs. Louis V. Keeler,
Class of 1911. 59.93

In the seventeenth century, the newly independent nation of the Netherlands created a far-flung network of trading posts and settlements, from Nieuw Amsterdam (now New York) to Brazil, western Africa, India, and Indonesia. One of the most carefully documented of these colonies was the short-lived expedition to Brazil from 1637 to 1644, when the Dutch, under the leadership of Prince Maurits of Nassau, attempted to establish a thriving sugar industry, as well as a capital city. Prince Johan Maurits brought with him a group of artists, map makers, and scientists to record this new world.

Frans Post, the artist who executed this painting, went to Brazil and saw these exotic landscapes firsthand; this work, like most of his paintings, was executed after he returned to his native Haarlem. His simple, almost naive organization of the recession into the background, ending in distant blue, and the generalized stick figures are typical of him. He often added armadillos, tapirs, anteaters, and other such exotic animals (see the lower left corner of this painting), as a kind of "signature;" he even would include an armadillo, for example, in a traditional subject from the Old Testament. This particular view of the various buildings and slaves of a sugar plantation was probably not meant to document a specific place but rather to suggest a typical establishment of this kind.

OTTO MARSEUS VAN SCHRIECK
Dutch, ca.1619–1678
Still Life with Thistle, ca. 1670

Oil on canvas. 49¼ × 39⅞ in.
(125 × 101 cm)
Gift of Mr. and Mrs. H. A. Metzger,
Class of 1921. 60.195

This monumental portrait of a
thistle illustrates the fascination
with the natural world – and with
its careful documentation – that
characterizes so much of Dutch
science and culture in the seven-
teenth century. It was then that
Anthonie van Leeuwenhoek, the
developer of the microscope, lived,
and the line between artist and
scientist was not as hard and fast
as it was to become later on. For
example, Johannes Goedaert was a
professional painter who illustrated
his own important book on moths.

Marseus van Schrieck worked
in Florence and Rome between
1648 and 1663, and he also visited
England and France. He was fasci-
nated by the world of grasshoppers
and lizards, butterflies and weeds,
and kept a small terrarium to
observe these little dramas firsthand.
This unusually elaborate – and
ambitious – composition is the kind
of work that impressed not only the
Grand Duke of Tuscany, for whom
he worked, but also the artist-
scientist Maria Sybilla Merian, who
created both text and images for
her monumental publication on
the insects of Surinam, as well as
other artists of the time.

ISAAC DE MOUCHERON
Dutch, 1667–1744
Villa d'Este, Tivoli, 1739

Gouache, watercolor, and pen
and ink. 9 × 13⅜ in. (23 × 34 cm)
The Gale, Ira, and Jennifer Drukier
Fund, with the Overton Endow-
ment Fund. 95.29

Isaac de Moucheron, a Dutch artist
descended from a noble family in
Normandy, was an architect (and
landscape architect), as well as a
successful painter and draftsman.
He traveled to Italy, and especially
Rome and Bologna, from about
1695 to 1697, and this experience
shaped his visual thinking for the
rest of his career. Like so many
northerners before and since, he
fell in love with the dream of Italy:
a place of timeless grace and beauty,
with ancient ruins and Renaissance
palaces bathed in warm Italian
sunlight.

 One of the highlights of de
Moucheron's sojourn was clearly
the Villa d'Este and other monu-
ments in Tivoli, near Rome. In 1739

he executed a series of three water-
colors – more than forty years
after his return to Amsterdam –
recreating the views in and around
Tivoli. Overtones of love and
romance are suggested by the clas-
sically dressed couples placed in
a boat or under a tree, or bringing
food and drink, as well as a
Berniniesque marble statue of Pluto
and Persephone on the left, while
the tall and twisting trees play
against the more geometrically reg-
ular forms of the obelisk (or pyra-
mid) on the right, the freestanding
arches on the left and background
right, and the Villa itself, set high
above the landscape on the left.

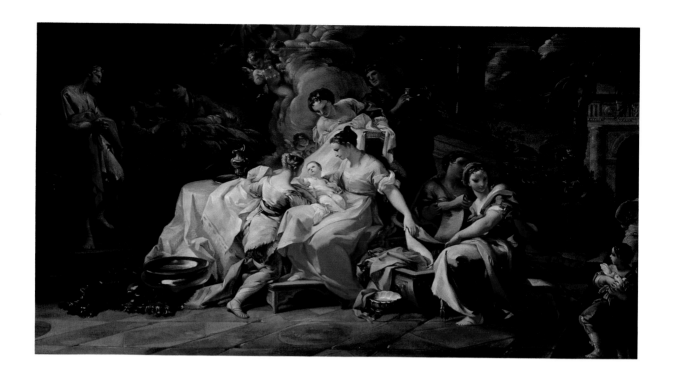

CORRADO GIAQUINTO
Italian, 1703–1765
The Birth of the Virgin, 1751–55

Oil on canvas. 21¼ × 38½ in.
(54 × 98 cm)
Herbert F. Johnson, Class of 1922,
Acquisition Fund. 85.37

Corrado Giaquinto was considered by his contemporaries as one of the major artists of the Roman Rococo, a style characterized by a graceful linear quality and pastel palette. Born in the small town of Molfetta, Giaquinto arrived in Rome by way of Naples in 1723. There he began to establish a reputation as a ceiling painter, decorating the vaults of Santa Cecilia in Trastevere. In the later 1730s, he was commissioned to paint the decorations for the palace of Turin, and by the 1740s, he was considered the most important fresco painter in Rome, having completed the decoration of Santa Croce in Gerusalemme, one of Rome's most important churches. His reputation was such that King Ferdinand IV of Spain asked him to be his court painter, a position he held from 1753 until shortly after Ferdinand's death in 1759, during which time he over-

saw the decorations of the Royal Palace at Madrid. Returning to Italy in 1762, Giaquinto settled in Naples until his death in 1766, one month after completing the decoration of the new sacristy of San Luigi di Palazzo.

The *Birth of the Virgin* is similar to a larger work of the same subject executed in 1751–52 for the Cathedral of Pisa. The Johnson Museum's painting owes its inspiration to the late seventeenth-century school of Naples and especially to the work of Luca Giordano. This work also bears affinities with Giaquinto's later *Marriage of the Virgin,* completed the year of his death. The Museum's painting, then, marks a midpoint in Giaquinto's career where, remembering the greats of the past like Giordano, he created compositions he would ultimately use for inspiration later in his life.

WILLIAM HOGARTH
British, 1697–1764
Portrait of Daniel Lock, F.S.A.,
1762

Oil on canvas. 36 × 28½ in.
(91 × 72 cm)
Bequest of David Goodstein,
Class of 1954. 86.30.4

Though known primarily as a satirist and propagandist, William Hogarth was also a superb portraitist due to his frank yet sympathetic approach to his subjects. Daniel Lock was the architect of the Foundling Hospital in London, an institution to which Hogarth directed a significant amount of his own resources and talents as one of the original founders and as the artist for the hospital. In addition to their work on the Foundling Hospital, Hogarth may have known Lock through the Free Society of Artists (F.S.A.), of which both men were members.

Daniel Lock was also the founder of Lock Hospital and is depicted here by Hogarth as holding the plans for that institution. The painting has an illustrious history, having been for many years in prominent English collections, including that of the Spencer-Churchill family and the family of Lord Northwick.

William Hogarth was largely responsible for ushering in a truly English style of painting. Previously, England had imported painters from the Continent, such as Holbein, Rubens, and Van Dyck. Throughout his career, Hogarth tried to break the English dependence on outside artists by offering his own work as an alternative; by doing so, he encouraged native artists to pursue careers in painting, thereby creating a "renaissance" in English art.

Louis-Marin Bonnet
French, 1736–1793
after François Boucher, French,
1703–1770
Head of Flora (Tête de Flore), 1769

Pastel-manner etching and engraving printed in color from seven plates. 15¾ × 12½ in. (40 × 32 cm)
Gift of Nathaniel Donson. 87.75

The son of a Parisian stocking manufacturer, Bonnet trained with the engravers Louis-Claude LeGrand and Jean-Charles François, the latter the inventor of the chalk-manner technique of printmaking. Erroneously referred to as engravings, chalk-, crayon- or pastel-manner prints are actually etchings made with a metal wheel called a roulette with a random pattern of variously sized points that was rolled over a plate coated with a protective wax ground. When the plate was etched in acid, the resulting pattern of dots provided a passable approximation of the original chalk drawing.

Bonnet's prints made in this way became immensely popular with collectors seeking images that imitated the subtle blend of colors epitomized by the drawings of Watteau, Boucher, and their contemporaries. During the late 1770s and 1780s, Bonnet's success as a color printmaker was unrivaled; he counted among his patrons the wealthiest Parisian collectors of the time, and at his death he was able to leave behind a sizable estate despite the changing tastes brought on by the Revolution.

This portrait, once thought to be a likeness of Madame de Pompadour but now known as an image of Boucher's seventeen-year-old daughter Marie-Emilie, is one of the greatest achievements in French eighteenth-century color printmaking.

CORNELIS VAN SPAENDONCK
Dutch, 1756–1840
Still Life of Flowers, 1793

Oil on canvas. 31¼ × 25 in.
(79 × 63 cm)
Bequest of David B. Goodstein,
Class of 1954. 86.30.8

Cornelis van Spaendonck was born
in the Dutch city of Tilburg, but
by the age of seventeen he had fol-
lowed his older brother Gerardus,
also a gifted still life artist, to Paris,
where they both enjoyed long and
successful careers. Cornelis, for
example, was director of the great
Sèvres porcelain works.

The three Dutch still-life paint-
ings discussed in this handbook
make an interesting comparison.
The intense realism and careful
documentation of the work by Otto
Marseus van Schrieck, with its
monumental thistle and minute
melodrama of lizard and grasshop-
per, is in some ways close to the
moral urgency – the vanity of all
human wealth and pretension –
that we feel in David Bailly's
painting, where the man who com-
missioned the painting has had
himself portrayed as merely a
miniature in the hands of a servant.
The van Spaendonck from the fol-
lowing century shares the technical
virtuosity and finish of the other
two earlier works but is very dif-
ferent from them in its lush cornu-
copia of flowers spilling over the
canvas. Although there may be
some symbolism, for example, in
the echo of the poppy on the left,
the symbol of sleep, in the sleeping
figures in relief on the right, the
dominant feeling here is enjoyment
of nature's generosity and the
artist's skill.

Francisco José de Goya y
Lucientes
Spanish, 1746–1828
*The Sleep of Reason Produces
Monsters (El Sueño de la Razon
Produce Monstruos)*, Plate 43 of *Los
Caprichos*, second edition, ca. 1803

Etching and aquatint. 7⅛ × 4¾ in.
(18.1 × 12.2 cm)
Membership Purchase Fund.
63.108

The series *Los Caprichos* is probably Goya's best known. Comprising eighty plates, Goya privately published the series, which was first advertised for sale in the Spanish newspaper *Diario de Madrid* in 1799 as being a criticism of "human errors and vices," although the subjects are often obscure and interpretation purposely difficult. Lampooning both political and religious figures, Goya soon found it diplomatic to present the original plates to the king for his *Calcografia,* in exchange for a pension for his son.

The Sleep of Reason is a self-portrait of the artist, surrounded by demonic-looking animals. It was intended as the frontispiece for the series, but Goya soon thought better of this, probably because the subject related too closely to two plates in Rousseau's 1793 Paris edition of *Philosophie* at a time when the very name of Rousseau was anathema to religious and political leaders in Spain. Instead, Goya created another, more traditional, self-portrait as the frontispiece and buried *The Sleep of Reason* well within the series, as plate 43.

In *Los Caprichos* Goya begins to push the boundaries of the intaglio process to achieve a sense of ambiguous space coupled with a modernist sensibility. This series grew out of Goya's developing sense of isolation, the result of a protracted illness he suffered in 1792–93, leaving him totally deaf. This, along with his difficult position as court painter to King Carlos IV at a time when he was becoming increasingly dedicated to the cause of the Spanish peasants, left him feeling compromised. Relying on a variety of influences, *Los Caprichos* served as a coded expression of the artist's growing involvement in Madrid's political milieu.

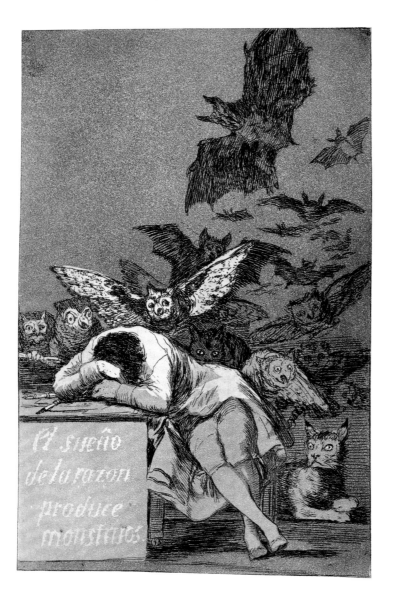

JOHN CONSTABLE
British, 1776–1837
Netley Abbey, ca. 1833

Oil on canvas. 12 × 15½ in.
(31 × 39 cm)
Bequest of David B. Goodstein,
Class of 1954. 86.30.3

The valley of the Stour, in Suffolk, was Constable's birthplace and frequently appears as a leitmotif in his work. His preferred compositions make use of the volatility of natural forces such as cloud formations and trees bent by the wind; painting *en plein air* prefigured the Barbizon painters. His highly suggestive response to nature, often compared to Wordsworth's poetry, would influence Géricault, Delacroix, and, later on, the French Impressionists. We can also see the extent to which Constable was himself indebted to Rubens, Ruisdael, and Gainsborough. Constable's expressive style in

Netley Abbey is punctuated with flashes of white brushstrokes which heighten the drama of this small, dynamic work. The darkened trees establish a frame for the stone-grey Gothic arches of the Abbey; the hovering birds in a turbulent sky of brown, apricot, and dull blue serve to intensify the moody, romantic setting. We hardly notice the two unobtrusive figures to the left, suggested by red and blue spots of pigment. Their individuality is absorbed by the imposing details of the Abbey and landscape, which Constable considered "experiments in natural philosophy."

DAVID OCTAVIUS HILL and
ROBERT ADAMSON
Scottish, 1802–1870 and
1821–1848
*Scottish Fishwives, Washaday
Group,* 1843–48

Calotype. 5½ × 7⅝ in.
(14.0 × 19.4 cm)
Membership Purchase Fund. 74.15

David Octavius Hill and Robert
Adamson's photographic collabora-
tion – begun just four years after
the announcement of the discovery
of the daguerreotype process –
involved making photographs as
references from which painters
could work. Hill, using his training
as a painter and lithographer, set
up the shots and arranged back-
grounds and costumes, while
Adamson manipulated the chemical
processes and the cameras. Using
the calotype process in which a
sheet of smooth paper has been
sensitized and then exposed for a
period of thirty seconds to five
minutes, Hill and Adamson pro-
duced more than fifteen hundred
photographs of people, landscapes,
and buildings in the four and
a half years they worked together.
Although those who preferred
the sharply defined daguerreotype
image were not satisfied by the

calotype, Hill and Adamson's
fuzzy, painterly pictures illustrate
perfectly this most beautiful of
nineteenth-century photoprocesses.

Some of the best known and
most haunting works of Hill and
Adamson are the numerous repre-
sentations of the fisherfolk of
Newhaven, a village on the Firth of
Forth only two miles from the Rock
House, their Edinburgh home and
studio. The Newhaven community,
founded by Huguenot immigrants,
depended to a large degree on the
fishing trade for its livelihood. Hill
and Adamson's project was con-
ceived as a way to raise money to
improve the working conditions of
these "fisherfolk." The women's
distinctively striped skirts identified
the "fisher lassies" as they sold
cod, herring, and oysters from their
baskets and creels on the streets
of Edinburgh.

WILLIAM HENRY FOX TALBOT
English, 1800–1877
*Lincoln's Inn, New Hall Library,
London*, ca. 1846

Salted paper print from a
calotype negative. 7⅞ × 9¾ in.
(20.0 × 24.8 cm)
Gift of Arthur and Marilyn Penn,
Class of 1956, Christopher Elliman,
David Elliman, and Andrea Branch,
by exchange. 91.26

William Henry Fox Talbot is generally recognized as the English inventor of photography. Working at the same time as Louis-Jacques-Mande Daguerre – who announced his own findings in Paris in 1839 – Talbot originated the negative-positive process that enables multiple prints to be made from a single negative; this continues to be the basis for photography today. As early as 1834, Talbot experimented with fixing an image by chemical means, and he made photograms by treating paper with silver salts and exposing it to light. In 1835, he produced a negative image of a window in his home, Lacock Abbey, but did not make a positive print from the negative until 1839. Talbot shortened long exposure times dramatically by using the improved calotype process, which he patented in 1841.

In 1844, Talbot published *The Pencil of Nature*, the first book to be illustrated with photographs, which were intended as examples of the various applications of the new medium. He later developed a photoengraving process, and in 1858 he began to make satisfactory halftone reproductions.

Talbot came from a wealthy family, studied at Trinity College, Cambridge, and was especially interested in linguistics and the sciences, particularly mathematics, chemistry, crystallography, botany, and astronomy. In 1832 Talbot was elected a Fellow of the Royal Society, England's most prestigious scientific body.

PHILIBERT PERRAUD
French, born 1815, active 1850s
Portrait of a Nun, ca. 1850s

Daguerreotype. Frame: 4⅝ × 4½ in.
(11.8 × 11.4 cm)
Gift of Arthur and Marilyn Penn,
Class of 1956, Christopher Elliman,
David Elliman, and Andrea Branch,
by exchange. 95.15.2

Louis-Jacques-Mande Daguerre announced to the world in 1839 that it was possible to capture and fix an image on a silver-coated, polished, copper plate. After sensitizing the plate and exposing it to the subject for three to thirty minutes, the image was fixed by washing in pure distilled water. Daguerreotypes were made in several specific sizes and were immediately encased under glass, usually in a folding frame made of wood with a thin leather coating or an early form of thermoplastic. Just ten years later, more than 100,000 daguerreotypes were made in Paris alone, most of them portraits.

One of the earliest practitioners of this new art was Philibert Perraud, born in 1815 in Macon, France. Very little is known about the artist's early years, except that he was a cook before he learned the daguerreotype process. Perraud ran a successful and well-known studio in Paris before going to Italy around 1845. In a diary entry in 1847, Perraud mentions having arrived in Athens. Shortly after arriving, he met Philippos Margaritis (1810–1892), a Turkish-born artist who was teaching drawing at the art school in Athens. Perraud taught Margaritis the art of daguerreotypy and the two collaborated on a collection of daguerreotype images of the antiquities in Athens. Perraud was back in Lyons by the early 1850s. This portrait of a nun from the 1850s could have been made anywhere during Perraud's travels, but the address inscribed on the reverse might have been in Lyons.

EDOUARD-DENIS BALDUS
French, 1815–1882
St. Ouen at Rouen, ca. 1855

Albumen print or albumenized
salted paper print. 17⁹⁄₁₆ × 12¾ in.
(45 × 32 cm)
Gift of Arthur and Marilyn Penn,
Class of 1956, Christopher Elliman,
David Elliman, and Andrea Branch,
by exchange. 91.29.2

Though he died penniless, Edouard-Denis Baldus epitomized the successful photographer. Trained as a painter, he combined the roles of artist, chemist, and entrepreneur. Born in Westphalia, Baldus began his career in the military. He turned early to an artistic career and arrived in Paris to study painting in 1838, shortly before Daguerre's experiments profoundly changed the art world. He began an intense study of photographic chemistry, and when Fox Talbot's paper processes were developed, Baldus found his niche. Best known as a recorder of architecture, Baldus emphasized strong symmetrical images taken frontally, playing on the rich tonalities inherent in Gothic buildings, like this image of the Cathedral of St. Ouen in Rouen. Baldus is, perhaps, best remembered for his commission to record scenes along the path of the railroad being built from Boulogne to Paris and on the Mediterranean coast. These photographs were bound into a richly decorated album and presented to Queen Victoria and Prince Albert on the occasion of their visit to Paris in August 1855. Ernest Lacan, editor-in-chief of *La Lumière,* the weekly journal of the first photographic society, said of Baldus's work: "It had a rare perfection… tonal beauty…incredible fineness of detail. M. Baldus knows how to choose his point of view."

EDOUARD MANET
French, 1832–1883
The Absinth Drinker (Le Buveur d'absinthe), 1860

Etching and aquatint. 11⅜ × 6¼ in.
(28.9 × 15.9 cm)
Membership Purchase Fund. 61.99

Born into a relatively well-off middle class family, Manet was fortunate to be able to choose a career in a field he enjoyed. Initially he joined the studio of Thomas Couture, but he soon rebelled against this academic training and began to produce images of everyday life that bridged the romanticism of Delacroix and the realism of Courbet.

Though printmaking never seemed to be an important part of Manet's *oeuvre,* he had a clear sense of its powerful immediacy. Inspired by Velasquez and Goya, and caught up in the etching revival initiated by Cadart and his Société des Aquafortistes, he created figures that mysteriously emerge from the shadows, modeled with an intricate cross-hatching and shading. Without the distraction of complex backgrounds his figures appear monumental.

The subject of this print was a tramp named Collardet, who modeled for the painting of the same subject, now in Copenhagen. The dramatic effect of this "street philosopher" – as Manet saw him – is simultaneously powerful and sad. The atmosphere is murky and dense, made more so by the cloud of aquatint enveloping the figure. The startling starkness of Collardet's white face emerges, vulnerable and quiet.

Manet first worked on *The Absinth Drinker* in 1861–62, using only a minimal etching line. At this time a few prints were pulled and printed on hollande paper. Around 1868 he returned to the plate and added the aquatint. This state was probably printed by Salmon in a very small edition. Salmon's grandson Porcaboeuf began to pull proper editions around 1910.

Jean-François Millet
French, 1814–1875
The Large Shepherdess (La Grande Bergère), 1862

Etching. 12½ × 9¼ in.
(32 × 24 cm)
Bequest of William P. Chapman, Jr.,
Class of 1895. 57.325

Millet was born and raised in a small hamlet near Cherbourg on the Normandy coast. His ancestry was strongly rooted in French peasant stock, and it is not surprising that his most successful works portray the everyday life of these people. As a young man he took art lessons in Cherbourg, quickly moving on to Paris where he studied and copied the great masters, particularly Michelangelo, Poussin, and Correggio, while taking lessons in an academic style of painting with the very popular Paul Delaroche. Millet learned to despise this style, and, though he could skillfully imitate it, he rejected it as facile and without emotion.

In 1849, at the outbreak of the cholera epidemic, Millet moved his family to Barbizon for what was supposed to be a two-month respite but turned into a twenty-six-year sojourn. At home in his new rustic surroundings, he again turned to the people of the fields for inspiration, recorded over and over again in oil, pastel, and etching.

La Grande Bergère is a superb example of Millet's talent with the etching needle. Rendered with an economy of broad, bold lines and with no unnecessary detail, he concentrates on the almost regal form of the knitting shepherdess, captured with densely cross-hatched strokes.

J. F. Millet

JULIA MARGARET CAMERON
British, 1815–1879
Our Twin Stars, ca. 1867, printed 1874

Albumen print. Diameter: 10¾ in. (27 cm)
Gift of Marilyn and Arthur Penn, Class of 1956, Christopher Elliman, David Elliman, and Andrea Branch, by exchange. 93.3

In 1863, Cameron's only daughter, Julia, and her son-in-law Charles Norman presented her with her first camera. Later she recalled her daughter saying, "It may amuse you, Mother, to try to photograph during your solitude at Freshwater Bay," the family home on the Isle of Wight. Mostly self-taught, Cameron quickly became conversant with the demanding wet-collodion process, doing so with verve and imagination. Although her career lasted only fifteen years, she produced an extensive body of work containing three distinct groups: portraits of famous Victorian figures, intimate family portraits, and allegorical images, reflecting the popularity of Pre-Raphaelite painting.

The hobby quickly turned into a passion. Cameron was a consummate artist, involving herself in all aspects of production from arranging the sitters, preparing the plates, making the exposure, and developing the prints, though she often called on the assistance of her domestic help, which is perhaps reflected in the erratic quality of the final images.

Our Twin Stars is a particularly poignant image depicting the artist's grandchildren, Margaret and Charlotte Norman. The early death of her daughter Julia, who died in childbirth in 1874, led to a series of highly charged, emotional family portraits. It was in 1874 that this print was made and given to her son-in-law, with the inscription, "Our Twin Stars, My Gift to the Beloved Father."

CHARLES-FRANÇOIS DAUBIGNY
French, 1817–1878
Fields in the Month of June (Les Champs au mois de juin), 1874

Oil on canvas. 53 × 88 in.
(135 × 224 cm)
Gift of Mr. and Mrs. Louis V. Keeler, Class of 1911. 59.87

When *Fields in the Month of June* was shown in the Salon of 1874, Daubigny's rapid juxtaposition of brushstrokes, absence of detail, spots of brilliant color, and immediacy represented a dramatic move away from the classical polish of official Salon painting. Courbet's skilled use of the palette knife and Jules Breton's treatment of rural subject matter contributed to Daubigny's style as much as the decision to work in natural sunlight for a more direct translation of his settings. His innovative treatment of landscape would, in retrospect, be viewed by historians as a transitional moment between the style of the Salon (on whose jury he served) and the radical experiments of Pissarro, Cézanne, Renoir, and Monet; Monet's painting of poppy fields was shown only a year earlier and its rejection by the same Salon on whose jury Daubigny served had provoked the latter's resignation. In 1872, Daubigny traveled to the Netherlands, where he began his most important painting to date, *The Mills of Dordrecht*. From his studio-barge, *le botin*, anchored at Auvers-sur-Oise, Daubigny continued to rely on Corot's organizing tonality (which had been his greatest influence as early as 1852), introducing in the Johnson Museum's monumental canvas vibrant accents and soaring expanses of sky that dwarfed the peasants laboring in the horizontal sweep of open field. One of his largest canvases, *Fields in the Month of June* overwhelmed unaccustomed eyes by its sheer scale and perspective. Not long before his death, van Gogh painted several versions of Daubigny's garden at Auvers; he had admired, fifteen years earlier, the Barbizon artist's "beautiful things" hanging in Goupil's London gallery.

JEAN-LÉON GÉRÔME
French, 1824–1904
Almeh Performing the Sword Dance, 1875

Oil on canvas. 23½ × 32 in.
(60 × 81 cm)
Membership Purchase Fund. 73.9

A brilliant draftsman and meticulous painter, Gérôme was a leading exponent of the academic tradition; he was widely praised for his highly finished, carefully modeled paintings and was the teacher of many artists, including the American realist Thomas Eakins. Gérôme's scenes of life in the Near East were well received by an audience that had a taste for exotic subject matter. Between 1854 and 1872, Gérôme traveled extensively throughout the Near East, North Africa, Spain, and Portugal. Gérôme is sensitive not only to his human subjects, but also to their often exotic context, accurately depicting the architecture and dec-

oration of the setting. Among his many canvases depicting women in semi-erotic situations, such as the slave market or the bath, are several paintings of the *almeh,* or belly dancer. According to a contemporary, Gérôme watched a dancer at a cafe and invited her to his studio where he sketched and photographed her and then purchased her dancing costume to take back to France. This painting was done in his studio by combining sketches, props, costumes, and memory.

EDGAR DEGAS
French, 1834–1917
Au Louvre: Musée des Antiques,
ca. 1876

Aquatint, etching and electric
crayon. 10½ × 9⅛ in. (27 × 23 cm)
Bequest of William P. Chapman, Jr.,
Class of 1895. 57.125

Influenced by photography and
Japanese prints, Degas's form of
Impressionism involved experi-
ments with a wide variety of tech-
niques. A consummate technician,
he was intrigued by process, often
rejecting simple solutions for more
elaborate combinations.

In 1879 Degas proposed to
Cassatt, Pissarro, Raffaëlli, and
Bracquemond the idea of producing
a print publication. The journal, to
be called *Le Jour et la nuit (Day
and Night),* reflected the artists'
interest in black and white imagery
and the contradictory properties
of light and shadow.

The journal was never pub-
lished, but Cassatt, Pissarro and
Degas made small editions of their
prints and showed them in the fifth
Impressionist exhibition in 1880.
Degas's contribution, *Au Louvre:
Musée des Antiques,* shows the
figure of Mary Cassatt standing in
front of an Etruscan sarcophagus, a
seated figure with a guidebook
(probably her sister Lucia) looking
on. The original design for the print
was a pastel in which the figures
are placed in reverse and are stand-
ing in the Grande Galerie of paint-
ings rather than among antiquities.

In this print, Degas has deftly
employed the etching and drypoint
lines to clearly delineate detail
while the aquatint, twice printed,
adds tonality and shading. Degas
revised the plate many times (nine
states exist, of which this is the
sixth), and the final composition is
sophisticated and polished, with no
apparent tentativeness in execution.

ADOLPHE WILLIAM BOUGUEREAU
French, 1825–1905
The Goose Girl, 1891

Oil on canvas. 60 × 29 in.
(152 × 74 cm)
Gift of Dr. Henry P. DeForest.
65.365

Bouguereau was trained and
worked within the French academic
tradition, whose standards of excel-
lence were based on neo-classical
interpretations of antiquity and
whose models of style and interpre-
tation were the work of Jacques
Louis David and J. A. D. Ingres. He
was almost an exact contemporary
of Jean-Léon Gérôme, whose *Almeh
Performing the Sword Dance* is
also in the Johnson Museum. Like
Gérôme, Bouguereau was an excel-
lent draftsman and meticulous
painter, famous for the luminous
quality he gave to the depiction of
flesh. He enjoyed great success
throughout his career and unlike
many other academic painters, did
not slide into obscurity during the
twentieth century. Bouguereau
specialized in paintings of beautiful
women, innocent peasant girls,
serene Madonnas, and pristine
nudes. He was very popular with
American collectors, who appreci-
ated his detailed style and idealized
subjects. *The Goose Girl* was pur-
chased by one such collector, Mrs.
George Frederick Cornell, wife of a
cousin of Ezra Cornell.

HENRI DE TOULOUSE-LAUTREC
French, 1864–1901
Le Divan Japonais, 1892

Color lithograph. 30¾ × 24 in.
(78 × 61 cm)
Membership Purchase Fund. 67.25

Commissioned by Edouard
Fournier, owner of the short-lived
Montmartre night club *Divan
Japonais,* this enigmatic poster typ-
ifies many of the stylistic changes
that occurred in French art in
the 1890s. Using bright colors and
a jarring Japanese perspective,
Toulouse-Lautrec presents a scene
of both great vibrancy and subtle
intrigue.

In the foreground, looming
large, sits the famous dancer Jane
Avril accompanied by the critic
Eduoard Dujardin, founder of the
Revue Wagnerienne and a theo-
retician of symbolist art. The two
sit companionably side by side with
slight, knowing smiles on their lips
as they observe the performance of
another of Montmartre's legends,
the chanteuse Yvette Guilbert who
is distinguished by her trademark
full-length black gloves. In por-
traying her, Toulouse-Lautrec has
cut off her head with the edge of
the paper, a brilliant compositional
decision.

Toulouse-Lautrec was a master
of such succinct characterizations
and yet for all his lampooning, he
was sought after by many of the
performers of his day; to be depicted
by him was a great honor. Both
Guilbert and Avril were frequent
subjects, as were Aristide Bruant
and May Belfort.

PIERRE BONNARD
French, 1867–1947
La revue blanche, 1894

Color lithograph. 31½ × 24½ in.
(80 × 62 cm)
Gift of the Museum Associates.
64.986

Bonnard studied law for three years before beginning his art studies in 1888 at the Ecole des Beaux-Arts and the Académie Julien, where he met Edouard Vuillard, Maurice Denis, and Ker-Xavier Roussel. By 1890 he was sharing a studio with Vuillard and Denis, which for nearly a decade served as a meeting place for the Nabis. In reaction against Impressionism, the Nabis were more interested in the decorative and emotive use of color and line. They were greatly influenced by Japanese woodblock prints and emulated the pure, flat colors and bold, simple designs found in the work of the ukiyo-e masters.

In 1889 Bonnard began his career in graphic design when he made his first poster for a champagne dealer. Toulouse-Lautrec is said to have so greatly admired this work that he decided to try his own hand at poster design. In the 1890s Bonnard's own graphic output was extensive, including posters, book designs, lithographs, and etchings.

La revue blanche was commissioned by the Natanson brothers in 1894 to advertise their influential monthly review, popular during the 1890s. Throughout its short existence the magazine published works by Toulouse-Lautrec, Bonnard, Vuillard, Roussel, and other of the Nabis. Bonnard's poster is an example of the subtle combination of image with typography, melding the prevalent Japanese influence with a subdued palette and bold imagery, an apt icon of *fin-de-siècle* Paris.

PAUL SIGNAC
French, 1863–1935
The Buoy (La Bouée), 1894

Color lithograph. 15⅞ × 12⅞ in.
(40 × 33 cm)
Bequest of William P. Chapman,
Class of 1895. 57.419

When Seurat first exhibited his painting *Une Baignade* at the Groupe des Artistes Indépendants in 1884, a movement whose underlying principles Paul Signac was instrumental in formulating, Signac was indelibly marked by Seurat's radical new approach. Upon meeting and exchanging views, Signac's comma-like applications of clear, brilliant color – not quite Seurat's "points" – developed into a formal systematization of complementary colors. *The Buoy* demonstrates the application of this method in its juxtaposition of fragmented tones of orange and blue, repeated by reflections in the water. In 1886, after having seen Pissarro's first small divisionist canvases, Signac described how he also produced paintings "by optical mixture of uniquely pure pigments (all the colors of the prism and their tones); by the separation of various elements (local color, light, and their interactions); by the balancing of these elements and their proportions (according to the laws of contrast, gradation, and irradiation); by the selection of a brush stroke commensurate with the size of the canvas." *The Buoy* may have been made at Portrieux or Port-en-Bessin, the picturesque Normandy harbor Signac discovered at about this time, although he also worked on similar motifs in other French ports. He was thought of as the most accurate theorist of the avant-garde and claimed to be "always looking for a freer hand without giving up the advantages of division and contrast."

CLAUDE-EMILE SCHUFFENECKER
French, 1851–1934
Portrait of Julien Leclercq and his Wife, ca. 1898

Pastel on paper. 18½ × 24 in.
(47 × 61 cm)
Gift of Mrs. Carol Meyer in
memory of Seymour Meyer, Class
of 1936. 69.11

Until the 1966 retrospective of his work at two museums in France, Schuffenecker was best known for his close relationship with Gauguin, van Gogh, Pissarro, Bernard, and Redon, as well as for organizing the famous Volpini Exhibition of Synthetist Art as an alternative to the official Salon at the Paris World's Fair of 1889. His initial academic painting under Carolus-Duran and Baudry passed through an intermediary divisionist stage strongly influenced by Seurat and Monet. After 1892, his work consists of mystical, dream-like compositions reflecting his involvement with the Rose + Croix Salon and the Theosophical movement. This double portrait of the avant-garde art critic for the Mercure de France, Julien Leclercq, a close friend of the artist, and his wife, the Finnish pianist Fannie Flodin, is a fine example of Schuffenecker's delicate and idealizing images during the symbolist period between 1892 and 1900 in which he struggled "for art and the ideal." Typified by flowing lines and softened color fields, subtle and sensitive portraits such as this one reveal the artist as a skilled draftsman and pastellist. Leclercq was, like Schuffenecker, one of the first French collectors of van Gogh's paintings, and, with the help of Theo van Gogh's widow in 1901, mounted the first retrospective of Vincent's work at Bernheim-Jeune in Paris. Fannie Flodin Leclercq, being Scandinavian, had facilitated the 1898 traveling exhibition of Schuffenecker, van Gogh, Gauguin, Vuillard, Sérusier, Maufra, Guillaumin, and Rodin in Helsinki, Oslo, and Stockholm.

PABLO PICASSO
Spanish, 1881–1973
Acrobats (Les Saltimbanques),
1905

Drypoint. 11¼ × 12¾ in.
(29 × 32 cm)
Gift of Mr. and Mrs. Sidney Paul
Schectman, Class of 1935. 79.123

Picasso's images of harlequins, actors, and acrobats create a counterpoint to his sad and austere figures of the preceding Blue Period. In the "Circus" or "Rose" period, a melancholy grace replaces the jarring angularity of the earlier pictures, and though this period was short-lived, lasting only from 1905 to 1906, it was the transitional phase that ultimately led to Cubism.

With precedents in Watteau, Toulouse-Lautrec, Daumier, and Cézanne, Picasso readily identified with the harlequin figure from the *commedia dell'arte.*

Born in Malaga, Spain, Picasso moved to Paris in 1901. The early years were hard ones, and it was not until around 1905 that there seemed to be an improvement in his circumstances. The circus figures relate to the influence of his homeland, the elongated bodies of Catalan Gothic sculpture, as well as references to Italian Mannerism. In *Les Saltimbanques* the figures, delicately drawn with the drypoint needle, emphasize the fragile relationships among the performers. It is as if each person were acting out his or her own personal tableau in preparation for the final performance.

FREDERICK EVANS
British, 1853–1943
Chapel, Westminster Abbey,
ca. 1911

Platinum print from dry plate neg-
ative. 6¾ × 9¼ in. (17.2 × 23.5 cm)
Gift of Arthur and Marilyn Penn,
Class of 1956, Christopher Elliman,
David Elliman, and Andrea Branch,
by exchange. 91.29.3

Frederick Henry Evans spent
much of his life involved in the
intellectual activity of his native
London. First employed as a bank
clerk, Evans opened a bookstore
on Queen Street, Cheapside, in the
1880s which was frequented by
such artists and literati as Aubrey
Beardsley and George Bernard
Shaw. When he retired from the
book business, his friend, George
Smith, proprietor of the Sciopticon
Company, convinced him to try his
hand at photography; they made a
series of slides of minute objects,
such as shells and parts of insects.
Evans portrayed his friends and
delighted in the abstract designs he
saw through the microscope, but
his forte was architectural photog-
raphy, particularly tonally elegant,
but unmanipulated pictures of
chateaux and cathedrals.

Commissioned by *Country
Life* to create a photographic record
of Westminster Abbey, our image
portrays the tomb of Edmund of
Lancaster (also known as Edmund
Crouchback), who died at Bayonne
in 1296 during the siege of
Bordeaux. Taken from a low van-
tage point as though to portray the
monument from the point of view
of the pilgrims who would have
knelt before it, Evans captures the
delicate tonalities of the ancient
stone. The triple canopy of the
Crouchback tomb rises over the
finely sculpted effigy of the mail-
clad earl. Stone portraits of the
deceased decorate the canopy over-
head while an angel sits gently at
his shoulder. Ten niches on either
side of the tomb contain "weep-
ers," alternately male and female,
each striking a faintly Gothic pose.

GEORGES BRAQUE
French, 1882–1963
Bass, 1911–12

Etching and drypoint. 18 × 12¹⁵⁄₁₆ in.
(46 × 33 cm)
Harold L. Bache, Class of 1916,
Memorial Endowment Fund. 76.25

Braque's earliest experiments in printmaking were probably inspired by Picasso's *saltimbanques* from 1904–05, although his first etching was somewhat out of character, a standing nude, perhaps related to Picasso's *Les Demoiselles d'Avignon*. However, he turned increasingly to still-life subjects as he developed his Cubist style, culminating in such works as *Bass*.

One of the most obvious features of his Cubist prints is the inclusion of words such as "Vin" and "Bass" which serve to flatten the surface and define the various planes within the image. Most likely this use of words evolved from Braque's love of poster art, the work of Steinlen and Toulouse-Lautrec he had grown up with, with their imaginative use of text within the image. In most cases the words in Braque's prints refer to obvious brand names or specific things while seeming to have only a peripheral connection to the subject being portrayed.

Braque uses a rich drypoint line, scratched, hatched, and reworked, to add to the lush quality of his surfaces. As in his collages, he plays with textures, mimicking wood grain and paint strokes alike, in imitation of his canvases. Although he made several plates during this period, only two, *Fox* and *Job*, were printed before the War. The rest languished in his studio until the late 1940s, when William Lieberman found them and encouraged Braque to have them printed. In 1950 *Bass* was printed by Georges Visat in an edition of fifty for the publisher Galerie Maeght.

JEAN METZINGER
French, 1883–1956
Sailboats (Scène du port), ca. 1912

Oil on canvas. 21½ × 18 in.
(54 × 46 cm)
Membership Purchase Fund.
79.58.1

The greatest liberating pictorial style of the twentieth century was the Cubism developed by Picasso and Braque in the first years of the century. For some artists, it led to abstraction; for others, it was merely a style to be adapted to pre-existing approaches to picture making. For Metzinger, Cubism was a system by which multiple perspectives could be juxtaposed on a single plane; his almost monochromatic palette meant that the viewer is not distracted from the study of perspective. Metzinger was an early proponent of Cubism and wrote some of the first important theoretical essays on it. *On Cubism,* written in 1912 with his fellow Cubist Albert Gleizes, was the first theoretical work devoted to the new movement and played a major role in its recognition.

Metzinger himself often experimented with Cubist techniques, but his work differs from other Cubists in that his paintings retain a recognizable scene, here a landscape, a fairly rare subject for the early Cubists, with a system of mathematically calculated proportions, planes, and angles superimposed on it, like a grid. In the works of Picasso and Braque, small rectangular planes first go above, then below, then simply fade into other planes; Metzinger reduced his recognizable subjects into a series of rationally calculated and plotted planes, each laid over the other, as they move back in depth.

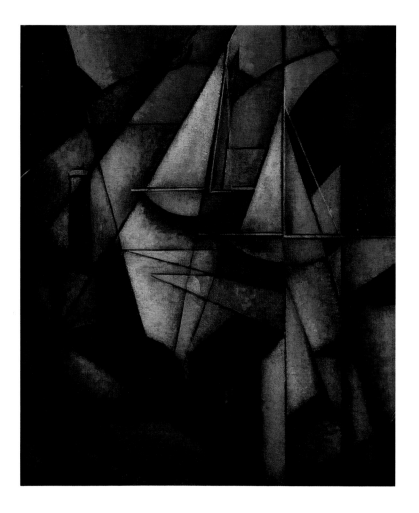

EMIL NOLDE
German, 1867–1956
South Sea Islander, 1914

Watercolor. 19¾ × 14¾ in.
(49 × 37 cm)
University Purchase Fund. 69.108

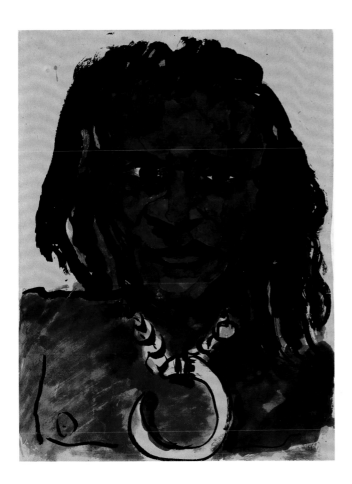

Nolde began his career as a wood-carver in a furniture factory, but after some successful forays into painting, he had, at the age of 38, his first one-man show in Dresden. This would prove a turning point for him; he was invited to join the *Die Brücke* group of German Expressionists, and, though he remained a peripheral member for the next year and a half, their energy and ideas were liberating for the older but less-experienced Nolde.

In 1913 the German Colonial Ministry invited Nolde to join the Kutz-Leber expedition to the South Seas. The intention of this group was to study health standards in New Guinea. Traveling across Russia, Siberia, and Manchuria en route, he filled numerous sketch-books as well as painting large-scale works, many of which were confiscated by the British at the outbreak of World War I and not returned until many years later.

South Sea Islander was proba-bly painted from life rather than executed later in his studio. The figure, facing us directly and with broad, accentuated features, is typi-cal of his portraits from this period. Like many of his contemporaries, Nolde was greatly influenced by African art as well as other "primi-tive" styles, and that influence can be seen here. He chose a paper native to New Guinea, which necessitated using a much drier brush, because the surface was extremely absorbent and caused the watercolor to bleed easily. His style of broad areas of wash rather than detailed brushstrokes was conducive to working with this paper, and the result is a richly rendered portrait.

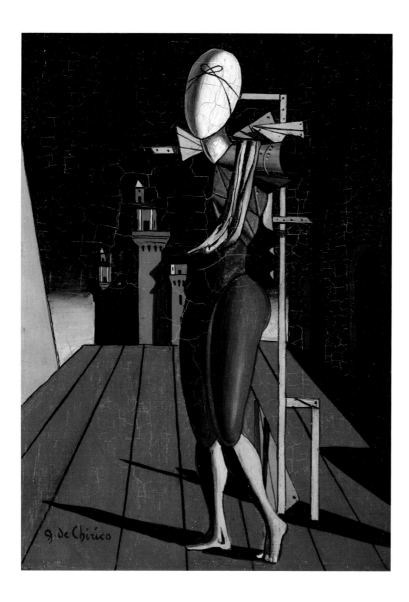

GIORGIO DE CHIRICO
Italian, 1888–1978
Andromache, 1916

Oil on panel. 8 × 5¾ in.
(20.3 × 14.6 cm)
Gift of Mr. and Mrs. Sidney Paul
Schectman, Class of 1935. 76.90

Immediately prior to World War I,
the Greco-Italian painter Giorgio
de Chirico created enigmatic paint-
ings in which he used a traditional
style to describe not the external
world, but haunting dreamscapes
infused with illogical images,
bizarre spatial constructions, and a
pervasive melancholic mood. He
was greatly inspired by the writings
of Friedrich Nietzsche, who believed
hidden realities were seen in such
strange juxtapositions as the long
shadows cast by the setting sun into
large open city squares and onto
public monuments. De Chirico called
his art "metaphysical," and with it
hoped to destabilize the meaning
of everyday objects by making them
symbols of fear, alienation, and
uncertainty. His paintings were
highly influential for the Surreal-
ists a decade later in their effort to
create art from the unconscious.
Andromache refers to the beautiful
and loyal wife of Hector, the Trojan
warrior slain by Achilles in the
Iliad. Here Andromache stands,
reduced to simple ovoids, alone in a
quiet, almost airless Italian *piazza*,
her mood reflected in the dark
shadows stretching across the
square. The buildings, equally sim-
plified, frame the image, lending it
an almost stage-like quality.

WASSILY KANDINSKY
Russian, 1866–1944
Small Worlds III (Kleine Welten III),
1922

Color lithograph. 11 × 9 in.
(28 × 23 cm)
Gift of Paul Ehrenfest, Class of
1932, and Elizabeth K. Ehrenfest.
79.26.6

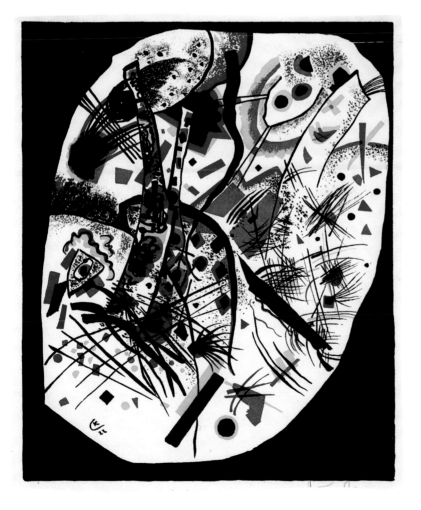

Kandinsky's first encounter with the graphic arts occurred at the printing firm of Kusverev in Moscow, where he became art director in 1895. Although his work for the firm was totally commercial, Kandinsky quickly assimilated printing techniques into his *oeuvre,* and his interest in the graphic arts continued into his years in Munich. He did numerous color woodcuts for the *Blaue Reiter* almanac and for his book of poems, *Klänge.*

In June 1922 Kandinsky moved to Weimar, where he accepted a professorship at Walter Gropius's Bauhaus school. At this stage his work was in a transitional phase, moving from more identifiable subjects to purely abstract images, characterized by a free-ranging spirituality coupled with a more confining adherence to the laws of mathematics. In all his work, as the subject retreated, color took on a more prominent role, communicating strong emotional power.

Kleine Welten was the result of years of exploring varied and complex issues in diverse media, including painting, drawing, printmaking, and writing. Produced as a series of twelve images in the graphic workshops of the Bauhaus and at an independent firm in Weimar under the artist's supervision, this group of lithographs, etchings, and woodcuts captures the disciplined passion of the artist. In the floating shapes and swirling lines, ranging from soothing to totally frenetic, a "cosmic" ballet is performed, suggestive of other realities, unknown worlds.

OTTO DIX
German, 1891–1969
*Woman Lying on a Leopard Skin
(Liegende auf Leopardenfell),* 1927

Oil on panel. 27½ × 39 in.
(70 × 99 cm)
Gift of Samuel A. Berger. 55.31

Severe economic hardship and a widespread sense of social dislocation led many German artists in the years between the wars to create images of contemporary disillusionment and decadence. Otto Dix and George Grosz became known as the leading figures in the movement called *Neue Sachlichkeit* (New Realism). Distinct from the preceding generation of German Expressionists, these artists emphasized urban activity and collective, rather than personal, beliefs. *Neue Sachlichkeit* artists often attacked the society that they felt perpetuated inequalities, but they also delighted in presenting its attractions on occasion. In this painting, Dix depicts the actress Vera Simailova, whose fashionable androgyny, feline stare, and animal crouch create an odd fusion of repulsion and seduction, opulence and vulgarity.

Woman Lying on a Leopard Skin is one in a number of penetrating portraits Dix made during the 1920s, the decade of his best *Neue Sachlichkeit* portraits. In all these works, Dix's experimental technique of mixing tempera pigment in oil and applying it to wood panel recalls German Renaissance practices seen in the art of such old masters as Dürer, Cranach, and Grünewald. Also reminiscent of German art of the sixteenth century was his precise use of line and sense of airless space. All of these characteristics were perhaps a response to the previous movement of German Expressionism as seen in the *Die Brücke* and *Der Blaue Reiter* groups.

PAUL KLEE
Swiss, 1879–1940
Why Does He Run? (Was läuft er?),
1932

Etching. 9⅛ × 11⅜ in. (23 × 29 cm)
Membership Purchase Fund. 69.5

Born in the small town of
Münchenbuchsee, near Bern,
Switzerland, Klee left his homeland
early to attend art school in
Munich. In 1898, on a school excur-
sion to visit the artist Walter Ziegler
in Burghausen, Klee became enam-
ored of the etching process and
made his first experiments in the
graphic medium. Although his

print output was not extensive, he
created both etchings and litho-
graphs throughout his life, stopping
only in 1932 when the Nazi regime
put an end to his public career.

Klee's work is inhabited by
tragicomic characters, figural exag-
gerations prompted by a combina-
tion of imagination and reason, an
intellectualized innocence and a
child's fantasy. He said of his own
work that "graphic imagery being
confined to outlines has a fairy-like
quality" – a quality derived from
his enthusiasm for primitive and
folk art, and children's drawings.
His two figures in *Was läuft er?*
seem to be acting out a scenario,
complete with pathos and drama

and laughter, encompassing so much
of the human experience in a few
lines.

In 1932 Christian Zervos, pub-
lisher of the *Cahiers d'Art*, was
having financial difficulties, and
many leading artists of the day,
including both Klee and his old
friend Kandinsky, contributed
prints to an edition of the *Cahiers*
that was intended to help Zervos
out of his troubles. Klee's work,
Was läuft er?, was his final print;
in 1933, under the Nazis, he lost
his professorship at Düsseldorf and
thereafter worked in seclusion
until his death in 1940.

HENRI MATISSE
French, 1869–1954
Portrait of Alexina Matisse, 1938

Charcoal. 23¾ × 15⅝ in.
(60 × 40 cm)
Gift of William Benedict, Class of
1929, and Mrs. Benedict. 69.167

This portrait is one of a series of
sketches Matisse made of his son
Pierre's wife Alexina (later married
to Marcel Duchamp) throughout
1938. In this drawing we see the
artist's thought process as he
redraws a line here, elaborates there,
smudges areas for shading, and
creates a work at once calculated
and informal, seemingly sponta-
neous. Matisse often used his
sketches as preliminary studies for
paintings, but in this series they
keep their autonomous quality.

HENRI MATISSE
French, 1869–1954
The Horse, the Rider, and the Clown, Plate V from the *Jazz* series, 1947

Color pochoir. 25⅝ × 16⁹⁄₁₆ in. (65 × 42 cm)
Gift of Bruce Allyn Eissner, Class of 1965, and Judith Pick Eissner. 80.63.5

An early form of stencil print, pochoir was an ideal choice for reproducing Matisse's twenty cut-outs called *Jazz*, depicting circus scenes, folklore subjects, life in Parisian music halls, and the artist's own travel experiences.

It was in the early 1940s, when he was confined to his bed for most of the day, that Matisse began to pursue the cut-out as an art form. His assistants painted opaque water-color onto white sheets of paper, which Matisse in turn cut into a variety of shapes, often retaining both the primary form (the "positive") and the cut-away piece (the "negative"), arranging them in vibrant juxtapositions. He pinned and re-pinned the pieces to the wall of his studio until he was finally

satisfied with the overall harmony of the composition.

The two principal themes to be found in *Jazz* are the noise and excitement of the circus (the series was originally named *Le Cirque*, but Matisse changed it before publication) and the syncopated rhythms of popular jazz music. In the *The Horse, the Rider, and the Clown* the horse is the only distinct figure; the equestrienne is implied by her fan-shaped skirt, overlapping the horse's flank, and the clown by his vibrant costume in green, black, and yellow.

JEAN DUBUFFET
French, 1901–1985
Smiling Face (La Bouche en croissant), 1948

Oil and sand on canvas.
36 × 28½ in. (91 × 72 cm)
Gift of David M. Solinger,
Class of 1926. 55.30

After training for seven years as a painter, Dubuffet gave up art and worked for twenty-two years as a wine merchant. He believed that the fine art he saw around him paled in comparison with the humble activities of the average person. He resumed painting in 1942, by which time European cultural traditions had become so discredited by the upheaval and atrocities of World War II that he was drawn to forms created outside the tradition of fine art, particularly urban graffiti, tribal art, and the creations of children and the insane. Dubuffet wrote, "In my paintings, I wish to recover the vision of an average and ordinary man...without using techniques beyond the grasp of an ordinary man." Dubuffet created clotted surfaces by mixing oil paint with grit and urban detritus. By subverting the viewer's expectations of beauty and by elevating the mundane, Dubuffet called into question many of the assumptions on which art had traditionally been based.

La Bouche en Croissant is such a painting. Not "beautiful" in the expected way, the painting confronts the viewer with a new manner of portraiture, simplified and direct. In both the application of the paint and the addition of sand in that paint, *La Bouche en Croissant* literally enters the viewer's space to be encountered and interacted with.

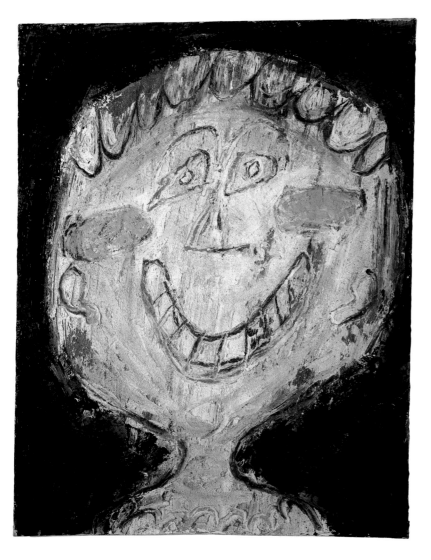

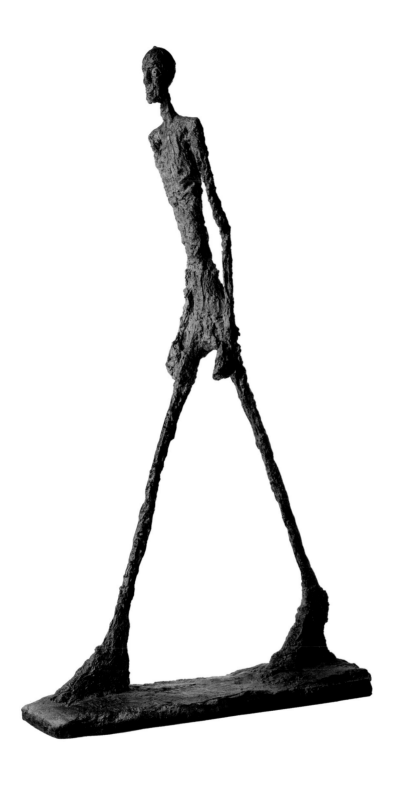

Alberto Giacometti
Swiss, 1901–1966
*Walking Man II (L'Homme qui
marche II)*, 1959–60

Bronze. 72 × 37 × 8½ in.
(183 × 94 × 22 cm)
Gift of Mrs. Percy Uris. 76.5

After World War II, Giacometti
turned from his earlier Cubist and
Surrealist work and became espe-
cially interested in creating figures
that would always appear to the
viewer as if from a great distance,
no matter how close one stood.
He achieved this by paring the
figure down to its essential compo-
nents, and by making the figure as
lean as possible. But Giacometti's
fragile men and women are also
inseparable from the post-war
attitudes that were crystallized in
the writings of French philosopher
Jean-Paul Sartre. An ardent
admirer of Giacometti, Sartre
believed that it was naive to hope
for any higher purpose in life since
man, though free, was alone and
responsible only to himself for his
actions. Giacometti's emaciated,
post-Holocaust figures with their
eroded, crumbling surfaces suggest
the antithesis of heroism or nobil-
ity, associations traditionally linked
to European sculpture. An avid
people-watcher, Giacometti drew
his inspiration from the world
around him: "In the street people
astound and interest me more than
any sculpture or painting. Every
second the people stream together
and go apart, then they approach
each other to get closer to one
another. They unceasingly form
and re-form living compositions in
unbelievable complexity…It's the
totality of this life that I want to
reproduce in everything I do."

ANSELM KIEFER
German, born 1945
Your Golden Hair, Margarethe
(Dein goldenes Haar, Margarethe),
1982

Straw, gouache, pencil, glue,
and photograph. 22 × 33 in.
(56 × 84 cm)
David M. Solinger, Class of 1926,
Fund. 83.41

In the early 1980s Kiefer began to add straw to his canvases and works on paper, and it became a vehicle for exploring German themes, often painful and without redemption.

The subject of Margarethe and Shulamith is based on Paul Celan's *Death Fugue (Todesfuge),* written in a concentration camp in 1945 and published in 1952. Margarethe represents the fair-haired German girl, with yellow straw for hair, a child of the land. Her counterpart Shulamith is a Jewish girl, with dark hair, usually shown in an urban environment, representing the decadence of the civilization that has turned on her and her religion.

Shulamith and Margarethe are never far from each other; in *Dein goldenes Haar, Margarethe,* the golden-haired Margarethe shares space with Shulamith, represented by a thick black brushstroke. Two tanks starkly reinforce the message of war and the essence of the artist's own conflict. For Kiefer, the tragedy of the Holocaust is continually reenacted by the knowledge that these two individuals can never again meet in Germany in an atmosphere of trust.

GERHARD RICHTER
German, born 1932
Untitled, 1988

Oil on paper. 11½ × 16¾ in.
(29 × 43 cm)
Acquired through the generosity
of the Harriett Ames Charitable
Trust. 96.8

The artistic production of Gerhard
Richter falls into three broad cate-
gories: figurative, that is, all the
paintings based on photography or
nature; constructive, more theoret-
ical work such as color charts,
greys, glass panes, and mirrors; and
abstract, most of the work since
1976 except for still-lifes and land-
scapes.

The variety in his work does
not indicate a lack of interest in
reality but rather a greater confi-
dence in accurately presenting dif-
ferent models to convey it. In fact,
starting with the first picture in
his catalogue raisonné, Richter has
been comfortable combining both
figuration and abstraction in many
of his pictures.

Richter's main sources for his
figurative work of the 1960s were
ordinary black-and-white family
snapshots or pictures appropriated
from the media. The banality of
these images and their muted color
range helped Richter to maintain
an attitude of expressive neutrality.

The abstracts, which Richter
has concentrated on throughout
the 1980s and 1990s, usually begin

with a soft ground of primary colors
arranged in a variety of geometric
patterns. Richter then applies an
overlay of paint, which is brushed,
dragged, squeegeed, or streaked in
aggressive colors. This process of
simultaneous creation and destruc-
tion, often repeated several times,
makes it difficult to determine the
figure-ground relationship. Richter's
abstracts, clearly his most sponta-
neous, visually complex, and emo-
tionally evocative work, perpetuate
the tradition of Modernist painting.

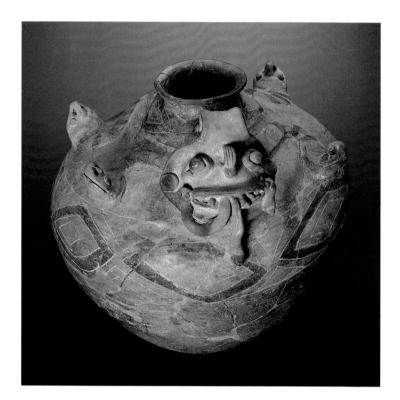

Bahia Monster
Ecuador, ca.500–300 B.C.

Ceramic jar. 13½ × 15 in.
(34 × 38 cm)
Gift of Peggy and Tessim Zorach.
74.53.131

Very little is known about the Bahia culture of coastal Ecuador. The people were probably fully agricultural and may have practiced long-distance trade of marine shells and other luxury goods with the coasts of Peru and Mesoamerica. They also built ceremonial centers complete with dedicatory offerings, and made sophisticated and beautiful ceramics that combined the use of various techniques.

This "Bahia Monster" funerary jar is a particularly fine example of this type of vessel. Its essentially snake-like nature is demonstrated through its triple tongue and the four snake-head limbs, as well as by the multicolored diamond-shaped markings around the body of the jar. These vessels are very similar to the Chorrera or Late Formative Period coiled serpent jars from the same region, but the Bahia vessels portray a much more fantastic creature than on the Chorrera ceramics. The Bahia monster may have been invented to link the transformation process of the creation of pottery with the transition from life to death and the entry of the soul into the Underworld. The association of serpents with death and with the Underworld is common in ancient Precolumbian imagery.

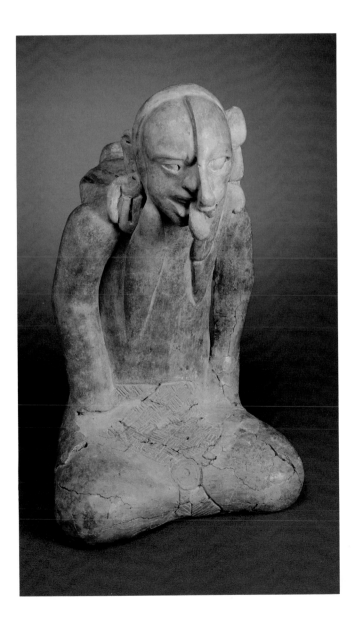

Were-Jaguar with Half-Mask
Olmec, Mexico, ca.150 B.C.–A.D. 250

Ceramic jar. 12 × 7½ × 9½ in.
(30.5 × 19.0 × 24.1 cm)
Membership Purchase Fund.
73.13.4

Were-Jaguars, half-human and half-jaguar creatures, were depicted in much of Olmec art. It is thought that shamans or shaman-kings were equated with jaguars in early Mesoamerica, much as they are today in some parts of Mexico and South America. The supernatural jaguar of the Olmec seems to have been associated with rain and fertility. The Great Jaguar, king of beasts in the jungles of Central America, was thus the ancestor of the royal human lineage through his role as rain-deity.

The shaman's transformation into a jaguar through his wearing of the skin of the beast is represented on this Olmec ceramic vessel, from Veracruz. His mask, with lolling tongue and pointed fang, clearly only covers half his face, showing that he is in the process of change. This hollow vessel may have been used to contain a potent hallucinogenic liquid made from plants that helped the shaman enter a trance and complete his transformation. The personage represented on the vessel might also have been noble. He wears ornate ear-pendants and a woven loincloth with a jade pendant suspended from its bottom point.

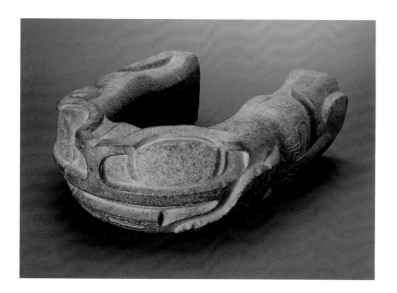

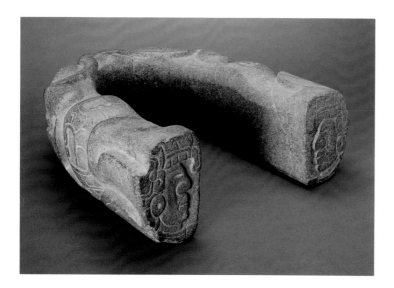

Yoke
Totonac, Mexico, ca. 250–A.D. 550

Stone. 16 × 15 in. (41 × 38 cm)
Membership Purchase Fund.
73.13.1

The ceremonial stone yokes of
the Classic Period on the Gulf Coast
of Mexico were part of the para-
phernalia associated with the pan-
Mesoamerican ritual ball game.
The yokes were probably carved
imitations of leather or basketwork
hip-protectors and were never
worn during the actual ball game.
They might have been used in reli-
gious ceremonies conducted after
the game. Yokes were also often
buried with what seem to be decapi-
tated and sacrificed player/warriors.

The ritual aspects of this
important piece of ball-game
equipment have to do with fertility.
Stone yokes often depict owls,
felines, toads, and serpents, crea-
tures associated with the night sky,
earth, and water. This particular
yoke seems to be a 'toad' type, but
it also has elements of the serpent
and the cat in its appearance. The
elaborate scrollwork designs on the
sides of the yoke may be glyphs
with a specific meaning, perhaps of
water or sprouting vegetation. The
ends of the yoke are decorated
with carved human heads facing
each other. These are possibly por-
traits of the lords involved in the
real ball game, or of the Heavenly
Twins who are often depicted
engaged in the supernatural game.

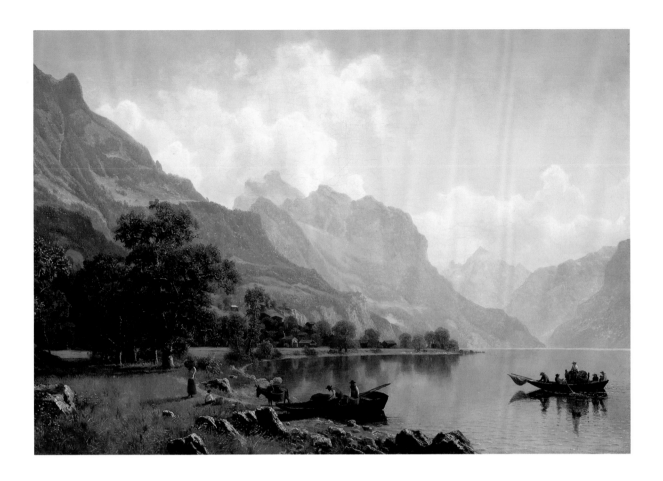

ALBERT BIERSTADT
American, born Germany,
1830–1902
Swiss Mountain Scene, 1859

Oil on canvas. 24 × 34 in.
(61 × 86 cm)
Gift of the Museum Associates.
71.106

Born in Düsseldorf, Albert Bierstadt's family moved to New Bedford, Massachusetts when he was two years old. Largely self-taught, he eventually made several trips to Europe, spending considerable time in Venice and Switzerland; he was especially impressed with the mountainous landscape of the latter. Shortly after his return from Switzerland, Bierstadt embarked on the first of a series of trips (1859–1881) to the western United States. It was his depictions of the "Wild West," romanticized and idealized for Eastern drawing room walls, for which he is best known. *Swiss Mountain Scene* marks that critical moment in time when Bierstadt has returned from Switzerland, before making his first trip to the West. In this painting, many hallmarks of his style are evident and were to be repeated in his depictions of the Rocky Mountains and Sierra Nevadas: mountains, with their peaks sharpened and crevices deepened, figures placed prominently in the foreground, and an overall sense of beauty and majesty without the dangers of the wilderness. Works such as this and his later depictions of the West were actively collected until the 1880s when taste changed and the more atmospheric French Barbizon School of landscape painting came into vogue.

JAMES MCNEILL WHISTLER
American, 1834–1903
Rotherhithe, 1860

Etching and drypoint. 10⅞ × 7⅞ in.
(28 × 20 cm)
Bequest of William P. Chapman, Jr.,
Class of 1895. 57.223

As a child Whistler had been given a book of Hogarth's engravings and etchings depicting robust scenes of eighteenth-century London life, and these images left a lasting impression on him. Throughout his career he was equally comfortable depicting an upper class Victorian drawing room and the drunks and dockhands he found in the Thames dockyards.

In 1859, discouraged by his treatment by the Salon committee in Paris, Whistler arrived in London and almost immediately began to pursue his experiments in etching with the aid of his brother-in-law, the surgeon and artist Seymour Haden. In preparation for a series of Thames images, Whistler moved in 1860 to the slum section of Wapping where he lived from June to November with his mistress and model Jo Hiffernan and created what has become known as *The Thames Set*.

The most successful of these prints, *Rotherhithe*, was made on the balcony of the Angel Inn at Rotherhithe, with a view northwest to the City, and St. Paul's just visible at the far left. Whistler, for all his perfectionism, did not bother to reverse the orientation of the scene when etching the plate, as he was more interested in the spatial elements, using a Japanese perspective. By placing the post asymmetrically and the figures low and directly against the picture frame, Whistler had taken the first steps in grafting an eastern sensibility onto a western composition, something that would remain for him a lifelong obsession.

JAMES MCNEILL WHISTLER
American, 1834–1903
*Green and Blue – The Fields –
Loches*, 1888

Watercolor. 10½ × 6⅞ in.
(26.7 × 17.5 cm)
Gift of Mr. and Mrs. Louis V. Keeler,
Class of 1911. 60.87

In 1888 Whistler married Beatrice
Philip Godwin, the widow of his
good friend the architect E.W.
Godwin. An artist in her own right,
Beatrice designed decorative panels
for furniture as well as jewelry.

Embarking on a three-month
honeymoon, the couple traveled
first to Boulogne and Paris and
then spent most of the month of
October in Loches, a small town
southeast of Tours, where Whistler
made a series of etchings and
taught his wife to etch as well.

Green and Blue shows the
green fields and low wooded hills
of Touraine. With great delicacy,
Whistler depicts the scene with
a myriad of subtle shades that
delineate the rolling hills and the
cows pastured in the background.
When the watercolors from this
trip were exhibited at Wunderlich's
in New York, one reviewer noted,
"The beautiful color-effects he so
frequently produces are quite mar-
velous – 'stunning' – is perhaps
the most appropriate word."

THOMAS EAKINS
American, 1844–1916
Study of a Model, 1867

Oil on canvas. 18½ × 15¼ in.
(47 × 39 cm)
Anonymous gift. 93.22.1

Thomas Eakins began his studies as a painter in 1861 at the Pennsylvania Academy of Fine Arts and independently took anatomy courses at the Jefferson Medical School. Dissatisfied, he left in 1866 for Paris where he enrolled in the Ecole des Beaux-Arts, studying under Jean-Léon Gérôme. A trip to Madrid in 1869 to see the work of Velasquez, however, left an indelible impression on his work. He returned to the United States in 1870, and in 1876 he was appointed instructor at the Pennsylvania Academy and became its director in 1882. He resigned in 1886 because the Academy's board of directors objected to his use of live nude models in drawing classes. Eakins persisted in maintaining that knowledge, especially scientific knowledge, was necessary for the creation of art, and a loyal group of students left the Academy and founded the Art Students League of Philadelphia.

Study of a Model, a painting made while he was still a student in Paris, marks an important early point in Eakins's career where many of his interests are visible: the nude model is explored for the interplay of light and shadow, for form and texture, and for its personality and inward reflection. Throughout it betrays, even at this early point in Eakins's body of work, his interest and belief in personal observation.

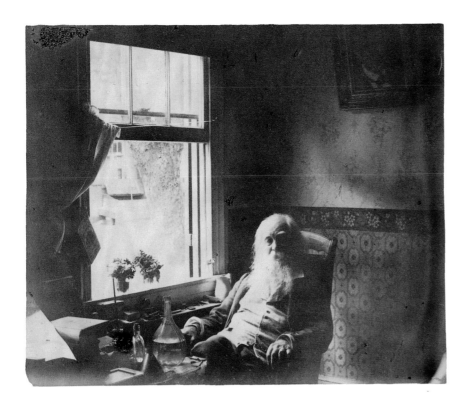

Thomas Eakins
American, 1844–1916
*Walt Whitman in Camden,
New Jersey,* 1887

Albumen print. 3¾ × 4½ in.
(9.5 × 11.4 cm)
Membership Purchase Fund. 74.14

In the early 1880s, Thomas Eakins began photographing friends, family, and students at the Pennsylvania Academy of Fine Arts where he taught and was appointed director in 1882. Because the use of photographs as a teaching tool was common in Europe in the late nineteenth century, Eakins probably became interested in photography while studying at the Ecole des Beaux-Arts in Paris in the late 1860s.

Shortly after his dismissal as director of the Academy in 1886, Eakins was taken to visit Walt Whitman for the first time at his home in Camden, New Jersey, by their mutual friend and Philadelphia journalist, Talcott Williams.

Whitman generally refused to pose for photographers, but because of his respect for Eakins's artistic skill and educational beliefs, he made an exception.

Eakins photographed the aging poet to supplement the oil sketches and life sittings for an oil portrait, which Eakins gave to Whitman on its completion. It was exhibited at the Academy in 1891 and was later bought by that institution from Whitman descendants, who had taken it to Canada.

CAÑON OF THE COLORADO RIVER,
near Mouth of San Juan River, Arizona

Timothy H. O'Sullivan
American, 1840–1882
Cañon of the Colorado River, Near the Mouth of the San Juan River, Arizona, 1873

Albumen print. 8¹⁄₁₆ × 10⁷⁄₈ in. (21 × 28 cm)
Gift from Arthur and Marilyn Penn, Class of 1956, Christopher Elliman, David Elliman, and Andrea Branch, by exchange. 91.26

Born in Ireland in 1842 (or possibly in New York to recently immigrated parents), Timothy O'Sullivan began commuting to Matthew Brady's Fulton Street Gallery while still in his teens. O'Sullivan recorded the horrors of the Civil War from Bull Run to Gettysburg, while managing Brady's Washington, D.C., studio. Because of a dispute over the attribution of photographs, O'Sullivan finished the war working with Alexander Gardner, another disenchanted former Brady employee.

O'Sullivan worked as an expedition photographer for Clarence King's geological survey of the fortieth parallel in 1867. He accompanied Cmdr. Thomas Selfridge on a search for a route through the Isthmus of Darien (Panama) and joined the Wheeler surveys of the Rocky Mountains and the Grand Canyon in 1871 and 1873. Return-

ing to Washington, O'Sullivan continued to issue prints from his own negatives. Shortly after becoming the official photographer of the Treasury Department, O'Sullivan fell ill with tuberculosis and died at his father's home on Staten Island in 1882.

Lt. George Wheeler's 1871 expedition up the Colorado River through the Grand Canyon to the mouth of the Diamond River was undertaken in flat-bottomed boats that required incredible strength to manipulate. O'Sullivan was up to the challenge, often helping to portage the boats, swimming in the swift current to save provisions, and scaling steep cliffs to find the perfect angle. The results of these efforts were some of the most monumental images of the American West ever recorded.

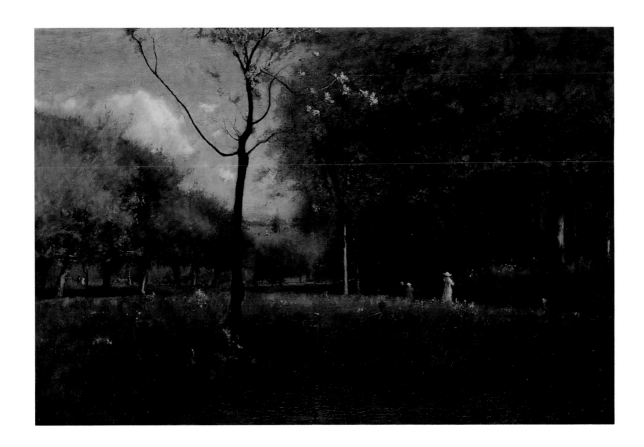

George Inness
American, 1825–1894
Landscape (Figures in a Field), 1886

Oil on canvas. 30 × 20 in.
(76 × 51 cm)
Gift of Edith L. and Martin E. Segal.
95.59

Although his early landscapes show the influence of the Hudson River School, Inness's trips to Italy in 1850, France in 1853–54, and both countries in 1870–74 had a profound effect on his work. While in Europe, Inness was greatly impressed by the Barbizon School of landscape painting, with its emphasis on tonality. From 1880 forward, his landscapes became less literal and more personal visions of nature. His independent and poetic style, with light as its true subject, emerged at about the same time that Impressionism was gaining strength; Inness's isolated vignettes of nature, with their small figures, are some of his most accomplished paintings.

Landscape (Figures in a Field), an example of his late style, is probably not a topographical depiction of a particular place but rather a poetic vision of a scene, depicted in a sweeping, summary style that only generally suggests landscape forms; the subject here is the mood of the scene, communicated by light filtering through mist and haze.

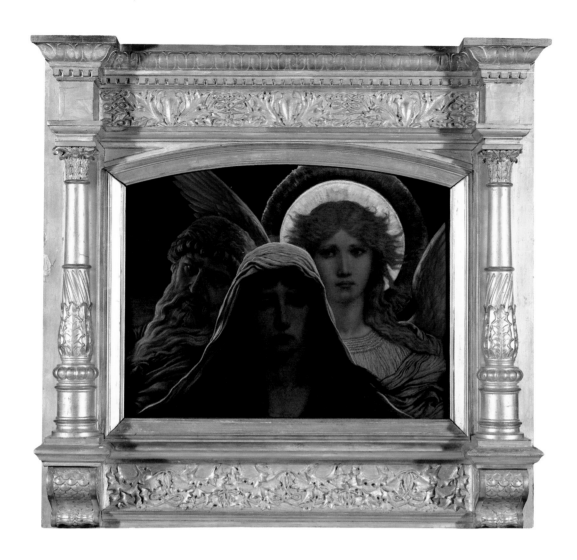

ELIHU VEDDER
American, 1836–1923
*The Sorrowing Soul between
Doubt and Faith*, ca. 1887

Oil on canvas. 16 × 21 in.
(41 × 53 cm)
Membership Purchase Fund. 70.92

Elihu Vedder was born in New
York City but spent most of his
adult life in Italy. Although aware
of the art of his time, he did not
follow any particular trend, but
instead created brooding, poetic
images out of his own perceptions,
dreams, and inventions. Best known
for his famous painting *The Ques-
tioner of the Sphinx*, his style is
marked by its simplicity of form
and linear patterns created by
clearly defined, rhythmic contours.
The movements and gestures in
his work have a timeless, ritual
significance, and his compositions

radiate a spiritual serenity undis-
turbed by everyday life. This paint-
ing, in its original frame, presents
Vedder's preoccupation with the
theme of the soul flanked by
worldly knowledge on one side, a
classical figure with the face of age
and experience, and by Christian
faith on the other, with a face of
youth and compassion surrounded
by a halo. Writing to his friend and
patron Agnes Ethel Tracy in 1887,
Vedder encouraged her to keep the
"3 heads," stating "you will never
get from me a more remarkable
picture."

LOUIS COMFORT TIFFANY
American, 1848–1933
Blue Vase with Leaf Design,
ca. 1890–1900

Glass. Height: 7 ½ in (19.1 cm)
Edythe de Lorenzi Collection.
64.896

Louis Comfort Tiffany was the
eldest son of Charles Tiffany,
founder of Tiffany and Company
in New York. He was trained as
a painter but eventually turned
his attention to the decorative arts
and began experimenting with
glassmaking techniques in 1875.
His early success with stained glass
windows and mosaics led to the
establishment of the Tiffany Glass
Company in 1885.

Tiffany called his glassware
Favrile, derived from the Old
English word "fabrile," meaning
handmade; it was created in the
Art Nouveau style, a fusion of
classical shapes and organic forms
punctuated with sinuous, asym-
metrical embellishments. An instant
sensation, it was actively sought
by both museums and private col-
lectors. With his innovations in
glass as well as in furniture design,
ceramics, jewelry and metalwork,
Tiffany became a major force in
the popularization of the Art
Nouveau style in the United States.

Two important gifts make up
the nucleus of the Tiffany glass
collection at the Johnson Museum:
A. Douglas Nash, son of Tiffany's
manager Arthur Nash, gave a
study group in 1957, which was
enhanced in 1964 with the Edythe
de Lorenzi collection, bequeathed
by her husband, Otto de Lorenzi.

ALFRED STIEGLITZ
American, 1864–1946
The Flat Iron – New York, 1902

Photogravure. 13 × 6¾ in.
(33.0 × 17.2 cm)
Bequest of William P. Chapman, Jr.,
Class of 1895. 62.3266

By the 1890s photography had effectively broken down into documentary and pictorialist, or "art" photography. During the next half century, Stieglitz's name would become synonymous with the pictoralist movement through his almost unstinting championship of photography as an art form.

As a student in Berlin, Stieglitz studied photochemistry; returning to the United States in 1890 he became a partner in the Heliochrome Company, a photoengraving business, and served as editor of the *American Amateur Photographer* from 1893–96. This was followed by the editorship of *Camera Notes,* the publication of the new Camera Club of New York.

By the turn of the century Stieglitz was an internationally known photographer. In 1902 he established the Photo-Secession with an exhibition at the National Arts Club and at the same time resigned as editor of *Camera Notes* to start a new quarterly, *CameraWork.* His standards for the publication were high: the gravures were printed on Japan tissue, retaining the delicate tones of the original and then hand-tipped into the publication. *The Flat Iron,* published in the October 1903 issue, distinguishes the subtle nuances of the process and shows Stieglitz's own high standards. The image itself reflects the dichotomy of his own vision of New York as powerful and modern, yet still almost fragile in its beauty.

FRANK LLOYD WRIGHT
American, 1867–1959
*Pair of Stained Glass Windows
(Martin House, Buffalo, NY)*, 1904

Clear and colored glass in
brass-coated and copper-plated zinc
canes, oak sashes. 24½ × 14 in.
(62 × 36 cm)
Membership Purchase Fund.
69.63a,b

Frank Lloyd Wright began his
illustrious career as an apprentice
in the Chicago architectural firm
of Louis Sullivan, famous for his
"invention" of the skyscraper.
Wright was with Sullivan from
1887 to 1893, during which time
he worked mostly on private houses.
By 1903, Wright had designed his
first independent house, for Susan
Lawrence Dana, in Springfield,
Illinois. In 1904, Wright completed
the Darwin D. Martin House in
Buffalo, New York, from which
these windows come. A low-lying,
hip-roof horizontal building

enhanced by wing walls, this struc-
ture betrays Wright's interest not
only in the structure of the house
but in all its interior appointments
and furniture as well; he designed
these windows in accordance
with his perception of the funda-
mentals of balance, line, color, and
symmetry. Wright viewed the
entire building as an organism in
which every part was equally
important. Therefore, windows and
furniture received the same atten-
tion as the rest of the structure.

GEORGE LUKS
American, 1867–1933
Subway

Pastel. $10^{15}/_{16} \times 13^{15}/_{16}$ in.
(28 × 35 cm)
Anonymous gift. 96.35.2

Luks's work reflected the restless temperament of the man himself. Born in a poor mining district in Williamsport, Pennsylvania, the squalor of city life never seemed to appall him, nor did he sentimentalize it. A one-time champion amateur boxer known as "Lusty Luks," he attacked the canvas or paper with as much forcefulness as he lived; his scenes of everyday life are realistic and unapologetic.

In the early 1880s Luks studied at the Pennsylvania Academy of Fine Arts under Thomas Anshutz, heir to the mantle of Eakins. From there Luks went to the Düsseldorf Academy for more training and then branched out on his own in London and Paris. In all, he stayed away ten years, and when he returned to the States he took a job as an artist-reporter for the *Philadelphia Press,* where he met John Sloan, Everett Shinn, and William Glackens. In 1896 Luks was sent by the Philadelphia *Evening Bulletin* to cover the Spanish-American conflict in Cuba.

In 1897 Luks moved to New York permanently where he continued to address issues of social concern. *Subway* fits into this category, with the well-to-do young matron, dressed up in brightly colored fur and muff, passing by the workers, squeezed in and dressed in dingy clothes.

HENRY OSSAWA TANNER
American, 1859–1937
Night, or *Return of the Fisherman*,
ca. 1905

Oil on canvas. 26¼ × 19¾ in.
(67 × 50 cm)
Gift of Mrs. Stephen W. Jacobs.
79.29.1

Tanner was born in Pittsburgh,
the son of a prominent Methodist
minister (later bishop). His interest
in art began as a youth and even-
tually he became a student of
Thomas Eakins at the Pennsylvania
Academy of Fine Arts. Tanner
taught for a brief period at Clark
College in Atlanta. Finding the
environment stifling in the United
States, Tanner went to Paris in
1891 where he would live, a pioneer
expatriate, until his death in 1937.
Tanner enjoyed great success in
Paris, receiving recognition from the
French government and Salon
juries. His principal subjects were
landscape, genre, and biblical scenes.
Tanner's art alone would be suffi-
cient to bring him to the attention
of those interested in art, yet he
is also significant as one of the first
African American artists to achieve
wide recognition, and his name is
often linked with that of Booker T.
Washington and W. E. B. DuBois.

In the summer of 1900,
Tanner began spending many of
his holidays exploring the Pas-de-
Calais district of northwest France
on the coast of the English Channel;
Night represents a scene from this
region. A father and son return,
after nightfall, from the sea to
their home, the image lit only by
the lantern held by the father. In a
letter to friends, Tanner called
Night "the best small picture I
have ever done."

AUGUSTUS SAINT-GAUDENS
American, 1848–1907
*Presentation Medal of the Women's
Auxiliary of the Massachusetts
Civil Service Reform Association,*
1905–06

Bronze. Diameter: 4⅞ in. (12.4 cm)
Gift of Lisa Baskin, Class of 1964,
and Leonard Baskin in honor of
John E. Marqusee. 94.15

Along with Daniel Chester French, Augustus Saint-Gaudens was one of the major figures of post-Civil War nineteenth-century American sculpture. Although he was most famous for his larger public and private commissions, he also executed medals marking the centennial of George Washington's inauguration, in 1889, and the World's Columbian Exposition, in 1893.

This work, apparently executed as a favor to his niece, honors prominent members of the Women's Auxiliary of the Massachusetts Civil Service Reform Association; only two examples are known, and this is the only one that was actually awarded (the name of the recipient, Marjie Ruth Mallery, is inscribed on the reverse). The detailed modeling and lettering was finished by the artist's assistant, Frances Grimes, and the plaster model was cast by the Gorham Company in Providence, Rhode Island.

Saint-Gaudens executed this medal later in his life, and it has a classical simplicity, openness, and dignity that are very different from his earlier work in this format. It was donated to the Museum by Lisa and Leonard Baskin in honor of John E. Marqusee; Leonard Baskin is himself a distinguished medalist and printmaker, and the Marqusee Collection of American Medals, over 400 strong, is now one of the most significant parts of the Johnson Museum's holdings.

ANNE BRIGMAN
American, 1869–1950
The Dying Cedar, 1909

Albumen print. 9½ × 6⅜ in.
(24.1 × 16.2 cm)
Purchased with funds from Alan
and Joan Libshutz (Class of 1967
and 1968), Martha Merrifield Steen
(Class of 1949) and Bill Steen, the
Estate of Warner L. Overton, and
the Herbert F. Johnson (Class of
1922) Acquisition Fund. 97.11

Anne Brigman, a native California
artist working in Berkeley, came
to photography relatively late,
when she was in her thirties and
working as a painter. She received
immediate critical acclaim with
her initial submissions to the sec-
ond San Francisco Salon of pictori-
alist photography and the first
Los Angeles Salon, and in 1903 she
was a surprise addition to Alfred
Stieglitz's *CameraWork* list of sev-
enteen Fellows and thirty Associate
members.

Brigman was considered a
free spirit, perhaps even eccentric,
with unconventional ideas about
women's roles. She was brought up
to appreciate the natural beauty
that surrounded her, and as a child
she and her sisters frequently
camped in the Sierra Nevadas with
their mother. As an adult she
returned to spend her summers
there, accompanied by friends and
siblings whom she used as models
in her landscapes. Unlike her East
Coast counterparts, she pho-
tographed the nude *in situ,* rather
than confined to a studio space.
This allowed the figures to merge
and meld with their natural envi-
ronment. In *The Dying Cedar,*
the figure seems, like Daphne, to
become one with the tree. Dusk
lends an air of haunting mystery
around the central figures. In 1909
The Dying Cedar was published
as a photogravure for the January
issue of *CameraWork.*

ROBERT HENRI
American, 1865–1929
Portrait of Carl Sprinchorn, 1910

Oil on canvas. 24 × 20 in.
(61 × 51 cm)
Gift of Anna Sprinchorn Johnson.
76.43

Born in Cincinnati, Robert Henri studied at the Pennsylvania Academy of the Fine Arts in the tradition of Thomas Eakins. He subsequently studied in Paris with Bouguereau, but his academic training eventually gave way to Impressionism. This too he abandoned for the darker tones and more painterly approach of artists like Velasquez, Manet, and especially Frans Hals. In 1907, he organized an exhibition in response to what he felt was the National Academy's inadequate representation of the art scene, becoming the outspoken leader of "The Eight" (so named from the eight artists in that exhibition: Arthur B. Davies, Ernest Lawson, Maurice Prendergast, George Luks, William Glackens, John Sloan, Everett Shinn, and himself), later sometimes called the "Ashcan School." His active and dynamic style of painting influenced the many students he taught at the New York School of Art (1903–1909) and at his own Henri School of Art (1909–1912), including George Bellows, Stuart Davis, Edward Hopper, Rockwell Kent, Paul Manship, and Yasuo Kuniyoshi.

Carl Sprinchorn, a portrait of a fellow artist, presents the viewer with the same concerns Henri taught his students: to focus on technique alone (as the Academy taught) was to "drain the life out of any ideas to which it is applied"; artists should "avoid dwelling on details" in order to capture the life, spirit, and essence of the subject depicted.

CHILDE HASSAM
American, 1859–1935
Rocks and Sea, Isles of Shoals, 1912

Oil on canvas. 23¼ × 25 in.
(59 × 64 cm)
Anonymous gift. 84.74

As the leading exponent of Impressionism in the United States, Hassam was often compared to Claude Monet, much to Hassam's annoyance. While certainly aware of Monet, Hassam identified more strongly with other artistic influences, such as the work of J. M. W. Turner, the writings of John Ruskin, and the "aesthetic movement" in general, which swept through New England in the late nineteenth century.

The Isles of Shoals are a group of small, rocky islands about ten miles off the New Hampshire coast, near Portsmouth. Hassam spent many summers on the largest island, Appledore, drawn, like many fellow artists, writers, and musicians, by the celebrated poet and journalist Celia Laighton Thaxter. The paintings executed at Appledore, accounting for approximately ten percent of his *oeuvre,* are perhaps his finest accomplishments in the exploration of color and form. He believed that true Impressionism was realism, in that the artist found inspiration in nature and did not allow artistic tradition to interrupt the connection between observation and the resulting image.

EDWARD HOPPER
American, 1882–1967
Monhegan Landscape,
ca. 1916–1919

Oil on board. 12 × 16¼ in.
(31 × 41 cm)
Gift of Herbert Gussman, Class
of 1933. 97.21

Early in his career, Edward Hopper spent the summers of 1916 through 1919 painting at Monhegan Island, Maine, a site that had also inspired many other artists, such as Robert Henri, George Bellows, and Rockwell Kent. A student of Henri's, Hopper was no doubt encouraged to visit this "wonderful place to paint." Monhegan seemed to captivate Hopper, who produced several paintings of the rugged coastline and spectacular panoramas it afforded. In this body of work, Hopper comes close to American Impressionism in his efforts to capture the fleeting effects of light and shadow on the dramatic land-scape about him. In this, he

approaches the manner of painting seen in Childe Hassam's *Rocks and Sea, Isle of Shoals* of 1912, also in this handbook. This short-lived tendency ultimately gave way to his typical calm and quiet manner of painting, as seen in *Portuguese Church in Gloucester* (1923). Throughout his career, though, he never lost his interest in the subtle effects of light, as witnessed in both these works.

EDWARD HOPPER
American, 1882–1967
Portuguese Church in Gloucester,
1923

Watercolor over black chalk and
pencil. 13½ × 19½ in. (34 × 50 cm)
Gift of Sheila H. Hearne in mem-
ory of William L. Hearne, Class of
1924; The Frank and Rosa Rhodes
Collection. 94.26.1

Hopper studied under Robert
Henri and Kenneth Hayes Miller
at the New York School of Art;
although he was influenced by the
Ashcan School, his work lacks its
characteristic exuberance. Instead,
a haunting stillness suffuses most
of Hopper's work, as if everything,
both animate and inanimate, were
caught in the eternal act of wait-
ing. We feel the squalor and pathos
of everyday life.

Hopper supported himself as
a commercial artist and illustrator,
and between 1915 and 1923 his
fine art output was confined almost
entirely to etching. The summer
of 1923 he spent in Gloucester,
Massachusetts, where he began to

paint watercolors regularly. One of
these, *Portuguese Church*, shows
some of his typical urban isolation
but tempered by Hopper's delicate
color choices, reflecting the colors
of the nearby sea. There is also a
sense of release; the bright sunshine
and the gaily waving flag suggest a
time of summer leisure.

SUPERIEUR

STUART DAVIS
American, 1894–1964
Place des Vosges, No. 2, 1928

Oil on canvas. 25⅜ × 36¼ in.
(64 × 92 cm)
Dr. and Mrs. Milton Lurie Kramer,
Class of 1936, Collection; bequest
of Helen Kroll Kramer. 77.62.1

Befriended by prominent members of the Ashcan School who worked for his father on the *Philadelphia Press*, Davis became a student of Robert Henri in New York. He exhibited five watercolors in the Armory Show of 1912, the exhibition credited with introducing America to the work of Picasso, Matisse, and other members of the European avant-garde. Deeply affected by his encounter with European art, Davis became a fervent student of modernism. *Place des Vosges, No. 2* was painted during his visit to Paris in 1928 and 1929, a time of rest between two aggressive periods of explo-

ration. He depicted the famous Parisian square, with its series of arcades, by manipulating the two-dimensional surface of the canvas so that it alternately asserts flatness and suggests depth. Davis borrowed from European modernism, with its aggressive flatness of space and geometric areas of color over the drawing that defines the subject, and made it American, infusing it with a sense of immediacy and energy. In this way, he was similar to other American artists of his time, such as Charles Demuth and John Marin, who also took Parisian modernism and made it more immediately accessible.

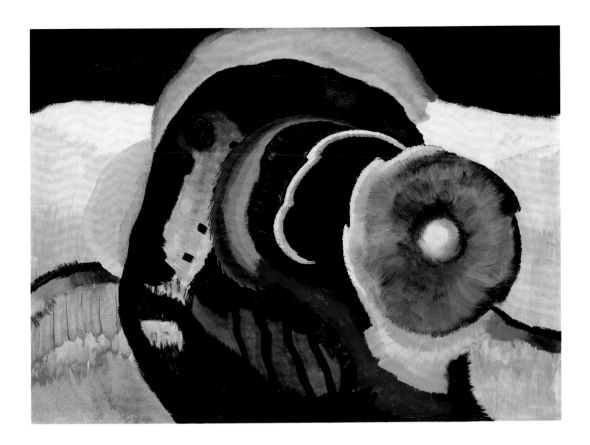

ARTHUR G. DOVE
American, 1880–1946
Alfie's Delight, 1929

Oil on canvas. 22¾ × 31 in.
(58 × 79 cm)
Dr. and Mrs. Milton Lurie Kramer,
Class of 1936, Collection; bequest
of Helen Kroll Kramer. 77.62.2

A Cornell alumnus (Class of 1903),
Arthur Dove began his career as
a successful illustrator for popular
magazines of the time: *Harper's,
Saturday Evening Post, Life,* and
Collier's. After he had saved enough
money, he traveled to Paris in
1908, where he was influenced by
the Fauves. He returned to New
York City in 1909 and in 1910 was
included in a group exhibition enti-
tled "Younger American Painters"
at Gallery 291, owned and operated
by the famous art dealer and pho-
tographer Alfred Stieglitz. By 1912,
Dove had had his first one-man
show at 291 called "Abstractions";
with Kandinsky and Kupka, Dove
can claim to have created the first
completely nonrepresentational
painting. More typical, however, are
the canvases Dove created in the

1920s when he started to introduce
a series of symbols for, most
notably, the sun, moon, and sea.
His various odd jobs as farmer and
lobsterman, along with the several
years he lived on a boat, connected
him intimately with these elemen-
tal aspects of nature.

Alfie's Delight was named for
the pleasure that his close friend
and fellow painter Alfred Maurer
found in the work. Dove's abstrac-
tion, or "extraction," as he called it,
of nature can be seen in the series
of overlapping discs and stem-like
forms which can be read as a row
of trees or flowers, exploding with
energy, and which try "to weave
the whole into a sequence of for-
mations rather than to form an
arrangement of facts."

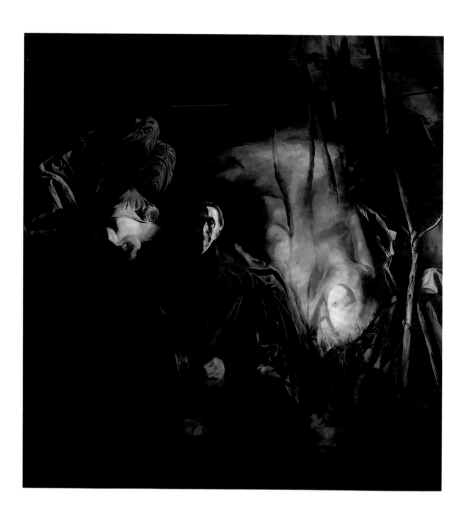

EDWIN W. DICKINSON
American, 1891–1978
Woodland Scene, 1929–35

Oil on canvas. 68 × 68¾ in.
(173 × 175 cm)
Gift of Esther Hoyt Sawyer in
memory of her father, William
Ballard Hoyt, Class of 1881, and
trustee of Cornell, 1895–1900.
54.33

Dickinson was born in Seneca Falls,
New York, and studied at the Pratt
Institute in Brooklyn and at the
Art Students League in New York
City. Although he had his first solo
show at the Albright Art Gallery
in Buffalo in 1927, he did not reach
a wide audience until a 1952 group
show entitled "15 Americans" at
the Museum of Modern Art. In
that exhibition, which included
Woodland Scene, Dickinson was
shown with artists such as Jackson
Pollock, Clyfford Still, and Mark
Rothko.

Dickinson produced only a
few large paintings that conveyed
the full range of his highly per-
sonal and yet evocative symbolism;
Woodland Scene is one of these.
The dark palette and passive, erotic
figures create not only a sense of
strangeness but also psychological
power. The result is perhaps due
to the synthesis of the many move-
ments Dickinson lived through,
from Romanticism to Cubism and
Surrealism. One should not, how-
ever, underestimate the influence
of El Greco, whose work he saw
and greatly admired while in
Europe in 1919 and about whom
he wrote in a letter to Elaine de
Kooning: "After I saw the *Burial of
Count Orgaz*, I knew where my
aspirations lay."

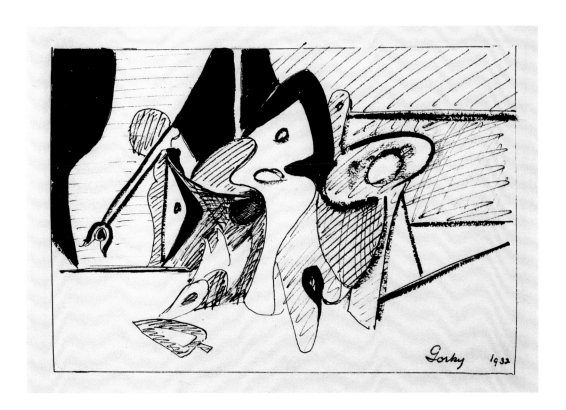

ARSHILE GORKY
American, born Armenia,
1904–1948
Study for Painting, 1932

Pen, brush, and ink. 10¼ × 13½ in.
(26 × 34 cm)
Gift of the Harriett Ames
Charitable Trust. 94.6

Gorky arrived in America in 1920, a refugee from the Turkish/Armenian conflict during which he and his sister watched their mother die of starvation. This early traumatic experience would inform much of his work, which is unflinchingly autobiographical.

In 1925 Gorky moved to New York where he began a five-year affiliation with the Grand Central School of Art, and by 1930 he had his first work exhibited by the Museum of Modern Art. *Study for Painting* was done soon after and uses many elements derived from his spiritual mentors – Picasso, Miró, and Léger. In many ways

Gorky embodies the transition from a European to an American aesthetic; he spent many years apprenticed to the styles of late Cubism and Surrealism, compounded with a decidedly American viewpoint. This drawing (a study for the Whitney Museum's *Painting*, 1936–37) falls into this transitional category.

In 1948, depressed after an operation for cancer and a car crash that had broken his neck and with his personal life in shambles, Gorky committed suicide.

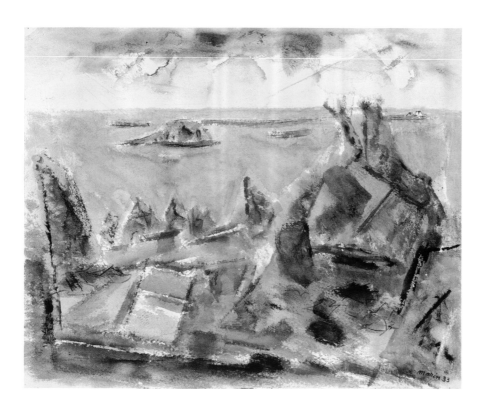

JOHN MARIN
American, 1870–1953
Off Cape Split, Maine Coast, 1933

Watercolor. 15½ × 19⅜ in.
(39 × 49 cm)
Dr. and Mrs. Milton Lurie Kramer,
Class of 1936, Collection; bequest
of Helen Kroll Kramer. 77.62.17

Trained as an architect, John Marin turned to a career in art in his late twenties, first attending the Pennsylvania Academy of Fine Arts and studying with Thomas Anshutz, then at the Art Students League in New York. In 1905 he left for Europe, coming under the spell of Whistler and the Japanese. Through Edward Steichen he met Alfred Stieglitz, and in 1910 he had his first one-man show at Stieglitz's New York gallery, 291.

The following year Marin returned to the States for good and began to apply his unique brand of Cubism to scenes of pulsating city life that surrounded him. His images capture the movement, excitement and flux of his environment, but, unlike his European contemporaries, he also included atmospheric effects and strong, overt emotions.

In 1914 Marin made his first visit to Maine. Slowly he made his way up the coast, eventually settling at Cape Split in 1933. His goal in depicting the Maine coast in its wildly varying moods was to paint "after nature's example" in a structural and sequential manner, not unlike the music of Bach. Watercolors such as *Off Cape Split* have both the delicacy and the power of a Chinese brush painting, combining the purity of the paper with a range of colors. Marin recognized and promoted the symbiotic relationship between the ink and the paper, allowing both a breathing space. As a result, his watercolors are airy and spacious, and capable of great subtlety and nuance.

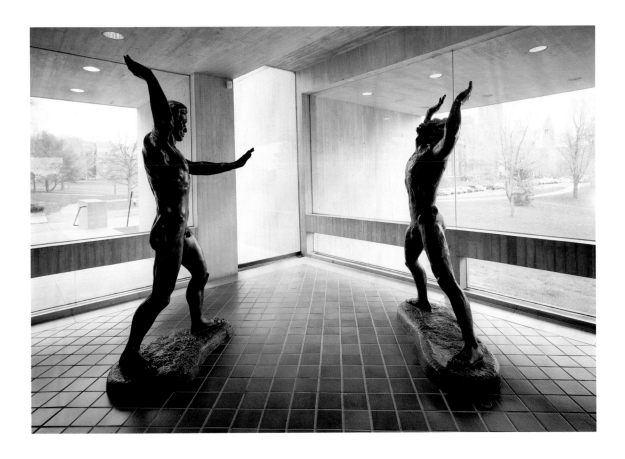

WILLIAM ZORACH
American, born Lithuania,
1887–1966
Conflict, 1935

Bronze.
84 × 55 × 21, 88 × 43 × 25 in.
(214 × 140 × 53, 224 × 109 × 64 cm)
Gift of Peggy and Tessim Zorach in
honor of Richard J. Schwartz, Class
of 1960. 90.27 a, b

William Zorach, who came to the
United States from Lithuania in
1893, was deeply influenced by the
Fauvist and Cubist movements in
their focus on simplified and some-
what abstracted forms. He began
his career as a painter, but in 1922
he switched his medium to sculp-
ture because he found in it a phys-
ical and emotional outlet.

Conflict was made when Zorach
was at the height of his powers.
He had just completed a work for
Radio City Music Hall and had
received a new commission from
the United States Treasury Depart-
ment. His simplified, monumental
style was coming into favor, and
his work was entering important
public and private collections. An
enthusiastic supporter, Abby

Aldrich Rockefeller, a founder of
the Museum of Modern Art, had
already purchased several small
works when she asked Zorach to
design some pieces relating to sports
for a sculpture garden she was
planning. Zorach made several small
models in bronze: a tennis player,
a football player, a baseball catcher,
and these two wrestlers. Unfortu-
nately, Rockefeller's husband, John
D. Rockefeller, Jr., was not enthusi-
astic about the project, and it was
never realized. Zorach later carved
the football player in stone and gave
it to the Bowdoin College Museum.
He enlarged the two wrestlers
and cast them in bronze, entitling
them, at various times, *Conflict,
Cain and Abel,* and *The Wrestlers.*

MARGARET BOURKE-WHITE
American, 1904–1971
Fort Peck Dam, Montana, 1936,
printed ca. 1965

Gelatin silver print. 18⅝ × 15⅛ in.
(47 × 38 cm)
Gift of Margaret Bourke-White
and *Life* Magazine. 65.539

Bourke-White, a 1926 graduate of
Cornell University, was one of the
first career women photographers,
beginning as an industrial photog-
rapher for *Fortune* in 1929 and
then as a photojournalist for *Life*
in 1936. For more than twenty-five
years she witnessed and recorded
the world's rapidly changing land-
scape, from Stalin's Russia to the
Depression in the deep South and
the death camps in Nazi Germany.
Her style evolved from her pictori-
alist vision at Cornell into preci-
sionist images of 1930s industry and
a more sentimental, heroicizing
view of the rural poor found in her
1937 book *You Have Seen Their
Faces*, with text by her soon-to-be
second husband Erskine Caldwell.
 When she joined Henry Luce's
Life magazine staff in 1936, Bourke-
White's first assignment was to
photograph the construction of Fort
Peck Dam, a WPA project under
way since 1933, to be used for the
introductory issue. Her cover pho-
tograph of the receding concrete
piers has the feel of an ancient
monolith redesigned for our cen-
tury. Bourke-White's perception
went beyond the obvious; she not
only covered the engineering tri-
umph of the dam but also produced
a clear-eyed report of the frontier
towns nearby, giving the essay a
breadth of vision new to the pho-
tojournalism field. In the introduc-
tion to the first issue of *Life* the
editors wrote, "What the Editors
expected – for use in some later
issue – were construction pictures
as only Bourke-White can take
them. What the Editors got was a
human document of American
frontier life which, to them at least,
was a revelation."

GEORGIA O'KEEFFE
American, 1887–1986
Pink Hills, 1937

Oil on canvas. 9 × 14⅛ in.
(23 × 36 cm)
Dr. and Mrs. Milton Lurie Kramer,
Class of 1936, Collection; bequest
of Helen Kroll Kramer. 77.62.7

In 1915, a series of important drawings by the then-unknown artist Georgia O'Keeffe fell into the hands of Alfred Stieglitz, which he included in a show the following year at his Gallery 291. By 1917 O'Keeffe had had her first solo exhibition at 291, and had joined the stable of artists supported and promoted by Stieglitz, including Charles Demuth, Arthur Dove, Marsden Hartley, and John Marin. In 1924, O'Keeffe married Stieglitz and showed annually at 291 until his death in 1946. In 1929, O'Keeffe made her first trip to Taos, New Mexico, and her work, semi-abstract, began to change. She returned annually to New Mexico until 1949 when she settled there permanently. Her paintings from

this time are exceptional for their exploration of the natural terrain and, more importantly, the spiritual quality she found within that terrain. A superb example of this investigation is *Pink Hills*, which, in a letter from 1976, O'Keeffe said was "painted from the red hills that are across the arroyo from where I've lived for 40 years."

PHILIP EVERGOOD
American, 1901–1973
The Pink Dismissal Slip, 1937

Oil on masonite. 28 × 22½ in.
(71 × 56 cm)
Gift of Harry N. Abrams. 57.409

Often associated with the American
Social Realists of the 1930s, Philip
Evergood's paintings mix expres-
sionistic fantasy, humor, drama, and
social criticism. Although he was
academically trained, his works
combine the simple, natural awk-
wardness of children's drawings
with an adult's awareness of the
complicated world around us.

Evergood was extremely
political and sought social change
through his work; he participated
in such organizations as the Artists'
Committee of Action and the
Artists' Union. Described as
"humanist" art, many of his paint-
ings deal with the futility of war,
the effects of racial prejudice, and
the economic struggle of the work-
ing classes. They often refer to
specific events in the artist's life.
He was once beaten severely and
jailed after a protest against cuts to
the Works Progress Administration
(WPA), which in 1936 dismissed
1,923 artists and writers from the
Federal Arts Project. *The Pink
Dismissal Slip*, painted in 1937,
shows an artist receiving notifica-
tion of his dismissal from the Arts
Project. Interestingly, the envelope
the figure holds is addressed to
"John Doe," making the figure a
symbol for all of the artists
involved.

REGINALD MARSH
American, 1898–1954
Grand Tier at the Met, 1939

Watercolor and goauche.
22⅛ × 30⅜ in. (56 × 77 cm)
Gift of Sylvia Brody Axelrad and
Sidney Axelrad. 76.66

Reginald Marsh was born in Paris, the son of painters Fred Dana Marsh and Alice Randall Marsh. In 1900 the family returned to America where Marsh was brought up in an atmosphere of social privilege. During his college years at Yale he devoted most of his energies to the extracurricular pleasures of parties, girls, and nightclubs while he worked as illustrator for *The Yale Record*.

After graduation Marsh gravitated naturally to the bustle and excitement of New York, where he was on the staff of the *New York Daily News* from 1922 to 1925. At the same time he continued his studies at the Art Students' League under the tutelage of John Sloan, George Luks, and Kenneth Hayes

Miller. From the *Daily News* Marsh moved on to the leading magazines of the day, contributing to *The New Yorker, Esquire, Fortune,* and *Life.*

Marsh thrived on the excitement of crowds, and he reveled in observing the public's pursuit of pleasure. He had a swift, unhesitating skill for capturing the moment with a realism reminiscent of Rowlandson and Hogarth.

In *Grand Tier at the Met* Marsh has transferred his attention to a more upscale milieu, but he is no less forthright in his depiction of the rich and the famous. Marsh himself was not an opera fan, which perhaps explains why his several images of the Metropolitan Opera and its patrons, done between 1934 and 1940, are generally unflattering.

THOMAS HART BENTON
American, 1889–1975
*The Artists' Show, Washington
Square, New York*, 1946

Oil and tempera on canvas.
40⅛ × 48⅛ in. (102 × 122 cm)
Gift of Jerome K. Ohrbach. 77.80

Although Thomas Hart Benton
had first been associated with the
circle of Alfred Stieglitz, he began
to feel that this group was too sep-
arated from reality, with their
"play with colored cubes and clas-
sic attenuations." His service in
World War II as a naval draftsman
forced him to make objective
records of the navy yard and instal-
lations at Norfolk, Virginia. Upon
his return to New York after the
war, he advocated an "American
scene" subject matter, in the face of
adverse criticism. This movement,
later called "regionalism," gained
in popularity and included such
prominent figures as Grant Wood,
Sinclair Lewis, and Sherwood

Anderson. But Benton's interpreta-
tion of the American scene was
unique, calling into play his knowl-
edge of the dynamic energy and
muscular, sinuous line of the work
of Michelangelo and El Greco.

 The Washington Square art
show occurred at the end of every
summer in New York, drawing a
wide range of artists, collectors, and
spectators. Benton successfully
captured the bustling character of
the event. The animation of the
figures and the amount of anecdo-
tal information are typical of
Benton's dynamic and compact
compositions, which influenced the
work of his most famous student,
Jackson Pollock.

WILLEM DE KOONING
American, born Netherlands,
1904–1997
Untitled (Nude Woman), 1947

Oil and pencil on composition
board. 10½ × 8½ in. (27 × 22 cm)
Gift of Dr. Marvin and Natalie
Gliedman. 86.113

A pioneer of the Abstract
Expressionist movement, Willem
de Kooning became one of the
most important figures in the
development of postwar American
painting. Born in Rotterdam in
1904, de Kooning began his studies
in art as an apprentice in a firm of
commercial artists and designers,
and later studied at the Rotterdam
Academy of Fine Arts and Tech-
niques. After immigrating to the
United States in 1926, he eventually
settled in New York, where he
began to associate with other artists,
musicians, and writers.

After working as a carpenter,
a house painter, and an artist in the
Federal Arts Project of the Works
Progress Administration, de
Kooning decided to pursue painting
full-time. In the late 1930s he
began working on a series of col-
lages, drawings, and paintings
devoted to abstracted images of
women, a series he continued
throughout his lifetime. These ges-
tural representations of figures
and anthropomorphic forms, made
up of vigorous brush strokes
and vibrant colors, emphasize de
Kooning's emerging Abstract
Expressionistic style and preoccu-
pation with improvisation and the
process of creation. *Untitled (Nude
Woman)* illustrates de Kooning's
interest in gesture and implied
motion through his manipulation
of line and paint.

YASUO KUNIYOSHI
American, born Japan, 1889–1953
Charade, 1948

Casein on masonite. 7⅞ × 5⅞ in.
(20.0 × 14.9 cm)
Gift of Dr. and Mrs. Milton Lurie
Kramer, Class of 1936, Collection;
bequest of Helen Kroll Kramer.
77.62.5

Yasuo Kuniyoshi was born in
Okayama, Japan, in 1889, and came
to the United States in 1906. He
attended numerous schools, includ-
ing the Los Angeles School of
Art, and in New York the Art
Students League and the National
Academy of Design. In New York,
he was influenced by both his
teacher Kenneth Hayes Miller and
his friend Jules Pascin. Two visits
to France in 1925 and 1928 gave
Kuniyoshi a taste of Parisian mod-
ernism, especially apparent in his
still lifes.

Kuniyoshi often depicted deli-
cate, somewhat melancholy women,
as seen in *Charade*. His bright,
pastel colors, compressed space,
love of textures, from thick impasto
to translucent glazes, and his
almost calligraphic brushwork are
all reminiscent of his Japanese
background and exposure to
French modernism. In his last five
years, the period of this painting,
Kuniyoshi's colors intensified, with
surprising new hues that served
to underscore the inventive combi-
nation of reality and fantasy found
in his work. As the artist himself
said, "When I have condensed
and simplified sufficiently I know
then that I have something more
than reality."

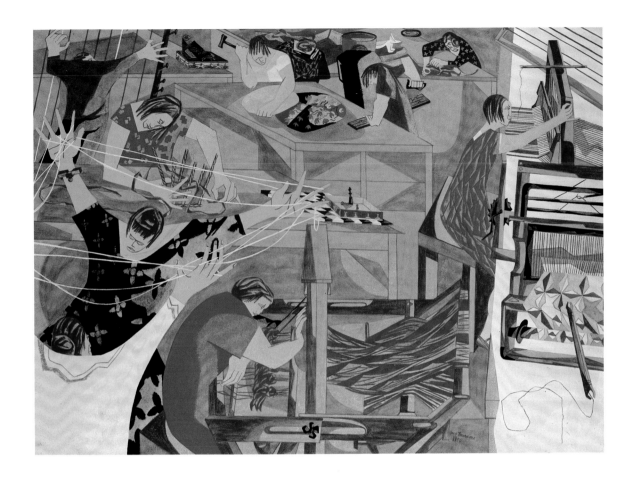

JACOB LAWRENCE
American, born 1917
Occupational Therapy No. 2, 1950

Gouache. 23¾ × 31¾ in.
(58 × 81 cm)
Dr. and Mrs. Milton Lurie Kramer,
Class of 1936, Collection; bequest
of Helen Kroll Kramer. 72.110.13

Jacob Lawrence was born in Atlantic City but was brought up in a settlement house in Harlem. This was the period of the Harlem Renaissance, a time of sharply focused social awareness and a burgeoning black consciousness, which nurtured the young Lawrence and opened his eyes to the life around him. He began taking art lessons early, and during the Depression, he worked for the WPA.

It was his own background in Harlem and the hard life of black Americans that informed Lawrence's earliest work. His *Migration Series,* supported by grants from the Rosenwald Foundation, was an immediate success and brought the twenty-four year-

old to national attention. Lawrence continued to work in series – possibly reflecting the oral tradition of the black community – and the individual images, while powerful on their own, have connective strength when viewed as a narrative.

Never one to shy away from human suffering, no matter how close to home, Lawrence did *Hillside Hospital Series* based on his stay at the psychiatric hospital in 1949–50. *Occupational Therapy No. 2* is from this series, and while it contains many of the elements of his earlier work – gestures arrested, simple shapes with no modeling, and primary colors – there are also humor and compassion.

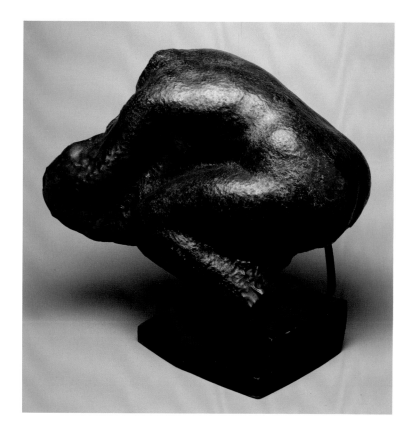

SAUL BAIZERMAN
American, born Russia, 1889–1957
Adriana, 1950–57

Hammered copper and armature.
21 × 28 × 17 in. (53 × 71 × 43 cm)
Gift of Arthur and Susan
Goldstone. 91.63

Saul Baizerman was introduced to
direct metal sculpture while study-
ing in Paris in 1925, and after
returning to New York, he decided
on a technique of beating sheets of
copper from both the front and
back to produce beautiful figurative
forms. The resulting sculpture gave
an impression of substantial mass,
although hollow and made of thin
metal. This technique also enabled
Baizerman to capture the feeling of
endless movement by creating
gently rolling rhythms, similar to
those found in the natural land-
scape. *Adriana* is an example of
such a sculpture, using both mass
and empty space to give the illusion
of solidity while conveying grace-
ful movement.

Baizerman's technique was
arduous and often painful. He
hammered at copper sheets so hard
that he was often knocked to the
ground by the rebound of his ham-
mer blow. The constant hammering
and banging of metal on metal
damaged the fine motor control of
his hands and impaired his hearing,
while the exposure to the poison-
ous oxides from soldering metal
eventually led to his fatal cancer.
Baizerman felt this to be an essen-
tial part of his creative process:
"How do I know when a work is
finished? When I am weak and it is
strong, the work is finished."

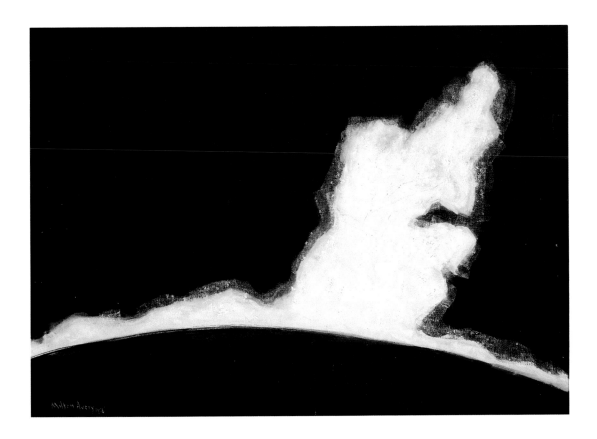

MILTON AVERY
American, 1885–1965
The White Wave, 1956

Oil on canvas. 30 × 42 in.
(76 × 107 cm)
Gift of Helen Hooker Roelofs
in memory of her father, Elon
Huntington Hooker, Class of 1896.
73.67

Milton Avery, born in a small town in upstate New York, attended the Connecticut League of Art Students. The mature style he developed in the 1950s, however, is the result of his self-teaching and experimentation. His sentiment, "why talk when you can paint," adeptly sums up his attitude toward painting. With no definite predecessors or direct followers, Avery did not become associated with any major school of painting. As Clement Greenberg pointed out, "He is one of the very few modernists of note of his generation to have disregarded Cubism." His oil paintings, like his watercolors, have a thin, dry quality that underscores the overall simplicity of their composition. Extreme simplicity, bordering on abstraction,

is a hallmark of Avery's works in general and his landscapes in particular. A simple wave is transformed into a form not unlike the eruption of a solar flare. A relatively late work, *The White Wave* revisits familiar subject matter, but gone now are all details except for the sinuous contour that defines the wave itself. His interest in color and simplified forms has been likened to similar interests in the work of Barnett Newman, Adolph Gottlieb, and Mark Rothko, the latter of whom said, "There have been several others in our generation who have celebrated the world around them, but none with that inevitability where the poetry penetrated every pore of the canvas to the very last touch of the brush."

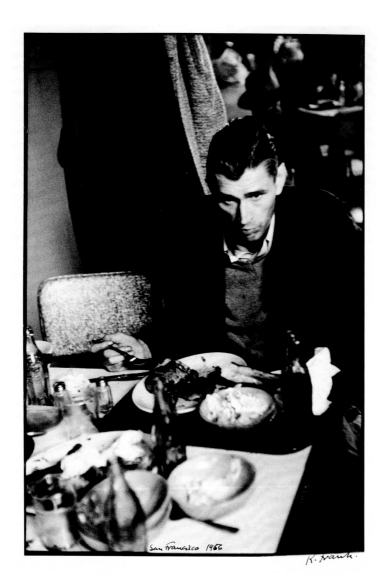

San Francisco 1956

R. Frank.

ROBERT FRANK
American, born Switzerland, 1924
Cafeteria – San Francisco, 1956

Gelatin silver print. 12½ × 8½ in.
(32 × 22 cm)
Gift of Arthur and Marilyn Penn,
Class of 1956. 85.68.531

Frank grew up Jewish in neutral
Switzerland during World War II.
At the age of sixteen he appren-
ticed himself to the photographer
Hermann Segesser, who lived in
the same apartment building as
Frank's family. This was followed
by an apprenticeship with Michael
Wolgensinger, and soon after the
war was over he immigrated to
America where, like many of his
contemporaries, he began his career
taking fashion photographs for
Harper's Bazaar.

Soon exasperated by this
type of work, Frank began to travel
both here and abroad. Encouraged
by Walker Evans, he was awarded
Guggenheim Fellowships in 1955
and 1956, which allowed him
the freedom to travel throughout
the United States, recording his
thoughts and feelings about this
vast country. His style was as
uninhibited and innovative as Jack
Kerouac's and Allen Ginsberg's,
and his images, like their written
word, came to epitomize the Beat
Generation.

Cafeteria – San Francisco is
from *The Americans*, a series of
eighty-three black-and-white pho-
tographs that tell a different story
of American life of the Eisenhower
years. Instead, Frank dwells on
the disenfranchised; his figures are
lonely, barely getting by, discon-
nected, and insecure.

LEE BONTECOU
American, born 1931
Flit, 1959

Welded iron, canvas, wire and black
velvet. 65 × 65 in. (165 × 165 cm)
Anonymous gift. 59.140

Born in Providence, Rhode Island,
and raised in Nova Scotia, Lee
Bontecou began studying sculpture
in New York City from 1952 to
1955 with William Zorach. After
she won a Fulbright Fellowship to
Rome in 1957 and 1958, and the
Louis Comfort Tiffany Award in
1959, she embarked on a successful
career in which she challenged
artistic conventions of both materi-
als and presentation in such works
as *Flit*. Conceived like a sculpture
but hung on the wall like a paint-
ing, Bontecou surprised many
viewers with her early works like
Flit, because of her use of industrial
materials like screen, pipe, burlap,
canvas, and wire. These construc-
tions or assemblages were aptly
characterized by critics like Carter
Ratcliff as "organic machines"
because Bontecou's work evoked
not only the mechanical, with its
use of manufactured materials, but
also the biological, with the bio-
morphic forms these works sug-
gested. In the case of *Flit*, an addi-
tional biological reference is
implied: Flit was a commercial bug
killer in the 1950s, and that word,
so clearly seen here, implies not
only a certain danger and threat,
but also a biomorphic, Venus's-
flytrap quality. In her use of indus-
trial and found materials, Bontecou
relates to the work of Richard
Stankiewicz and, later, Mark di
Suvero. In her later work, she aban-
doned burlap and screen for vac-
uum-formed plastics, another
industrial material, creating fish
and flower forms that contain, in
their tendrils and preying appear-
ance, the same sense of menace as
her earlier works.

ROBERT RAUSCHENBERG
American, born 1925
Migration, 1959

Combine painting: oil, paper, fabric,
printed reproductions, printed paper,
and wood on canvas. 49⅞ × 40 in.
(127 × 102 cm)
Anonymous gift. 59.141

Rauschenberg, suspicious of the
pretensions of fine art, experiments
freely with nonart items and mate-
rials that others would dismiss
as junk. He has said, "I don't really
trust ideas, especially good ones.
Rather I put my trust in the mate-
rials that confront me, because
they put me in touch with the
unknown." Rauschenberg's sensi-
tivity to texture and material
enables him to draw objects from
completely unrelated contexts and
juxtapose them in order to make
a witty or poignant observation. In
Migration, Rauschenberg has
brought together many elements
in a visually provocative manner: a
clock without hands, a piece of a
cardboard moving box, newspaper
photographs, numbers from a
sports jersey, and a soiled white
shirt. He isolates these objects in
distinct areas, yet pieces of the
objects are found throughout the
canvas. Even the paint that defines
the areas is not static, but runs into
neighboring colors. Rather than
stating or even suggesting a fixed
meaning, Rauschenberg brings
together the flotsam and jetsam of
the postindustrial world so that we,
the viewers, are left to create our
own set of meanings, just as we
must do in the world outside the
gallery. Collage assemblages such
as *Migration* are typical of the
works Rauschenberg produced in
the 1950s, which changed during
the 1960s with his greater use of
the silkscreen process.

ROBERT RAUSCHENBERG
American, born 1925
Booster, 1967

Color lithograph. 72 × 35½ in.
(182 × 90 cm)
University Purchase Fund. 67.73

In the early 1960s Rauschenberg began his long experimentation with the lithographic process. Never hindered by tradition, he was wildly inventive in his use of disparate methods and processes. The result is that many of his prints read as collages, with overlapping transparent areas creating a shifting, fluid space.

In 1967 Rauschenberg took these ideas even further in a series of images entitled *Booster and 7 Studies. Booster* is made up of an X-ray self-portrait laid over with a time chart of 1967, revealing the artist as Inner Man, an idea he would use again the next year in his *Autobiography*. To this he adds other simple images and further enhances these with blue, red, and black. We are left with the ghostlike figure of the artist offering himself as a *memento mori,* a reminder of the temporality of life.

JIM DINE
American, born 1935
Untitled, 1959–60

Wood, fabric, paint, and found
wheel. 17 × 120 × 5⅝ in.
(43 × 305 × 14 cm)
Gift of Inez Garson in memory
of Alan R. Solomon (1920–1970).
73.42

Painter, printmaker, and sculptor,
Jim Dine is often associated with
the Pop Art movement of the 1960s.
A prolific artist, Dine continues to
work with a system of recurring
visual themes that includes tools,
hearts, robes, and trees. His assem-
blages often combine gestural
painting with found objects loaded
with his own personal symbolism,
but allow viewers to integrate their
own feelings and formulate their
own connections.

A visiting critic in Cornell's
College of Architecture, Art, and
Planning in 1966, Dine's studies in
art began at the University of
Cincinnati and the Boston Museum
School in the early 1950s, where
he worked in both painting and
sculpture. After completing his BFA
at Ohio University in 1958, Dine
moved to New York City, and
quickly developed an interest in
the performance art "Happenings"
being created at that time by Allan

Kaprow and others. The Happen-
ings' combination of expressionistic
painting, sculpture, and perfor-
mance broke down the barrier
between art objects and objects used
in everyday life, and Dine's subse-
quent work continued to empha-
size the physical act of creation.

Dine's construction, *Untitled*,
1959-1960, is an early example of
the artist's combination of found
material, expressive gestural paint-
ing, and symbolism. The repeating
cross forms emerge from the
dense textural surfaces, while the
crumpled wheel from what may
have been a child's toy at the center
mysteriously draws the viewer's
attention. The work relates to a
performance piece done in 1960
entitled *Car Crash*, which was based
on an actual accident involving the
artist and his wife.

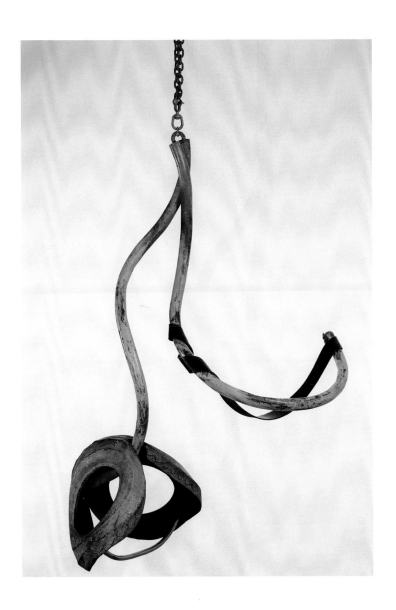

MARK DI SUVERO
American, born China, 1933
Untitled, ca. 1965

Painted metal, rubber tire, leather,
and chain. 88 × 32 × 61 in.
(224 × 81 × 155 cm)
Membership Purchase Fund. 75.42

Just as Abstract Expressionist
painters explored the idea of gesture
by using unconventional tools to
shape the creation of a painting,
Mark di Suvero incorporates the
idea of gesture into his sculpture
through the scale of his work as
well as his use of found materials.
Once describing his own work as
"painting in three dimensions,"
his monumental sculptures often
use improvisation, tension, and
balance. Di Suvero's sculpture is
strongly influenced by his associa-
tion with the world of machine
shops, garages, and boatyards.
Constructing his work at garages
or other sites where machinery
was made and repaired, di Suvero
incorporates such commonplace
elements as rubber tires and chains.
These materials contribute to an
unpretentious sense of fun and
down-to-earth grit. As in his other
large scale sculptures, di Suvero
paid careful attention here to com-
position, balance of forms, and
capacity for movement, intending
the sculpture to be viewed from a
variety of angles and positions.

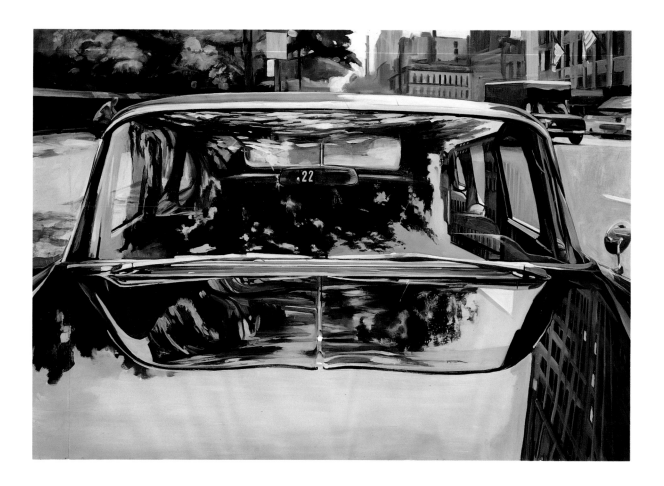

RICHARD ESTES
American, born 1936
Untitled (Car #22), 1967

Oil on masonite. 35¾ × 51½ in.
(91 × 131 cm)
Gift of Roger Hecht, Law, Class
of 1971. 93.36

After training at the Art Institute of Chicago (1952–56), Richard Estes created New York City street scenes painted directly from his own snapshots. Estes uses several shots of the same scene under different lighting conditions (sun, clouds, rain) and different focus settings, for he feels that neither the human eye nor the camera is exactly "right." The results of this process are his meticulous, coolly detached glimpses of contemporary urban civilization. He particularly delights in depicting highly reflective surfaces, such as glass and chrome, and the distortions they produce. This work also presents the viewer with an iconic emblem of American culture: the automobile. The results of his investigations have led him to be included in the so-called Photo-Realism movement, although his clearly visible brushwork of strong strokes and defined edges separates him distinctly from others in this movement, such as Tom Blackwell, Don Eddy, and Richard Cottingham.

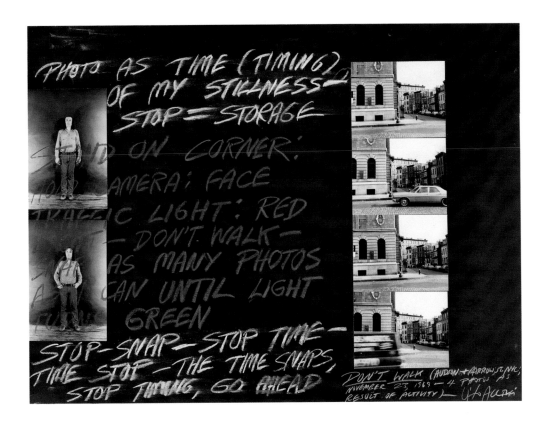

Within the image (chalk text):

PHOTO AS TIME (TIMING)
OF MY STILLNESS—
STOP = STORAGE
STAND ON CORNER:
HOLD CAMERA; FACE
TRAFFIC LIGHT: RED
— DON'T WALK —
AS MANY PHOTOS
I CAN UNTIL LIGHT
GREEN
STOP—SNAP—STOP TIME—
TIME STOP —THE TIME SNAPS,
STOP TIMING, GO AHEAD

DON'T WALK (HUDSON + BARROW ST, NYC;
NOVEMBER 23, 1969 — 4 PHOTOS AS
RESULT OF ACTIVITY)

VITO ACCONCI
American, born 1940
Don't Walk, 1969 (1975)

Photographs and chalk.
29⅞ × 39⅞ in. (76 × 101 cm)
Purchased with funds from the
National Endowment for the Arts
and individual donors. 78.6

Vito Acconci startled gallery viewers in the 1960s with his aggressive performance pieces that evolved around body-centered activities. He has carried this into his other work, his writings, installations, and sculptural work, as he explores the realities of self and situation. He often resorts to mundane, everyday props and always uses a real-life situation as his starting point. There is a consistency of purpose in his work, as he makes the connections between his own body and his destination.

In *Don't Walk* Acconci combines photographs and chalked words in a sequential manner, arresting the movement of his performance. In this case Acconci is recording his response to an ordinary street sign, and the use of the chalk, the medium of sidewalk writing, emphasizes the normality of his action. It is the documentation of the action and the creation of a work of art out of it that is unusual, raising questions about what is art and what is not.

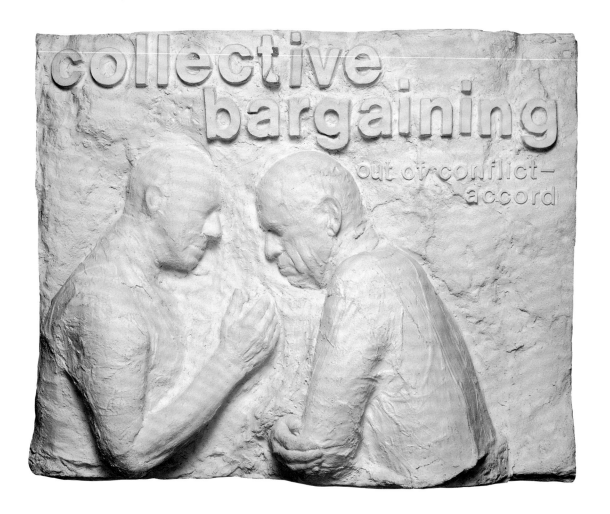

GEORGE SEGAL
American, born 1924
*Collective Bargaining: Out of
Conflict – Accord*, 1974

Plaster. 36 × 45¼ × 11½ in.
(91 × 115 × 29 cm)
Gift of Theodore W. Kheel, Class
of 1936. 91.100

George Segal's sculptures are cast
from living models in plaster of
Paris. Rather than casting from the
internal impression of the mold,
to produce an exact replica of the
human model, Segal uses the plas-
ter mold itself as his art, express-
ing himself via the manipulation
and reconstruction of its unrefined
surface. Usually figures in the
round, Segal's sculptures are known
for the way they make visible the
communication, or lack of commu-
nication, between people. He once
said that he had a strong "interest
in the confrontation and/or dia-
logue between two people," and
this can be seen in *Collective Bar-*

gaining, one of his few examples of
relief sculpture. This work was
commissioned by Theodore Kheel,
the prominent New York labor
attorney, patron of Segal, and
advocate of collective bargaining –
a negotiating process in which both
labor and management sit down
together to discuss their problems
and possible solutions. *Collective
Bargaining* depicts Floyd "Red"
Smith, the leader of the Interna-
tional Association of Machinists of
the AFL-CIO from 1969 to 1977, on
the left, and Elmer T. Klassen, the
former president of the American
Can Company, on the right.

SUSAN ROTHENBERG
American, born 1945
Untitled, 1975–76

Charcoal, tempera, and pastel.
20 × 24¾ in. (51 × 63 cm)
Acquired through the generosity
of Gale, Ira, and Jennifer Drukier.
97.13

After graduation from Cornell in the mid-sixties, Susan Rothenberg explored various artistic avenues before arriving in New York in 1969. Her earliest series of "drawings" were conceptual in nature and involved such disparate materials as wire and screen and plastic sheets, either stapled or nailed to the wall.

Eventually Rothenberg went back to canvas and paper as her primary matrices, and forms became recognizable. In 1973 she began the series of horses, first from a doodle, then to full-scale work. The image of the horse was very personal, reflecting the artist's own psyche, an examination of her fears and dreams. The intimacy is particularly apparent in the drawings, reflecting the artist's raw, spontaneous intentions.

The earliest horse pieces are compelling in their simplicity: the horse or horses generally stand or run, and their lack of grace and sheer bulk lends an overwhelming presence to the work. As Rothenberg further explored her theme, she began to impose forms in front of the horses, accelerating the inherent flatness of the surface, as in this work. The horse is drawn and redrawn, darkly embedded in the paper, with the] shape pressed against its flanks. It is a work that speaks of the artist's process, the charcoal rapidly smudged and reworked, contrasted with the soft pale green of the paper, an image of mysterious dichotomies.

JENNIFER BARTLETT
American, born 1941
In the Garden #116, 1983

Color screenprint. 29¼ × 37⅞ in.
(74 × 96 cm)
Purchased with funds given by the
National Endowment for the Arts;
Martha Merrifield Steen, Class
of 1949, and Bill Steen; and Special
Gifts. 90.13

Ironically, Jennifer Bartlett's *In the Garden* series evolved out of a minimalist/conceptual vision. This lush series, in sharp contrast to her earlier work, uses bright colors and a romantic approach to a garden scene, replete with pool and a sculptural attendant in the shape of a small cherub. In this print, the setting is seen side-by-side from two different angles: the left hand side of the sheet is devoted to the statue perched on the edge of the pool, knees bent, as if to urinate into it; the right side allows us to look over the same figure's shoulder into the pool, as if a participant in the scene. This loss of momentum results in a gentle but eerie stillness, a haunting look at the life of a garden during the course of many months.

Spending a winter in the south of France on the outskirts of Nice, Bartlett confronted her surroundings with intense curiosity. With the fluctuation of the seasons, time of day, and weather, the garden changes its personality radically, from inviting to chill and remote. It has proved to be a versatile and fertile subject for Bartlett, and she has used it as a commentary on the way we see the familiar, the changes we see and the ones we don't see, and also the comfort of the known.

Lithograph. 37¼ × 28 in.
(95 × 71 cm)
Purchased with funds from Truman
W. Eustis and matched by the
New York Times, for the Class of
1951 Collection of Contemporary
American Prints. 89.25

April Gornik's images are pur-
posely deceiving; at first glance
they seem to evolve out of the great
tradition of nineteenth-century
American landscape painting but
on closer examination it is obvious
that these vistas do not exist any-
where, an abstract realism realized
in the artist's imagination. Her
vision is an elegant one, filled with
contemplative silences and a
provocative sadness.

In art school in the 1970s
Gornik's style reflected the times,
conceptual and abstract. As a stu-
dent first at the Cleveland Institute
of Art, then at the Nova Scotia
College of Art, she turned to pho-
tography combined with descriptive
captioning to express herself.
Arriving in New York in 1978, she
returned to painting – and conven-
tional painting at that. First on
plywood, and then on canvas, she
painted her personal abstract land-
scapes, which eventually evolved
into a more realistic rendering, still
and unpeopled.

In *Light at the Source* there
is a tangible spirituality beautifully
expressed by the dense blacks and
soft greys created with the litho-
graphic crayon. The light dramati-
cally pierces the clouds, dazzling
the water's surface. Characteristic
of Gornik's work, it is simultane-
ously an eerie and romantic view,
silent and waiting.

FRANK STELLA
American, born 1936
The Fossil Whale (Dome), 1992

Color etching, aquatint, relief,
and engraving. 73½ × 53 in.
(187 × 135 cm)
Gift of the Friends of the Johnson
Museum. 92.41

A prolific printmaker and painter,
Frank Stella has explored a wide
range of imagery and techniques,
from the spare elegance of the
early minimal works of the late
1950s to the energy of the recent
wall pieces. Stella's interest in
printmaking stems from the lithography revival of the early sixties,
under the auspices of two workshops, June Wayne's Tamarind
Workshop in Los Angeles (now in
Albuquerque, New Mexico) and
Tatyana Grosman's Universal
Limited Art Editions on Long Island.
Both workshops emphasized the
collaborative process between artist
and master printer; today Stella
works closely with Ken Tyler of
Tyler Graphics in Mount Kisco,
New York.

One of Stella's most ambitious
prints to date is *The Fossil Whale
(Dome)*, executed at Tyler Graphics
and derived from Herman Melville's
Moby Dick. His use of several
techniques, vibrant colors, and shaping of the paper, bulging out from
the wall, expands on his earlier
experimentation.

JOHN AHEARN
American, born 1951
Ernestine, 1992

Acrylic on plaster.
23½ × 18½ × 7 in.
(60 × 47 × 18 cm)
David M. Solinger, Class of 1926,
Fund. 96.11

John Ahearn is one of a large
number of important artists who
attended Cornell University, includ-
ing Arthur G. Dove, Margaret
Bourke-White, Richard Artschwager,
and Susan Rothenberg. He was
trained as a painter at Cornell, but
found himself as a sculptor when
he moved to the South Bronx in
his twenties. Here, in collaboration
with Rigoberto Torres, he opened
a storefront studio and began mak-
ing life-size casts of the people who
lived in the area. He met Ernestine,
the subject of this work, at a
women's shelter and was particu-
larly impressed with her energy
and optimism.

The simplicity of the pose,
the rough modeling of details, and
the thin, quick application of the
paint all help express the unpre-
tentious directness and spontaneity
of the sitter herself. Small details –
the red and blue bracelets, the
Nefertiti earrings, the lifted left
index finger – add to the energy of
the figure, and to the humanity of
her remarkably expressive face.

Index of Donors and Funds

Index of Artists

A Handbook of the Collection
Herbert F. Johnson Museum of Art

was designed by
Gilbert Design Associates
and printed by Meridian Printing
on Donside's Gleneagle dull text.

The typeface is Aldus, designed for
Linotype in 1952-53 by Hermann
Zapf. It was named after the
15th-century Venetian printer Aldus
Manutius.

The book was bound by Acme Book
Bindery.

4,000 softcover and 1,500 casebound
copies for the Herbert F. Johnson
Museum of Art on the occasion of the
25th Anniversary of the Museum.

January 1998

25th Anniversary 1973–98